ROSE

Reaktion's Botanical series is the first of its kind, integrating
horticultural and botanical writing with a broader account
of the cultural and social impact of trees, plants and flowers.

Published
Apple Marcia Reiss
Bamboo Susanne Lucas
Birch Anna Lewington
Cactus Dan Torre
Cannabis Chris Duvall
Carnation Twigs Way
Geranium Kasia Boddy
Grasses Stephen A. Harris
Lily Marcia Reiss
Oak Peter Young
Palm Fred Gray
Pine Laura Mason
Poppy Andrew Lack
Rhododendron Richard Milne
Rose Catherine Horwood
Snowdrop Gail Harland
Sunflowers Stephen A. Harris
Tulip Celia Fisher
Weeds Nina Edwards
Willow Alison Syme
Yew Fred Hageneder

ROSE

Catherine Horwood

REAKTION BOOKS

In memory of my mother, who inspired my passion for roses

Published by
REAKTION BOOKS LTD
Unit 32, Waterside
44–48 Wharf Road
London N1 7UX, UK

www.reaktionbooks.co.uk

First published 2018

Printed and bound in China

A catalogue record for this book is available from the British Library

ISBN 978 1 78023 013 2

Contents

Introduction: The World's Favourite Flower *7*

one The Classical Rose *17*

two A Rose without a Thorn *32*

three The Royal Rose *50*

four The Birth of the Modern Rose *65*

five 'Peace' and Propagation *82*

six From *Rosarium* to *La Roseraie* *99*

seven The New Rose Garden *113*

eight The Literary Rose *128*

nine 'Only a Rose . . .' *150*

ten The Rose in Art and Decoration *161*

eleven Posies, Petals and Perfume *179*

Appendix I: The Rose Family and Its Groups *197*

Appendix II: Recipes *206*

Timeline *211*
References *215*
Select Bibliography *221*
Associations and Websites *223*
Acknowledgements *225*
Photo Acknowledgements *227*
Index *229*

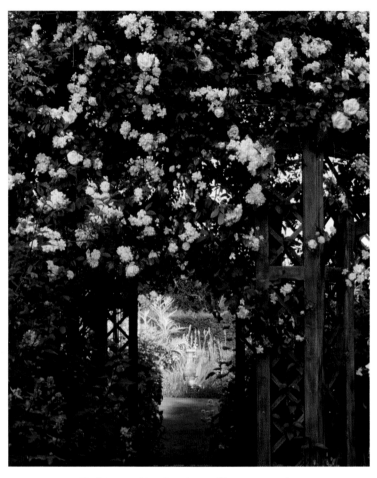

Climbing rose 'New Dawn', scrambling over an arch at
Wollerton Old Hall, Shropshire.

Introduction:
The World's Favourite Flower

I n spring 2017 the popular BBC television programme *Gardeners'
World* invited its viewers to celebrate its half-centenary by voting
for the most important and influential garden plant of the pre-
vious fifty years. Of course, the winner was the rose. What chance did
the others have against the world's favourite flower? From Alberta to
Australia, there are few gardens that don't have at least one. Even if
you can't grow them, you have probably bought them as cut flowers
or been emotionally touched by them at some point in your life,
since they are the flowers we most often choose to mark our most
significant occasions – weddings, anniversaries, births and deaths.

The rose has been a favourite of Egyptian queens and Roman
emperors, medieval monks and Crusader knights, and Tudor and
many other monarchs. Herbalists and apothecaries in the past, and
botanists and perfumers today, love its healing properties and its
scent. No other flower has had such a high status in religion and roy-
alty, politics and patriotism, decoration and literature. Yet the rose is
also deeply personal and inspires loyalty, devotion and occasionally
frustration. Pity the Reverend Samuel Reynolds Hole, first president
of Britain's National Rose Society, who, in the late nineteenth century,
had to leave home during the pruning of his 5,000 rose bushes
because it was too painful to watch – and doubtless painful for those
doing it as well.

Roses symbolize the very essence of an English garden, from
the fragrant climber framing the modest cottage door to the vibrant

colours of formal rose gardens. Yet their story could hardly be more international – from China and Japan to the plains of Persia, captivating the royal courts of Europe and the hearts of enthusiasts across the United States. The rose is the universal floral symbol of love and romance. It is even an anagram of 'Eros'.

Most of us who grow roses think of them mainly in terms of their size, colour and habit. There's that huge, beautiful pink one that climbs up the kitchen wall and flowers all summer, the deep red one that grows in the border, which we cut to bring its glorious scent into the house, or the stiff upright orangey one that's been there forever, planted by some previous owner and which we haven't got the heart or the energy to dig out. We may even know their names and whether they are climbers, shrub roses or hybrid teas. But most likely we know little about their history. Perhaps the shell-pink climber is 'New Dawn', the first modern climbing rose, launched in 1930, producing delicate blooms from late spring until early autumn, and voted the World's Favourite Rose in 1997. You don't need to know its pedigree to grow it and enjoy it – that its great-grandparent was one of the earliest Chinese introductions, 'Parks' Yellow Tea-scented China', which arrived in Europe in the 1820s. But its Chinese genes help explain its long flowering period and delicate flower shape.

My challenge in this book has been to distil, as the Bulgarian rose growers do to extract the oil from its petals, the essence of what the rose has meant over the centuries and around the world. The long history of roses is not easy to unravel. Gertrude Stein's 'rose is a rose is a rose is a rose' got it wrong. Even Carl Linnaeus (1707–1778), father of botanical naming, admitted in 1753 that 'the species of *Rosa* are very difficult to determine and those who have seen few species can distinguish them more easily than those who have examined many.'[1]

Just how old some roses are we will never know. North American fossils can be dated back to perhaps the warm, damp Eocene period 40 million years ago. Rose fossils some 35 million years old were found at the delightfully and aptly named village of Florissant in

South Park, Colorado. One of the most recent discoveries was made in the Yunnan Province in southwestern China in 2012. It dates from the Miocene period, between 5 and 25 million years ago, and is one of the best rose leaf examples in the world. Its discoverers named it *R. fortuita* n. sp., because of the 'fortunate circumstances' that led them to find it.[2] The team has since been able to make direct links to living rose species in southwestern China, especially *R. helenae*, a species found in China, Thailand and Vietnam.

Why have more rose fossils not been found if they were so widely distributed? American palaeontologist Charles Resser believes it could be because roses have usually grown in dry areas, less conducive to creating fossils. As rose fossils are found only in the northern hemisphere – in Asia, Europe and North America – it is likely that they developed before the major northern land masses separated from each other; an ancient family indeed. Species roses still grow right across the northern hemisphere, from tough *Rosa rugosa* on the rocky coast of Japan to scented *R. damascena* across Central Asia, the Middle East and Europe, and simple *R. californica* in west coast North America.

Before the arrival of the long-flowering China roses in the late eighteenth century, European gardeners were restricted to relatively few varieties, mainly gallicas, damasks, albas and centifolias, the main groups we now call 'old roses'. (For a fuller list of the old rose groups, see Appendix 1.) Gallicas are among the oldest known roses while damask roses were established in Western Europe in the mid-sixteenth century. They interbred with the wild dog rose, *R. canina*, still seen in hedgerows, to produce the beautiful albas. At some point, probably in the late sixteenth century, the albas crossed with autumn damasks to create the centifolias or 'cabbage roses' much loved by seventeenth-century artists and twentieth-century fabric designers.

The eighteenth and nineteenth centuries were a prolific time for plant introductions from around the world, including roses. But they were also a time of increasing interest in rose breeding,

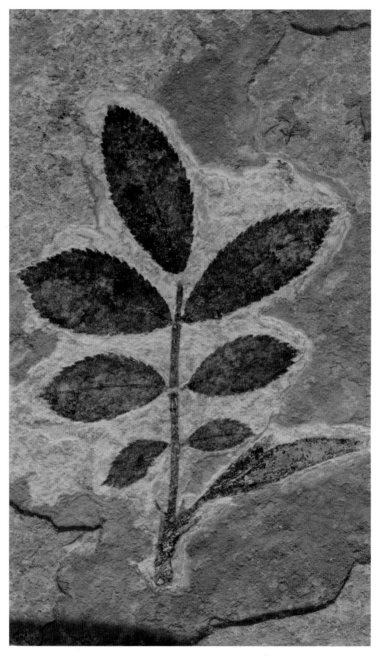

R. fortuita n. sp., a rare rose leaf fossil found in Yunnan Province
in south-western China in 2012.

producing some of the most unusual varieties still grown today. All these roses ultimately originated from pure species, but inevitably natural hybridization occurred and sports appeared that could no longer be classified as pure. Rose classification became so complicated that it was hard for even the breeders to know the originals of their new varieties. Since the eighteenth century, roses have been classified using the Linnaean system, based mainly on detailed visual identification. In the 1920s geneticist Charles Chamberlain Hurst at the Cambridge Botanic Gardens studied the genetic make-up of roses. Over 25 years, he plotted their family tree, finding that the oldest European roses were *R. canina*, *R. moschata* and *R. gallica*. Recent DNA research from Japan has overturned some of his conclusions, but his work remains the foundation of modern rose genetics.

Across the centuries, the rose has inspired competition between breeders but also camaraderie and, usually, a willingness to transcend national differences. Precious budded cuttings have crossed the boundaries of oceans and even wars. The brothers Louis Claude and Philippe Noisette, one with a rose nursery in Paris, the other in Charleston, South Carolina, exchanged roses across the Atlantic in the 1810s. Meanwhile, Napoleon's empress Joséphine was setting out to collect every known variety including those in England, despite the small matter of her husband's ports being blockaded by the Royal Navy.

'La France', the very first hybrid tea, was launched in 1867, giving it a special place in rose history. Nearly eighty years on, French nurseryman Francis Meilland's breeding of another hybrid tea during the Second World War, named 'Peace' in 1945, won even more hearts as the world returned to normality. It was the rose chosen to be given to the first delegates of the organizational meeting of the United Nations in San Francisco in 1945. By 1980 it was estimated that over 100 million 'Peace' roses had been sold, and in 1995 they were widely planted in public 'Peace' gardens to celebrate the fiftieth anniversary of the end of the Second World War.

This was just part of the enormous popularity of hybrid teas and floribundas, roses that dominated the twentieth century. Both types

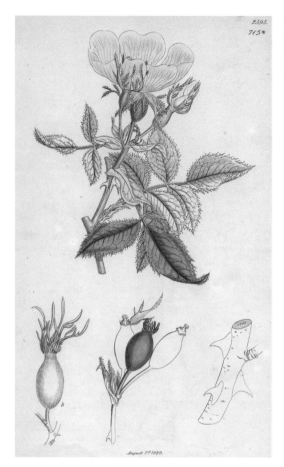

R. *canina*, the dog rose, so familiar in British hedgerows; James Sowerby, 1821, print from watercolour.

flower throughout the summer and resist most diseases better than old roses, those in groups dating back before 1867. They are tradition-ally grown on their own, away from other plants. However, fashions change and they are now being challenged by a new group, shrub roses, which sit more happily in mixed borders. In the twenty-first century, David Austin's English Roses dominate in the modern shrub rose group, while in America, the 'Knock Out'® range of ground cover or landscape roses, from amateur breeder William Radler, has made him a fortune. Behind all these blockbuster roses lie years of breeders patiently propagating tens of thousands of seedlings until the right one comes along. Their obsessive search for new strains now allows

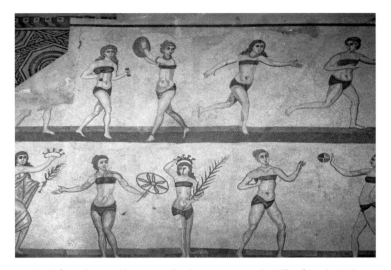

Detail from the *Ten Girls Mosaic*, early 4th century BC, at the Villa of Casale, Sicily, showing a winning athlete placing a rose crown on her head.

us to grow virtually disease-free and often beautifully scented roses right through the summer. (For a more detailed list of the modern rose groups, see Appendix I.)

Some in the rose world regard old roses as the only true varieties. Others see them as disease-ridden plants that flower for just two weeks a year. Certainly, the efforts of people like Graham Stuart Thomas, Vita Sackville-West and Constance Spry in England saved many of them from disappearing in the mid-twentieth century after the arrival of hybrid teas and floribundas. More recently, in America, the delightfully named Texas Rose Rustlers started in the 1980s to rescue old roses, known as heritage roses there, from extinction, taking cuttings from cemeteries and abandoned gardens. Their work has inspired similar groups across the country.

In 1936 rose historian Edward Bunyard described the rose as 'an index of civilization'.[3] The earliest known depictions of roses certainly go back to ancient Chinese, Egyptian, Greek and Roman times. The word 'rose' comes from the Latin *rosa*, which in turn comes from the Greek *rhodon*. The Mediterranean island of Rhodes takes its name from the flower and minted coins embellished with it. Persia

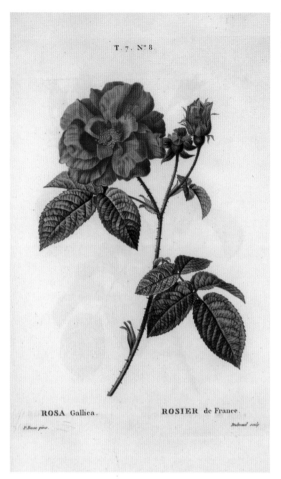

T. 7. N° 3.

ROSA Gallica. ROSIER de France.

(today's Iran), which plays a central role in this story, is home not
only to many species but to much of the mythology, art and literature
surrounding the rose. The word 'rose' or *rosa* has also been adopted
in many Western countries to describe the colour pink – both liter-
ally, as in rosé wine, and metaphorically, as in 'rose-tinted spectacles',
making the world seem benign and beautiful, or 'la vie en rose'.

No flower has more symbolic links. To Christians, roses have
often been an emblem of love, death, purity and, in the Catholic
rosary, prayer. The Ottomans loved them in their mosque decora-
tions, gardens, kitchens and even bath water. From the fourteenth

to the sixteenth century, the Arabs and Crusaders brought the first highly scented varieties to Western Europe. From that point, France became the European centre for rose growing for many centuries, its fame peaking in the nineteenth century. Empress Joséphine spent a fortune attempting to collect every known variety. Her collection was kept at Malmaison, her home outside Paris.

The rose is also central to English royalty. The Lancastrian red and Yorkist white roses came to represent the struggle for power in the Wars of the Roses. Although, as we shall see, this was much embellished by Shakespeare, the Tudor rose, combining the red and the white, did become the symbol of a great royal dynasty and is still the national flower of England. At Queen Elizabeth II's coronation in 1953, her state dress was embroidered with the familiar red and white Tudor rose. During her reign, several coins have included the rose on the reverse, including the current 20p piece. The rose symbol is also worn proudly by the England Rugby Union team.

But England does not have exclusive rights to the rose. Many other countries have chosen it as their national symbol: Bulgaria, the world's leading producer of attar of rose; Iran and Iraq, both today and in their previous incarnations as Persia and Mesopotamia being home to some of the oldest and most beautiful roses; and Cyprus, the Czech Republic, Ecuador, Luxembourg, the Maldives and Slovakia, which also have the rose as their national flower, joined in 1986 by no less than the United States. Here too, there is a sporting link. The iconic Rose Bowl Stadium in Pasadena, California, is so called for its original connections to the Pasadena Tournament of Roses New Year's Day Parade, started in 1890.

'What a pother have authors made with Roses!' wrote herbalist Nicholas Culpeper in his *Complete Herbal* of 1653. 'To write at large of every one of these, would make my book swell too big.' I share his sentiments. Judging by my sagging bookshelves, and those of the libraries I have visited, the 'pother' by authors has not abated over the centuries. Lyrical references to the rose are part of the plant's rich heritage, from Persian poets such as Omar Khayyám, to the

best-selling medieval *Roman de la rose* from France, to Shakespeare and the Romantic poets.

In the visual arts, too, the rose is everywhere. The Dutch masters had their favourites and even included the insects that munched on them. French artist Pierre-Joseph Redouté's *Les Roses* is still the world's most popular flower book, never out of print since its publication in the early nineteenth century. The German composer Richard Strauss's opera *Die Rosenkavalier* and Russian choreographer Mikhail Fokine's ballet *Le Spectre de la rose* come weighed down with romantic associations. And from medieval troubadours to twentieth-century pop stars, the rose is at the heart of love songs in every style. Over 4,000 have 'rose' in their titles. And who could ignore the scent of roses, for millennia a luxury, whether dabbed behind the ears or from a bouquet of cut flowers?

In preparing this book, I counted up the different rose varieties I have grown in four different gardens over the years. It came to over a hundred – so far. Do I have a favourite? That would be like asking if one has a favourite child. Roses are sometimes unruly but always enchanting. It's an impossible question. I love them all.

one

The Classical Rose

Tucked away in the Herbarium at the Royal Botanic Gardens, Kew, among the hundreds of thousands of dried plant specimens, is a shallow rectangular box. Inside are some papyrus stems encased in flower buds. Beside them lie a few single detached buds and a small fragile petal, browned with age. Little wonder – the collection dates to AD 170 – but there is no doubt what the flower buds are despite their desiccated state: they are roses. This section of a rose wreath was found by British archaeologist Sir William Flinders Petrie in the late 1880s at a site he excavated at Hawara in Lower Egypt. It had been placed in the coffin of the deceased, and preserved by the drying sand that encased them for seventeen centuries.

The French rose grower Pierre Cochet (1823–1898), sent some examples from Hawara, wrote: 'I have received from the four corners of the world samples of roses, plants and earth; but I have never experienced such emotion as that on opening your small parcels!!!'[1] In Cochet's hands were some of what remain, as far as we know, the earliest extant examples of roses in the world. No wonder they sent shivers down his spine. Here was confirmation of a way roses were used in the ancient past – and a distinct variety: labelled on arrival at Kew as R. *sancta*, this species is now more prosaically known as R. × *richardii*. Before this discovery at Hawara, plant historians had relied on a variety of sources – from images on shards of pottery and silk paintings to mentions in poems and sacred texts – to tell them what roles roses played in the ancient world.

17

R. × *richardii*, known as R. *sancta* when remains were found
in Hawara, Egypt, in the late 1880s.

The fragile Hawara rosebuds pose many questions, the first being
how and where roses were grown across the ancient world. Pottery
shards found in the Jiangsu region of China, dating from 3500 BC,
are decorated with five-petalled flowers that may or may not be roses.
Although China can rightly claim to be the oldest cultivator of roses,
little written evidence remains of which varieties were grown in the
first few centuries because many books were destroyed during the
iconoclastic reign of Emperor Ts'in She Huang Ti (246–208 BC).
However, the works of Confucius (551–479 BC) escaped destruction,
and he tells of roses being widely cultivated in the Imperial gardens
in Beijing centuries before the book-burning emperor. We know
that, during the following Han dynasty (206 BC–AD 220), wild roses
covered the Imperial palace walls. But these gardens had originally
been started during the reign of Chin-Nun (2737–2697 BC), so roses
had almost certainly been cultivated for many centuries. From early
frescoes to silk paintings, images of roses become almost ubiquitous

in early Chinese art, although they never gained the status of the peony or chrysanthemum.

Chinese rose historians suggest that the evolution from a wild rose into what we would now call a China rose happened much later, towards the end of the Tang dynasty, around AD 900. Tang poetry confirms people's love for the flower: 'Every family plants roses instead of plum blossoms,' wrote poet Jia Dao. The poems also suggest that the Chinese knew the difference between wild roses, rugosas and banksias. They were expert rose growers. Breeding began in earnest during the Song dynasty (960–1279) and peaked during the Ming dynasty (1368–1644), when over a hundred different varieties were grown across China. Many were mentioned in Wang Xiangjin's *Qun Fang Pu* (The Cyclopaedia of Flowers, 1621).

West of China, roses are first seen in the floral patterns decorating early Minoan (*c.* 2800–2400 BC) jewellery and paintings in Crete. A famous example is the rose on frescoes in the great palace at Knossos. There have been many guesses by academic botanists as to what variety this might be, from *R. canina* to *R. gallica*. Identification

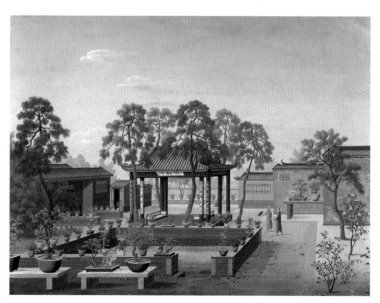

A formal garden of a wealthy Chinese merchant with rose bushes.

A fresco with the first painted rose and a blue bird from the
Minoan Palace of Knossos, Crete, c. 2800–2400 BC.

has not been helped by the 'enhancement' of the fresco by the Swiss
artist Émile Gilliéron *fils*, part of the team that archaeologist Sir
Arthur Evans brought to Crete in 1900. The idea that the rose was
yellow has more to do with the fading of later illustrations than the
colour of the fresco's rose itself, which is pale pink.

The gardens of Persia and Mesopotamia also influenced Western
classical gardens. Babylon's is one of the earliest known gardens in
the ancient world but, for all the fabled glory of its so-called hanging
gardens, there is little evidence that roses grew in Mesopotamia. One
translation does state that Assyrian King Sargon (r. 2845–2768 BC)
had 'rose trees' at his capital, Akkad.[2] Early records of gardens such
as that of the Babylonian king Nebuchadnezzar II (r. 605–562 BC)
show that plants were grown for pleasure as well as for food. There
are claims that Semiramis, Queen of Assyria (r. 811–802 BC), grew
roses in her garden. In the famous 'Royal Garden' at Pasargadae in
Iran, the Persian Cyrus the Great (r. 558–528 BC) is thought to have
included roses in the planting scheme.

When Alexander's army returned from Persia in the late fourth
century BC, they sang the praises of the perfumed gardens they had

seen. This was when the ancient Greeks began to see gardens as outdoor rooms for pleasure. The earliest Persian gardens were enclosed, but excavations have found some from the end of the first century AD opening straight on to the countryside with a backdrop of mountains. The influence of Persian gardens, *paíridaeza* (paradise gardens), was clearly felt among the Greek elite, entering the Greek language as *paradéisos*, then Latin and finally English. The word comes from Old Persian *pairi* meaning 'around' and *daeza* 'wall'. Roses soon had a place in Greek ornamental gardens alongside statuary.

In Egypt flowers were used for decoration and as gifts for royal guests. Scented flowers were the perfect symbol of luxury, given that perfumes were a necessity owing to the poor sanitary conditions. Although the Egyptians did not yet have the skills to distil the concentrated oils from roses, they were able to extract a less sophisticated scent using smoke – later called 'perfume', from the Latin *per fumum*: 'through smoke'.

Under the New Kingdom in Egypt (*c.* 1570–1085 BC), flowers were used for religious ceremonies and to adorn honoured guests. Tables were decorated with flowers, much as they are today. By the Ptolemaic period (332–330 BC) flowers accompanied Egyptians from birth to death. Soldiers at war would anoint their bodies with perfumed rose oils. After death, a body was also embalmed with oils. As we have seen from the roses sent to Pierre Cochet, they were also placed in tombs and sarcophagi.

Long before the Greeks conquered Egypt in 332 BC, they had witnessed the Egyptians' gardening prowess. It was two-way traffic, as the Greeks also brought plants to Egypt to grow in its warmer climate. With the arrival of the Romans in 30 BC, the rose came to overshadow even the lotus, which had been the sacred flower for many generations of pharaohs in Egyptian iconography. When Cleopatra (r. 51–30 BC), the last independent ruler of ancient Egypt, greeted Mark Antony, his path was famously strewn knee-deep with rose petals.

By this time, Egypt was seen as a nursery garden with a guaranteed climate. The Greek philosopher Theophrastus (372–287 BC) tells

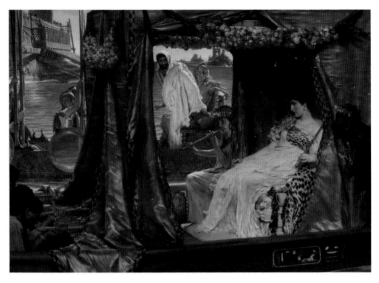

Cleopatra in her rose-bedecked barge on the river of Cydnus;
Sir Lawrence Alma-Tadema, *The Meeting of Antony and Cleopatra*, 1883.

us that roses flowered two months earlier there than in Europe. The
demand was insatiable, as reflected in this comment from a harassed
grower in the Egyptian city of Oxyrhynchus in the second century AD:

> Roses are not yet in full bloom here – in fact, they are scarce
> – and from all the nurseries and all the garland weavers we
> could just barely get together the thousand that we sent you
> with Sarapas, even with picking the ones that ought not to
> have been picked until tomorrow.[3]

The following lines by the Roman poet Martial (AD 41–100) confirm
the importance of Egyptian floriculture: 'Her winter roses Nile has
sent to thee, / Caesar, in boastful mood and deemed them rare.'[4]
Roses were far more than just a commodity to the Egyptians. Having
replaced the lotus as the symbol of Isis, Egypt's 'Queen of Heaven',
they became part of folklore. In a complicated story told by Roman
author Apuleius (c. AD 124–179), his protagonist, Lucius, living in
Roman-occupied Egypt, dabbles in magic and accidentally turns

himself into an ass. A slave-girl friend persuades him that the only way to recover his human form is to eat a rose. His first attempt fails when he is driven away by a furious gardener. Eventually, after many twists and turns, his prayers to the goddess Isis are answered when she appears to him in a vision, instructing him to eat the crown of roses worn by one of the priests officiating at her temple. This he does and he is restored to his human self, devoting the rest of his life to her worship.

Many Greek and Roman goddesses were also associated with roses. A statue of Artemis (the Roman Diana) at her eponymous temple at Ephesus, from around 550 BC, has a rose on the hem of her gown, probably a gallica. There was a legend that the beauty of a young girl, Rhodanthe, was so highly praised that Apollo, Artemis' twin brother, turned her into a rose. There are also many stories associating Aphrodite (the Roman Venus) with the origins of the rose. Although less prominent than that of Isis in ancient Egypt, Aphrodite's link with the rose prefigures later Christian traditions. Sadly, the ninth-century BC description in Homer's *Iliad* of Aphrodite anointing and embalming the dead body of Hector with rose oil, while roses decorated his shield, has now been discredited by recent research, but 'rosy-fingered dawn' remains in the vocabulary.

The Greek poet Anacreon (580–490 BC) described the rose as 'the most beautiful of flowers, the joy of gods, the pillow of Cupid, the garment of Aphrodite'.[5] In one well-known story, he associates Aphrodite with both the white and the red rose. He tells how the foam surrounding her as she emerged from the sea turned into the white rose. He then describes Aphrodite washing blood from her wounded lover, Adonis. Drops fall on to a nearby white rose, turning it red, symbolizing the goddess's passion for Adonis and forever associating the red rose with love. However, spoilsport rose historians point out that there were no known red roses in Europe at that time, only pale-pink ones.

Similar legends surround the poet Sappho (*c.* 630–570 BC), who was probably born on the Greek island of Lesbos – coincidentally

also the birthplace of Theophrastus, who wrote the first practical work on growing roses (*c.* 300 BC). There are many references to roses in Sappho's poetry, including the roses of Pieria, birthplace of the Muses, a holy shrine 'all's with roses overhung', and comparisons of brides to roses. In a recently discovered fragment of her poetry, about the end of a female relationship, she urges her former lover:

> Let me remind [you of]
> All the lovely and beautiful times we had,
> All the garlands of violets
> And of roses . . . that you've put on in my company,
> All the delicate chains of flowers
> That encircled your tender neck . . .[6]

Another early classical reference to roses comes in around 446 BC from the Greek historian Herodotus (490–*c.* 420 BC), writing about the garden of King Midas in Macedonia in the seventh century BC. In addition to his supposed golden touch, Midas grew roses: 'wild – wonderful blooms, with sixty petals apiece, and sweeter smelling than any others in the world'.[7] Quite which 'rose' this might have been is disputed. Other translations use 'blossoms' rather than 'petals'. But could it have been *R. centifolia*? Or a double gallica? German rose historian Gerd Krüssmann, writing in 1977, believes that it is 'without doubt a *Rosa gallica* with double flowers, or a double *Rosa alba* which was already in existence at that time'.[8] As often happens among experts, others disagree.

From Pliny the Elder (AD 23–79) and other sources, we know which roses were familiar to the Greeks and Romans. The Greeks also appear to have initially grown roses commercially for garlands and chaplets, or floral coronets, and only later for ornamental purposes. Theophrastus (*c.* 371–*c.* 287 BC), the 'Father of Botany' and author of *Historia plantarum* (Enquiry into Plants), tells us that they had detailed knowledge of how to cultivate and prune roses for better flowering. They knew that growing from cuttings was much better than from

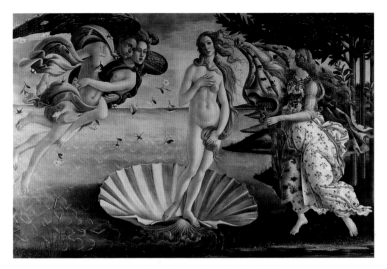

Venus rising from the sea through a cloud of roses;
Sandro Botticelli, *The Birth of Venus, c.* 1482.

seed. Some translations suggest that they removed and burned their
rose bushes every year. More likely, they cut them back hard and
burned the prunings, as many of us do to this day.

Pliny mentions twelve different roses in his massive *Natural History*
(*c.* AD 77–9), a model for future encyclopaedias, unfinished on his
death in the ashes of Vesuvius. One of the most easily recognizable
would have been *R. canina*, the dog rose, with just five petals. Pliny's
roses are mainly named after places such as 'Praeneste' or 'Campania'.
In 1936 rose historian Edward Bunyard suggested that some of Pliny's
descriptions are so similar that they probably refer to the same rose
growing in different areas. For example, the Cyrinae and Carthage
roses are probably both the same damask. Recently, Linda Farrar, a
historian of Roman gardens, has confirmed this by identifying Pliny's
roses as *R. gallica*, *R. phoenicea*, *R. bifera* ssp. *damascena*, *R. moschata*, *R. canina*
and *R. centifolia*, although Krüssmann would dispute the latter.

Roses were a part of everyday Roman life, from cooking and
cleaning to entertaining and religious festivals. Young men would
tenderly call their lovers *mea rosa*. Each season was commemorated
by a flower and the flower for spring was a rose, usually represented

by a girl wearing a floral coronet, or chaplet, of roses and holding a single-stemmed rose. 'This must be seen', says Farrar, 'as a mark of respect for this flower.'[9] Palladius (*c.* fifth century AD), known best for his *Opus agriculturae*, recommended using split reeds to support the stems of roses.

Detailed research on the gardens of Pompeii has revealed that flowers, and especially roses, were grown for making garlands and for perfumed oils. By 40 BC, Roman scholar Marcus Terentius Varro understood that the best way to propagate roses was to make 'cuttings about three inches long from a stem already rooted, set these out and later, after they have formed their own roots, transplant them'.[10]

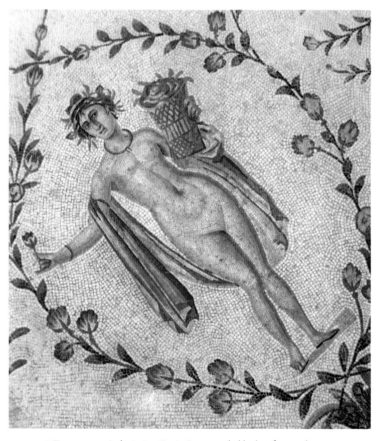

A Roman mosaic depicting 'Spring' surrounded by her flower, the rose.

A fresco with roses that was uncovered at the Villa dei Misteri,
Pompeii; 1st century AD.

Curiously, there was also a belief that moving roses frequently made
them flower better. It was also thought that watering them with hot
water would encourage early flowering.

Some gardeners believed that where the rose was grown made
a difference to its colour and scent. The available varieties were, of
course, extremely limited. Roses from Syria and Persia were highly
thought of. 'Roses from Cyrene [in Libya] are the most fragrant,'
wrote Pliny.[11] He also tells us that the fields around Pompeii, in
Campania, produced three crops of roses a year of exceptional scent.
'Egypt is of all countries in the world the best adapted for the pro-
duction of unguents, but Campania with its abundance of roses, runs
it close.'[12] Pliny based many of his observations on the earlier texts
of Theophrastus, who also describes the Cyrenian rose as the most
fragrant. When Pliny mentions attar of rose, the essential ingredi-
ent for aromatic oils, he singles out Phaselis, on the coast of Lycia in
southwestern Turkey. It is unclear which methods of distilling were
used at this time.

Roman homes were often decorated with flowers, which were
depicted in mosaics and painted on walls and even ceilings in the

wealthier homes. Mosaics were devoted to roses, with tiny tesserae (stone or ceramic pieces) used to depict the pale-pink colours. Roses also appeared on fabrics. Frescoes show that in the grandest Roman gardens, pergolas supported roses as well as grapevines, imitating the hippodrome, which had roses planted in the central area.

The Romans were fanatical consumers of roses for garlanding, petals and oils. What better way to impress your neighbours than to shower them with such an ephemeral extravagance as rose petals? This did not come cheap. One of Emperor Nero's (AD 37–68) many excesses was to spend the equivalent of £100,000 today on rose petals, imported from Persia, to be scattered along a beach.

While there was no shortage of labour for the wealthy in a slave-based economy, water and climate were also essential. Varro's *De re rustica* (*c*. 40 BC) instructs how to grow roses commercially. They should be planted alongside violets in the suburbs, although 'it would be folly to undertake this on a distant farm with no facilities for reaching the market.'[13] Roses and violets were the most popular flowers for chaplets and floral coronets. 'Where are my roses, where are my violets, where my beautiful parsley?' revellers would sing.[14] The Roman writer on agriculture Columella (*c*. AD 70) tells of a farmer returning from the market having sold all his roses, 'soaked with wine with staggering gait, and pockets full of cash'.[15]

Crowns and chaplets were worn by both men and women on special occasions. Honoured guests would be crowned with floral wreaths and draped in garlands, much as visitors are welcomed in India today. Conquering heroes were given laurel wreaths, but lovers would exchange rose crowns. Chaplets were sold in the markets, often by the women or young girls who had made them. However, as in Covent Garden, being a flower girl could suggest a bad reputation: 'you are with the roses, rosy is your charm; but what do you sell, yourself or the roses, or both?'[16]

In addition to imports, mainly from Egypt, roses came from market gardens in the fertile areas south of Rome. Tibur (Tivoli), Campania and Praeneste (Palestrina) were prime rose-growing areas,

with the largest centre being Paestum, near Naples. Virgil wrote of a twice-blooming Paestum rose, *biferíque rosaria Paestí*. But even the warm climate of southern Italy could not guarantee a good crop. The poet Propertius (47–14 BC) warned: 'While your blood is young, while your years are free of wrinkles, make the most of it, lest tomorrow take its toll on your face. I have seen the rose-beds of perfumed Paestum, lying low beneath a morning wind from the south.'[17]

The rose could be a symbol of excess. Cicero (*c.* 106–43 BC), appointed to prosecute Verres, governor of Sicily, mentioned roses repeatedly in his arraignment. Verres, Cicero railed, spent so much time indoors carousing during the winter months that he knew spring had arrived only when a rose appeared on his dinner table. When he did venture out on marches, it was not on horseback, as might

Dionysus, the Greek god of wine, wearing a rose chaplet, Herculaneum, AD 55–79.

be expected, but carried by eight men on a litter. His head and neck were garlanded with roses, and he lay on a pillow of a gauzy Maltese textile stuffed with rose petals while holding a rose-petal-filled bag to his nose, 'as was', says Cicero scathingly, 'the custom of the kings of Bithynia'. The region then called Bithynia, in western Turkey, is still home to a thriving rose-growing industry.

Even worse, the young Roman emperor Heliogabalus (*c*. AD 203–222) spent lavishly on flowers, both for decoration and to infuse in *mulsum*, a drink made from roses, white wine, absinthe and honey. Bisexually promiscuous, he had married five times by the time he was assassinated at the age of eighteen. He infamously once smothered his dinner guests in rose petals released from the ceiling, an event captured on canvas by Sir Lawrence Alma-Tadema, 'the painter who inspired Hollywood', as we shall hear later, in *The Roses of Heliogabalus* (1888).

Alongside its links to love, passion, devotion and luxury, the rose was also associated with war, death and the fragility of life. Rose chaplets were awarded for military triumphs – so often that Cato the Elder (234–149 BC) felt that the tradition had been cheapened. Chaplets were worn only after the fighting was over. Lucius Fulvius, a money-lender, was seen wearing one in the entrance of his shop during the second Punic War and promptly imprisoned. There is also a suggestion that the Roman legions' standards, the *Rosaliae Signorum*, may have been crowned with rose garlands.

A rose was placed on the forehead of the departed and on graves, a symbol of enduring love. Children were left money to plant rose bushes to commemorate their dead parents. Even today, many countries have burial rituals involving roses. Surviving late Roman funerary portraits often show a rose garland, possibly similar to the one found at Hawara in the 1880s.

The last word on roses in the classical period may go to the Roman poet Ausonius (AD 310–395) in his poem 'De rosis naescentibus' (On New-blown Roses). As the Roman Empire was crumbling under pressure from the barbarians, Ausonius settled near Bordeaux to grow roses, and wrote:

Collina, virgo, rosas, dum flos novus et nova pubes
Et memo esta aevum sic properare tulum.

Gather, girl, rosebuds while the flower is fresh and fresh is
 youth,
Remembering that your own time is hurrying on.[18]

Thirteen centuries later, Robert Herrick repeated these thoughts in
the more familiar lines of 'To the Virgins, to Make Much of Time':

Gather ye rosebuds while ye may,
Old time is still a-flying;
And this same flower that smiles today
To-morrow may be dying.

two

A Rose without a Thorn

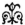

The coming of Christianity', says plant historian Alice Coats, 'dethroned the rose.'[1] With the fall of Rome in AD 476, the knowledge of intensive floriculture virtually disappeared from Western Europe. At the same time, early Christian writers condemned the rose for its associations with Roman pagan hedonism.

Other religions were more sympathetic. In Persia Zoroastrians had long associated the rose with Ahura Mazda, their supreme god. It is often mentioned in their encyclopaedic *Bundahišn* (Creation) text. All Zoroastrian angels were allocated a flower, the rose being associated with one called Din-pavan-Din. The Zoroastrians may also have been the first to make a link between the rose's thorns and evil, claiming that they were thornless before the arrival of the 'Destructive Spirit', Ahriman. The theme of a smooth-stemmed rose in a paradise without sin is a recurring one.

Persia was known as the 'Land of Roses'. Garden designer and plant historian Penelope Hobhouse has pointed out that, curiously, the Persians do not have a separate word for 'rose': *gol* (also written as *gul*) means both rose and flower in Persian.[2] Maybe they were surrounded by so many roses that this was the first flower that came to mind. The fable of the rose and the nightingale, dating from around AD 720, was a frequent component of Persian and Arab poetry and decorative art. It became the most enduring literary allusion to the rose. The traditional story tells how Allah chose the

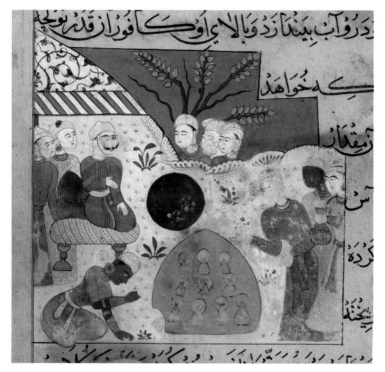

Watercolour illustration showing the distillation and preparation of rosewater for the Sultan of Mandu, Ghiyath al-Din, from *The Niʿmatnama-i Nasir al-Din Shah*, an early Indian cookery book, *c.* 1495–1505.

white rose over the lotus as his favourite flower. Legend has it that the flowers complained that the most sacred flower, the lotus, was closed at night, and asked for a new Queen of Flowers. In response, Allah created the white rose, placing thorns on its stems to protect it. A nightingale was so captivated by the new flower that he flew into it and was pierced by the thorns, which spilled his blood and turned the white rose red. The rose, *gol*, and the nightingale, *bolbol*, became contrasting symbols of love, the former beautiful but often cruel, the latter devoted.

When the Persian Sassanian Empire (AD 224–651) disappeared under Arab rule, much of its culture, traditions and tastes were absorbed by the Muslim conquerors. In rose historian Edward Bunyard's words, 'in penetrating into Syria, that classic home of the

Rose, the victorious Arabs were themselves conquered by the Rose.'[3] A legend soon entered Muslim mythology that as Muhammad rode his horse, al-Buraq, towards heaven, he paused by the Dome of the Rock in Jerusalem and white roses grew from his beads of sweat, while yellow roses grew from those of al-Buraq. To this day, Muslims are reluctant to step on rose petals, which are swept away or picked up to avoid them being trodden on.

The Islamic world also inherited the Persian idea of the paradise garden, which had so influenced the Greeks. The Arabic for paradise is *al-janna*, meaning simply 'the celestial garden'. Persian walled gardens were real. Understandably in such a dry region, among their delights was constantly running water. The rose was the most important flower in these gardens, known as *gulistan* – the rose or flower garden. The Persian court poet Farrokhi (*c.* 980–1037) wrote in his divan or verse collection of what sounds like a repeat-flowering rose, probably R. *bifera* or the autumn damask rose, treasured for its perfume and second flush of flowers.

Commercially, roses were not grown under the Arabs for garlanding or chaplets, as in Greece and Rome, but for the production of rosewater. This scented water was and still is used both for cooking and scenting delicacies and also as part of the ritual cleansing of the body before prayer – and of buildings as well. After Saladin crushed the Crusaders at the Battle of Hattin in 1187, he ordered that all sacred buildings, including the Al-Aqsa Mosque in Jerusalem, which had been converted into a church by the Christians, be purified by being washed down completely with rosewater. It is said that so much rosewater was needed that it had to be brought from Damascus on five hundred camels. This ritual was repeated in 1453 when the Ottoman Sultan Mehmet II, aged just 21, captured Constantinople and ordered the cathedral of Hagia Sophia to be purified with rosewater. The importance of rosewater to Islamic religious practices probably stems from the earlier Persian sacred status of the rose.

Sufism, a hybrid Persian religion that took its beliefs from both Islam and Christianity, treated the rose as a symbol of unity with God.

Mehmet II
(1432–1481), Sultan
of the Ottoman
Empire, smelling
a rose; Turkish
miniature, 1400s.

It has pride of place in Sufi poetry such as Sa'di's *Bustan* (The Orchard, or Garden of Perfume, 1257) and *Gulistan* (1258), and Sa'd Ud Din Mahmud Shabistari's *Gulshan-i Raz* (Secret, or Mystic, Rose Garden, 1317). The latter answers fifteen questions about Sufi beliefs using the rose as a metaphor that would have been familiar to its readers. The Western view of medieval Persia is still shaped by Edward FitzGerald's very free 1859 translation of *The Rubáiyát of Omar Khayyám*, with its talk of sultans, caravanserai and, of course, roses and nightingales. But more of that later.

Because the rose remained so important to the Persians and Arabs, the skill of rose growing did not disappear among them as it did in Western Europe. Instead it thrived and travelled with them. When the Arabs reached Spain in 771, they may well have brought

some of the roses grown in the Middle East. One of the many joys of roses is that they travel well either as seed or dormant roots. Plant historian John Harvey has traced six works that refer to roses being grown in southern Spain under the Arabs. They start with *Le Calendrier de Cordoue* (c. 970) and end with the Persian *Treatise on Agriculture* (c. 1450).

While the rose thrived within Islam, its status within Judaism and early Christianity was problematic. Flowers were and are rarely used in Jewish rituals. The Hebrew Bible (and Old Testament) condemned the use of roses and other flowers in garlands, presumably because of their pagan associations. However, when a 'rose' is mentioned in the King James Bible, the word often refers to other plants. A famous example is 'the wilderness shall blossom as the rose' (Isaiah 35:1). Revised versions keep the word 'rose' but add a side note that it might be an autumn crocus. Similarly, when the bride in the Song of Solomon sings 'I am the rose of Sharon' (2:1), this probably refers to a hibiscus.

There is, however, one undisputed mention, also in the Song of Solomon:

> Those who forsake the true path, reasoning not aright, say within themselves: 'Let us fill ourselves with costly wine and ointments: and let no flower of the spring pass by us: Let us crown ourselves with rosebuds, before they be withered; Let none of us go without his share in our proud revelry' (2:8).

Written in the mid-tenth century BC, this already hammered home the dour message that gallivanting with rosebud crowns was associated with pagans and heretics. These sentiments were shared by early Christians such as Clement of Alexandria in the second century AD: 'The scent of roses is fabulously refreshing and, indeed, assuages and dispels headaches, yet it is forbidden for us to anoint ourselves with their attar, yea, even a single such wanton injunction is banned.'[4] It did not help that there was a legend that the crown of thorns worn

by Christ on the cross was made from stems of *R. canina*, the dog rose, and another that a rose bush at the feet of Christ's cross enabled Satan to climb up to heaven.

From the third century AD, however, roses were gradually rehabilitated. Several early saints praised them or talked about their uses. They include St Cyprian (martyred in 258), St Jerome (*c.* 347–420) and St Benedict (*c.* 480–547). St Dorothy, patron saint of gardeners and florists, martyred in 311 during the Diocletian persecutions, is often shown holding red roses. By around 430 the Christian poet Sedulius was already linking the Virgin Mary and the rose:

> As blooms among the thorns the lovely rose, herself without
> a thorn,
> The glory of the bush whose crown she is,
> So, springing from the root of Eve, Mary the new Maiden
> Atoned for the sin of that first Maiden long ago.[5]

Over the next thousand years, the image of Mary as 'the Rose without a Thorn' became an essential theme within the Catholic Church. The white rose represented her virginity and the red rose her sufferings and compassion, while a five-petalled rose came to symbolize Christ's wounds. The white rose is predominantly associated with purity and modesty, while the red rose – in reality, closer to dark pink than blood-red until modern times – has long been linked to martyrdom. A typical story is that of St Alban, the first British Christian martyr, beheaded on 22 June 209 (although much of his story is disputed). Tradition has it that a red rose grew on the spot where he was executed. For centuries he has been commemorated on that date with a procession, including a giant wooden figure of him with red roses sewn to the hem of his gown, and prayers which start, 'Among the roses of the martyrs brightly shines Saint Alban.'[6]

Roses were also associated with other miracles. In 584 St Gregory of Tours, the Merovingian historian, wrote that they had bloomed

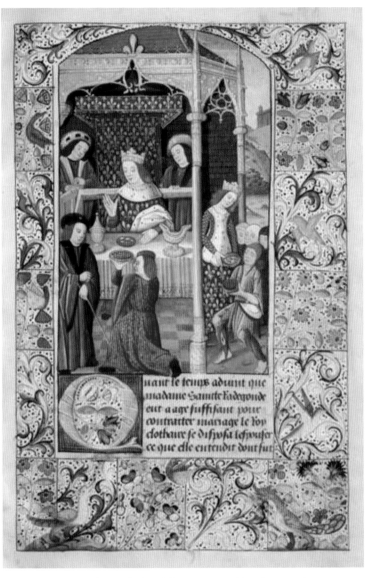

uant le temps aduint que madame Sainte Radegonde eut a age suffisant pour contracter mariage le Roy clothaire se disposa lequel ce que elle entendit dont fut

St Radegund was known for her skill in growing and love for roses; the Master of St Radegund. *The Life of St Radegund, c.* 1496, illuminated manuscript.

in January, just one of 'many strange portents appear[ing] in Gaul'.[7] Venantius Fortunus (*c.* 530–609), a Latin poet who achieved fame in various Frankish courts, wrote of the rose gardens created by two queens, the impressively named Ultragoth, wife of Childebert I (d. 558), and Radegund (*c.* 520–587), a Thuringian princess and wife of the Merovingian king Clotaire. After her husband had killed her brother, Radegund fled to a nunnery. She had become friends with Venantius and it is from his writings that we know about her passion for roses. While she followed a frugal lifestyle, possibly eating only lentils, her love of roses and skill in growing them are suggested in Venantius' description of one of his visits to eat with his patroness: 'The table holds almost as many roses as the fields.'[8] Radegund was renowned for wearing a hair shirt but that did not stop her surrounding herself with her beloved flowers. 'Wherever you set your foot,' Venantius wrote, 'a trampled rose glows back at you.'[9]

When the Merovingian Franks' kingdom disintegrated in 768, it was Charlemagne (742–814) who ruled vast swathes of Western Europe, crowned as the first Holy Roman Emperor on Christmas Day 800. His many administrative achievements included listing which plants should be grown in the monasteries under his control in what is now France, Germany, the Low Countries, Italy and much of Europe. Most were medicinal herbs, but the list, a copy of which still exists in a monastery in St Gall in Switzerland, also mentions two specific ornamental plants: 'Our will is that you shall have all kinds of plants in the garden and, in particular, first lily, secondly roses.'

Rose historians have pointed out the significance of the form used – singular for the lily, plural for the rose – which may suggest that just one variety of lily but more than one type of rose was being grown at that time. These were most likely to have been the blush-white alba and a darker gallica. Charlemagne reputedly imported vast quantities of rosewater for his court at Aachen, having discovered its scent on his travels. He may well have been influenced by Alcuin (735–804), the English scholar who became his senior advisor. Here Alcuin tells of what he misses, having left York to join Charlemagne's

court: 'Farewell, dear cloister, where sweet apple scents ascent, / Where lilies white and ruby roses blend.'[10]

There is a tradition that an ancient *R. canina* growing against the wall of Hildesheim Cathedral in southern Germany was planted by Charlemagne's son, Louis the Pious, soon after the cathedral's dedication in 818. This would make it the oldest known living rose. The story is that Louis lost a precious relic which was later found hanging from a rose bush. He showed his gratitude by establishing a church on the spot, which became the cathedral, and planted the rose bush. This rose survived the bombing of the Second World War, unlike the cathedral, which has since been rebuilt.

Although roses were rehabilitated in medieval Western Europe, it is unclear which ones were grown, how or where, as there are no good botanical or horticultural sources. For a thousand years, detailed horticultural records are scant and unreliable. When, around 1265, the learned Dominican friar Albertus Magnus produced rose bushes covered in flowers for a January banquet to celebrate Epiphany for the Holy Roman Emperor William of Holland, it was thought that he had used magic to do so. In reality, his methods may have been similar to those described in *Le Ménagier de Paris* (1393), such as ways of storing roses in bud in sealed barrels to flower in the winter. Albertus wrote what has been described as 'the only theoretical botany of the Latin West', *De vegetabilibus* (c. 1265).[11] It mentions five varieties of rose. These have been identified as *R. alba*, *R. arvensis*, *R. canina*, *R. rubiginosa* and, finally, a red rose, perhaps *R. gallica*.

R. damascena, as its name betrays, was most probably brought to France from Damascus in Syria but no one is sure when. Similarly, there was a tradition that Thibault IV (known as *Le Chansonnier* or the Minstrel), King of Navarre and Count of Champagne, brought *Rosa gallica* 'Officinalis' back from his exploits in the so-called 'Barons' Crusade' in 1239/40. The plant that he may have brought back to France, supposedly in his helmet for safety, became an immediate commercial success in the town of Provins, in the fertile wine-growing region east of Paris. However, this may be a commercial fiction

The 'Thousand-year Rose', a tree at Hildesheime Cathedral in Hanover, Germany, was supposedly planted by Charlemagne's son, Louis the Pious, in AD 818; photograph, *c.* 1900.

invented in the early nineteenth century to promote the town's con-
nections with roses. What is true is that 'Officinalis' soon became
known as 'the apothecary's rose' or 'Provins rose' for its strong scent.
Local Provins herbalists began making preserves from the petals,
selling them for their health-giving properties. You can still buy
rose-flavoured honey, liqueurs and other delicacies in the town's
tourist shops.

While to many today the phrase 'odour of sanctity' implies smug
sanctimoniousness, to some pious Catholics it still describes an
unaccountable perfume emitted by a holy person, often from the

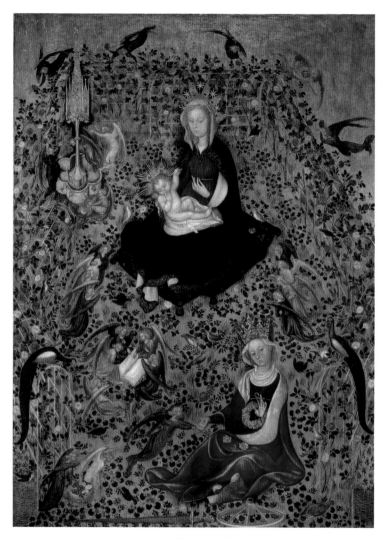

Michelino da Besozzo, *The Madonna of the Rose Garden*, c. 1420–35, tempera on panel.

wounds of stigmata. For instance, since the canonization of the much-venerated Padre Pio (1887–1968), an industry has developed selling scented rosary beads, carved in the shape of roses and steeped in a rose-like scent, evoking the rosary's medieval origins.

There are several versions about the origins of the rosary, taken from the Latin for rose garden, *rosarium*. The most popular tells how

a Spanish priest, Domingo de Guzmán (1170–1221), desolate that he had failed to convert the heretic Cathars in southwest France, retired to a cave. There he was visited by a vision of the Virgin Mary, who gave him a string of beads and told him to 'preach my psalters' to the Cathars. In reality, the Cathars were massacred but the young monk went on to establish the Dominican order, or 'Black Friars', and was later canonized as St Dominic. Another version tells of the young monk making his devotions to the Virgin Mary when she appeared to him and created a garland of 150 roses. By the time she had finished, the roses had shrunk into tight buds, forming a necklace that unsurprisingly Dominic treasured.

Some versions of these stories suggest that the beads that the Virgin Mary left behind were full of the perfume of the rose, the flower of paradise. Since then there has been a tradition of making rosary beads from rolled rose petals, one carried on still by Spanish Carmelite nuns in Ávila. The Catholic Church is unique in associating the rose directly with prayer beads although, according to historian Eithne Wilkins, centuries ago, Hindu beads were made from the petals of *Hibiscus rosa sinensis*, the hibiscus flower often confused with the rose in translations of the Old Testament.

While the true origin of the rosary is unknown, by the 1470s Alanus de Rupe, a Dominican friar, planned the first Confraternity of the Rosary, a brotherhood dedicated to its worship. Although he died before it started, this is the earliest known record of the rosary's formal use as an aide-memoire for prayer. This probably developed from the 'paternoster' (Lord's Prayer) beads used by early Christians to count their prayers, which may, in turn, have developed from knotted ropes. Orthodox Christians, Muslims, Hindus, Buddhists, Bahá'í and Sikhs all use prayer beads in some form.

The Catholic Church increasingly encouraged the use of the rosary as part of the veneration of Mary. The word *rosarium* was also used for hymns in her praise. As early as the eleventh century Catholics were taught that they had to learn the *Ave Maria* ('Hail Mary') by heart – in addition to the Apostles' Creed and the Lord's

A scented rosebud
rosary in honour
of St Padre Pio
(1887–1968).

Prayer, which were already compulsory. Eithne Wilkins has found
that, by the thirteenth century, there were guilds of bead-makers
across Catholic Europe, reflected in street names such as Paternoster
Row in London and Paternoster-Gässchen in Vienna. Lepanto, the
great naval victory over the Ottomans by a Catholic coalition fleet
on 7 October 1571, is still celebrated as the Feast of Our Lady of the
Rosary, having been dedicated to the Virgin Mary by Pope Gregory
XII in 1573.

Several medieval religious events centred around roses, usually
involving pious women. St Elizabeth, Queen of Hungary (1207–
1231), was caught by the king, her husband, taking loaves to the poor
in midwinter, which he would have regarded as beneath the dignity of
her role. But when he pulled back the cover of her basket, the loaves
had miraculously turned into fresh red roses. In a similar wintry tale,
St Rita of Cascia (1381–1457) called for some roses on her death-
bed although there was snow on the ground. When a friend went to
search for some, she found a red rose in bloom. Canonized in 1900,
St Rita is the patron saint of hopeless causes, and in Spain, on her
saint's day, believers wear red roses.

The rose was also associated with various Church rituals. Both Ascension and Pentecost took the title *Pasqua delle rose*, the Festival of the Rose, the former by 1366. In Italy rose petals are dropped from inside church domes on the fiftieth day after Easter, the petals being symbols of the fiery tongues of Pentecost. Across Western Europe chaplets of roses found their way back into church ceremonies, but only if worn by virgins. Prayer books and psalters also became known as flower gardens, especially rose gardens or *rosaria*, and were illuminated accordingly.

Another example of the rose's rehabilitation is the pope's Golden Rose. No one knows exactly when it was first introduced, but in 1049 Pope Leo IX already referred to it as an ancient tradition. Made from the finest filigree gold, early examples were decorated with red paint but soon they were embellished with precious stones, especially rubies. At their centre is space for offerings of balsam and musk. Every year one of these magnificent roses was created, initially a bunch of small single five-petalled roses. By the late fifteenth century, they had developed into a bouquet of glimmering flowers.

A Golden Rose was presented annually by the Pope to a ruler who had shown outstanding devotion to the Faith. Early recipients include Henry VI of England in 1444, James III of Scotland in 1482 and Isabella I of Castile in 1493, the last as a reward for (together with her husband, Ferdinand of Aragon) finally expelling the Moors from Spain in 1492. Frederick the Wise of Saxony received one in 1519 for his opposition to Martin Luther. Henry VIII – before his split with Rome – was awarded three, by three different popes, and granted the title 'Defender of the Faith' for his vigorous defence of Catholic theology. There is a vivid description in Raphael Holinshed's *Chronicles* (1577) of the final Golden Rose awarded to Henry, by Pope Clement VII in 1524:

> a trée forged of fine gold, & wrought with branches leaues and floures resembling roses. This trée was set in a pot of gold which had three feet of antike fashion. The pot was

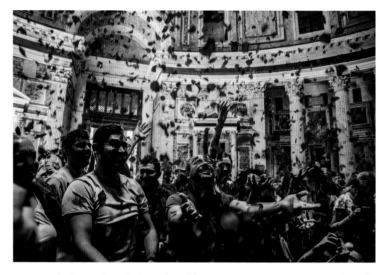

Rose petals thrown through the oculus of the Pantheon, Rome, representing the Holy Spirit's descent to earth, fall on the congregation during the Pentecost Mass in June 2017.

of measure half a pint, in the uppermost rose was a faire sapphire loupe pressed, the bignesse of an acorne, the trée was of height half an English yard, and a foot in breath.

From the middle of the seventeenth century, the honour was awarded only to royal women, with their male counterparts receiving 'the Blessed sword and hat'. That most pious of English queens, Mary I, received one in 1555, as did her cousin Mary, Queen of Scots, in 1560, as well as queens of France, Hungary, Naples, Poland and Spain. If no one was thought worthy, the rose was put away until a suitable candidate could be found. The ceremony of papal blessing for the Golden Rose still takes place on the fourth Sunday in Lent, Laetare Sunday, also known as Rose Sunday, the only time during Lent when purple vestments are replaced with rose-pink ones. The Rose is now awarded to shrines rather than individuals, the last three recipients being in Mexico, Poland and Portugal.

Alchemists also drew on the rose in its five-petalled form, which can be used as a base for a pentacle (five-pointed star), the key

The Golden Rose in the Kaiserliche Schatzkammer (imperial treasury)
of Hofburg Palace, Vienna, Austria.

Rosicrucian symbol of the rose and cross from Robert Fludd's *Summum Bonum*, 1629.

symbol of magic and mystery. Roses were described as the magician's flowers *flos sapientum*. They had been associated with secrecy since classical times. This may originate from a myth that Eros gave Harpocrates roses to keep him from speaking about his mother, Aphrodite's, indiscretions. Another story is that the term *sub rosa* ('under the rose'), meaning confidentiality, came from a less whimsical source. Greek soldiers, having been driven back by the Persian king Xerxes in 479 BC, are said to have hidden under a bower of roses to plan a later successful counterattack. Whatever its true origins, the term *sub rosa* was widely adopted in many European countries. Romans painted roses on their ceilings; in medieval council chambers a rose would hang from the ceiling to remind attendees that secrecy was required. Even today, we still call a central light fitting a 'ceiling rose'. Confessionals began to have roses carved on them, indicating the priest's vow of secrecy. Wearing a rose behind one's ear, a custom

now particularly associated with Spain, is said to be another sign of confidentiality.

The rose was also the symbol of the secret Rosicrucian Order, named for the fourteenth-century German mystic-magician Christian Rosenkreus (b. c. 1378). According to a 1614 pamphlet, *Fama fraternitatis rosae crucis* (The Fame of the Brotherhood of RC), Rosenkreus lived to be 105 and his body lay hidden away in a state of perfect preservation for 120 years. Such was the secrecy surrounding the Order that it has never been clear who wrote this pamphlet or others that soon followed. New recruits to the Order were told they would be 'found', with no clues as to who was behind the Brotherhood. Their beliefs were part Christian, part Gnostic, rejecting the material world for the spiritual with an injection of the occult. Rosicrucian expert Christopher McIntosh is in no doubt that 'the appealing quality of the rose-cross motif' contributed to the durability of the Rosicrucian cult. This is one chapter in the history of the rose that may never be fully understood.

three
The Royal Rose
🙞🙜

On the edge of the southern French city of Aix-en-Provence, once surrounded by windswept olive groves, sits a thirteenth-century Gothic church, L'Église Saint-Jean-de-Malte. Built on the site of a priory, it was the burial place of Raimond Bérenger IV (1209–1245), Count of Provence. He is commemorated in a statue, resplendent in chain mail. His left hand holds the traditional sword and shield. But in the other he holds a double rose, clasped to his chest as though he had just plucked it from a bush. In the thirteenth century the statue was probably painted and we could have seen the colour of the rose. Most likely it would have been gold, because Bérenger was awarded one of the early Golden Roses by Pope Innocent IV. This was such an honour that Raymond took it as his family badge. His daughter, Eleanor, naturally also adopted the rose as her symbol. For England, this was to have great significance because Eleanor of Provence left her father's court to marry England's King Henry III on 14 January 1236.

Eleanor's emblem, a golden rose with a green stem, was taken up by her two surviving sons. Her elder son, Edward I (1239–1307), was thus the first king of England to choose the rose as his symbol. The carving of him as a young man in Westminster Abbey is the earliest image of a member of the English royal family with a rose. His younger brother Edmund, Earl of Lancaster (1242–1296), chose a red rose for his symbol. Through marriage to Blanche of Artois, Edmund was Count of Champagne, east of Paris, and spent time there in the town

of Provins, already a growing area for *R. gallica* 'Officinalis' or 'the apothecary's rose'. Edmund probably brought this rose to England and adopted it as his own, creating the enduring link between the red rose and the House and County of Lancaster.

The red and white roses are, of course, associated with what we now call the Wars of the Roses (1455–85). The term was coined by Sir Walter Scott in his novel *Anne of Geierstein* (1829): 'civil discords so dreadfully prosecuted in the wars of the White and Red Roses'. But the imagery had been there for centuries, especially as conjured up by Shakespeare. In *Henry VI, Part I,* he portrays the war's origin in a famous scene in Temple Gardens in London's Inns of Court, set with roses growing around a bower. Richard Plantagenet, later Duke of York, urges his friends to follow his suit – 'From off this briar pluck a white rose with me.' The Earl of Somerset retorts: 'Let him that is no coward nor no flatterer, / But dare maintain the party of the truth, / Pluck a red rose from off this thorn with me.' As the friends select their sides, the punning continues with suitably 'barbed' references to loyalty and betrayal. 'Prick not your finger as you pluck it off; / Lest, bleeding, you do paint the white rose red, / And fall on my side so against your will,' Somerset goads. The repartee continues. Plantagenet: 'Hath not thy rose a canker, Somerset?' / Somerset: 'Hath not thy rose a thorn, Plantagenet?' And so it goes on with the two factions divided by the colour of their roses. Finally, the scene ends with the Earl of Warwick's prophetic warning:

> This brawl to-day;
> Grown to this faction, in the Temple garden,
> Shall send, between the red rose and the white,
> A thousand souls to death and early night.

Noble families had initially adopted personal symbols because of the need for identification on the battlefield. From the early twelfth century, a new type of helmet called a bassinet came into use. This gave more protection to the face than the Norman helmet it replaced,

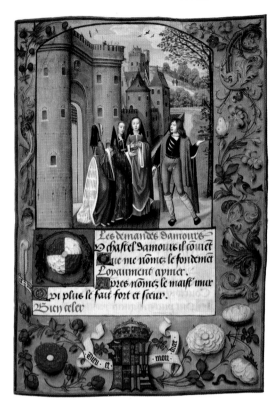

A miniature depicting a *Chastel d'amour* (Castle of Love), with a border containing the royal arms of Henry VII impaled with those of Elizabeth of York between red and white roses.

but made it much harder to see whom you were fighting with or against, so knights and their followers added distinctive designs on their shields and crests on their helmets. Many incorporated objects from nature, such as flowers, fruit and leaves. A formal heraldic language evolved to describe these designs. Blazons, the written descriptions of families' coats of arms, often mention roses: 'barbed' refers to roses with sepals of a different colour to the petals, usually shown as green; 'seeded' refers to the centre of the rose or its stamens. Any flower depicted in its natural colour is called 'proper'. Most familiar is the simple five-petalled rose, with its royal associations. The rarer multi-petalled heraldic rose is called a 'damask' and always appears with a stalk.

A variation on the single rose heraldic emblem harks back to the Romans – the 'chaplet of roses'. It traditionally features four separate

rose emblems on a leafy circlet but it can be purely roses. Another heraldic use of the rose, rarely seen these days, is as a 'cadency' showing the place in the family ranking. All sons are entitled to bear the family coat of arms but each must be distinguished by an additional symbol. For the seventh son, that symbol is a rose.

The rose had also become part of the code of chivalry. From Italy to England, knights and their ladies played flirtatious games using rose stems to 'joust' or tip baskets of roses on each other in the *Chastel d'amour* (Castle of Love), a popular allegory often depicted in ivory carvings.

While various descendants of Edward I took different coloured roses as their badges, the white rose had no particular significance until Richard, Duke of York (1375–1414), son of Edward III, married his cousin Anne Mortimer and adopted her white rose for his own. When their grandson became King Edward IV (1442–1483), he placed it for the first time on one of the coins of the realm, a noble. Now known as a Rose Noble, it was introduced in 1464 and shows Edward with a large five-petalled rose centred on the side of one of his ships. He also commissioned a stained-glass window for Canterbury Cathedral with rose emblems, each backed by a circle of sunrays, known as *rose-en-soleil*.

In February 1461 Edward IV defeated the Lancastrians at the Battle of Mortimer's Cross in Herefordshire. The morning of the battle had seen a parahelion, a meteorological phenomenon where three suns appear to rise in the sky. Following his victory, Edward added the golden rays of the Sun to his white rose emblem in celebration. This may have given us one of Shakespeare's most famous puns: 'Now is the winter of our discontent / Made glorious summer by this son [Sun] of York,' the opening words of *Richard III*.

The battle of Towton, in Yorkshire, eight weeks after Mortimer's Cross, was described as 'probably the largest and bloodiest battle ever fought on English soil'. It ended with Edward gaining the English throne from Henry VI. Soon after, the graves of some of the possibly 28,000 soldiers who died that day, 29 March 1461, were planted

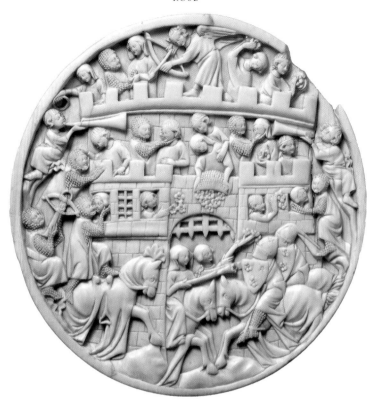

Roundel with scenes of the attack on the Castle of Love, with a lady tipping a basket of roses on the approaching knights, *c.* 1320–40.

'either in affection or in triumph' with rose bushes.[1] The original rose is thought to have been a white variety of *R. spinosissima*, a dwarf Scots rose, with 'the appearance of a pink spot on the flower . . . trac[ing] the blood of Lancaster'.[2] However, such was the enthusiasm of Victorian battlefield visitors that no wild roses remain on the 'Bloody Meadow' of Towton.

When Edward married Elizabeth Woodville, the widow of a Lancastrian knight, Sir John Grey, she had to renounce the red rose as her emblem and adopt Edward's white rose. As a further symbol of allegiance to the king, she was also obliged to present him with a single white rose on 24 June each year as 'rent' for Pyrgo Priory in Essex, which she had been given on their marriage. This is an early

example of a 'rose rent', and is unusual in using a white rather than a red rose.

One of the oldest rose rent ceremonies is the annual presentation of a red rose as a fine for breaking fourteenth-century building regulations – yes, they did have them then. In 1379 the wife of Sir Robert Knollys, having bought two facing houses on Seething Lane, a narrow street near the Tower of London, decided to link them with a 'haut pas', a covered walkway at first-floor level, to give her access to her rose garden at the back of the opposite house. Her neighbours saw this as both 'over-bold' and 'presumptuous' and complained to the City Corporation. Since her husband was a well-respected soldier, the City imposed only a symbolic 'quit-rent' fine on Lady Knollys – a single red rose from her garden to be presented at the Guildhall on 24 June, the same day Elizabeth Woodville had to present her white rose.

The tradition of rose rents was repeated around the country, always on the same date – 24 June, the Feast Day of St John the Baptist

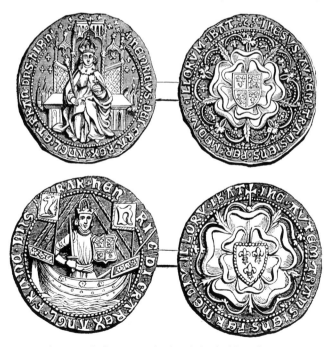

Sovereign and Rose Rial of Henry VII, both with the double Tudor rose, *c.* 1400.

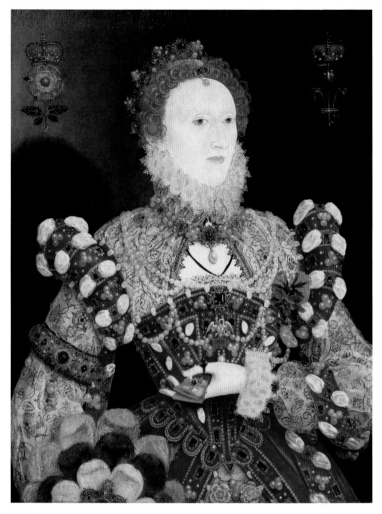

Nicholas Hilliard, *Portrait of Elizabeth I* (the 'Pelican Portrait'), *c.* 1573–5, features blackwork roses on Elizabeth's sleeves and the Tudor rose in the top left-hand corner.

– when roses would have been at their best. The tradition continues to this day. A woman who donated some land for the building of a new hospice in Winchester in 2014 charges its owners, in place of a peppercorn, a ground rent of twelve red roses to be delivered on Midsummer's Day each year. It also crossed the Atlantic. Red Rose Rent Day in the United States was started in 1731 by the family of

Couplets in honour of Henry VIII, celebrating the union of the Houses of York
and Lancaster, Bruges, c. 1516.

William Penn, founder of Pennsylvania. It was revived for a while by the Conard-Pyle Rose company in the mid-twentieth century, which invited a descendant of Penn, Philip Penn-Gaskell, to collect the red rose rent for the land their nursery stood on from Robert Pyle, who had recently masterminded the launch of the famous rose 'Peace' in the States, as we shall hear.

Exactly which white and red roses were used to create the royal symbols of England is unknown. Since they were always represented without significant botanical detail, it is impossible to tell. But it is generally thought that the white rose of York is *R. alba* and the red rose of Lancaster a damask or a gallica. Similarly, while we know from Master John Gardener's *Feat of Gardening* (1440) that he sold roses, they were described only as red and white.

With the end of the Wars of the Roses, the houses of York and Lancaster came together when the Lancastrian Henry Tudor married Edward IV's daughter, Elizabeth of York. 'We will unite the white rose and the red; / Smile Heaven upon this fair conjunction / That long have frowned upon their enmity,' says Henry at the end of Shakespeare's *Richard III*. Heraldically, this was represented by the Tudor rose symbol – the double rose with an outer ring of five red Lancastrian petals surrounding a much smaller five-petalled Yorkist white rose.

In England, after Henry VII established the Tudor rose, roses were everywhere. Shortly after his coronation in 1485, ambassadors arriving to meet him at his residence in the manor of Woodstock found it had been 'freshly painted with red roses, portcullises, greyhounds and rougedragons', the heraldic devices of Henry VII's dynasty.[3] Later, at the Palace of Richmond, 'everything, from the great cistern in the palace's courtyard to the roof timbers, was scattered with red roses'.[4] By the time Henry VIII ascended the throne, Thomas More (1478–1535) wrote of how the roses were now united, 'combined to become a single flower, a rose with the qualities of both'.[5]

In addition to their symbolic appearance in Tudor life, roses were widely planted in royal gardens. In the 1540s Henry VIII's gardener at Southwark bought 1,000 slips, or cuttings, of damask roses and 3,000

'red rossiers'.[6] Throughout the sixteenth century, the rose was at the heart of English symbolism, in coinage and ships' names (including Henry's famous *Mary Rose*), heraldry and the names of inns (especially The Rose and Crown) and playhouses, but especially in clothing. Floral embroidery was a distinctive English fashion, with flowers of many sorts, from carnations to roses, being exquisitely stitched on to fabrics for elaborate and conspicuously expensive outfits.

Of all the Tudor monarchs, it is Queen Elizabeth I (1533–1603) who is most closely associated with the rose, especially *R. rubiginosa*, the eglantine or sweet briar, its scented leaves and simple flower shape emphasizing her virginity. The Queen Elizabeth Bible in the Bodleian Library in Oxford has an embroidered cover of the double Tudor rose and the eglantine. Portraits of Elizabeth wearing sumptuously embroidered gowns are rarely without roses. Nicholas Hilliard's 'Pelican Portrait' (*c.* 1573–5) is typical. Elizabeth's undershirt is covered with both Tudor roses and sweet briars in blackwork stitching. In the top left-hand corner of the painting, there is a Tudor rose symbol, unusually with leaves, topped with a small crown.

John Gerard (1545–1612) used an illustration of an eglantine on the frontispiece of his 1597 *Herball*, where he listed fourteen different 'Kindes' of rose, although some are very similar to each other. 'The Plant of Roses,' begins his chapter 'Of Roses',

> though it be a shrub full of prickles, yet had bin more fit and
> convenient to have placed it with the most glorious floure of
> the world . . . for the Rose doth deserve the chief and prime
> place among all floures whatsoever. Some be red, others
> white, and most of them or all sweetly smelling.

Gerard included all the known English varieties, noting: 'All these sorts of Roses we have in our London gardens, except that the Rose without pricks, which is as yet a stranger in England.'[7]

Discounting his overlapping sorts, Gerard talks of *R. alba*, 'Rose de Provins', the damask rose or *R. Provincialis*, and 'the great Rose, which

is generally called the great Province Rose, which Dutchmen cannot endure; for they say it first came out of Holland, and therefore to be called the Holland Rose', soon known as *R. centifolia*.[8] A further section is devoted to single and double musk roses. Here also we find mentions of the first yellow rose, again both single and double, which Gerard calls *R. lutea* and *R. cinnamonae*, respectively. He notes that wild roses, including Elizabeth's beloved eglantine, grow 'in most parts of England . . . it growth likewise in a pasture as you goe from a village hard by London called Knightsbridge, unto Fulham, a village nearby, and in many other places'.[9]

Soon after Queen Elizabeth's death in 1603, London botanist and apothecary John Parkinson named 24 different rose 'species' in *Paradisi in sole paradisus terrestris* (1629), ten more than Gerard had listed in 1597. Both Gerard and Parkinson mention a multi-coloured rose. Gerard calls it a musk 'blush', Parkinson a 'Rosa versicolor, the party coloured Rose, of some Yorke and Lancaster'. Today, 'versicolor' is associated with both *R. × damascena* 'Versicolor', the York and Lancaster rose, and *R. gallica* 'Versicolor', or 'Rosa Mundi' ('Rose of the World'). It was thought that the latter was named for 'Fair Rosamund', the mistress of Henry II (1133–1189). His wife, Eleanor of Aquitaine (1122–1204), was supposedly so jealous of Rosamund, the great love of Henry's life, that she plotted to murder her. There are many myths surrounding Rosamund's life and eventual death in a nunnery near Oxford. However, there is no evidence that 'Rosa Mundi' was named for her. Less romantically, but more likely, it was found as a sport on a rose bush in Norfolk in the seventeenth century.

For centuries, the rose had been intertwined with English royalty, but on the death of Elizabeth I, her first cousin twice removed, King James VI of Scotland, succeeded her as James I of England (1566–1625). James, the first Stuart king of England, issued 'Rose and Thistle' pennies with the floral emblems of his two kingdoms on opposite sides, and adopted a personal badge split between the two. With the accession of the Hanoverians in 1714 – when George I, Elector of Hanover, was invited to take the throne of Great Britain and Ireland

R. gallica 'Versicolor', or 'Rosa Mundi'; Georg Dionysius Ehret
(1708–1770), watercolour.

on the death of Queen Anne – the rose was no longer the official badge of royalty. However, the white rose remained as a symbol of the Jacobites, who aimed to restore the Catholic King James II – or, later, one of his Catholic Stuart descendants – to the throne. Jacobites wore a white cockade in the shape of a flat rose on their caps. Some still celebrate White Rose Day, 10 June, the birthday of James II's son, also named James, 'The Old Pretender' and – to Jacobites – rightful heir.

Informally, however, the rose has remained central to English identity and this is often reflected in its traditions. Hungerford in Berkshire has a red rose ceremony, having presented one to Queen Elizabeth II, her father George VI, grandfather George V and great-grandfather Edward VII. Its roots lie in a tribute traditionally paid by the town to the Duke of Lancaster, one of the titles still held by the monarch, possibly going back to a late fourteenth-century charter of rights given by the first duke, John of Gaunt (1340–1399).

In 1986 the British Labour Party adopted the rose as its symbol. For many years, it was thought that Peter Mandelson, New Labour's spin doctor, much feared and hated by both the far left and the Conservatives, came up with the idea to replace Labour's traditional socialist (and communist) Red Flag symbol. However, on a 2001 BBC Radio 4 programme, 'Why People Hate Spin Doctors', the former Labour leader Neil Kinnock claimed that he came up with idea of the red rose and that Mandelson's only contribution was to insist that the designer lengthened the rose's stem. Kinnock lost the 1987 election but the rose has remained Labour's symbol. Mandelson's long stem and realistic green leaves with a hint of a prickle or two have gone, replaced by a pared-down graphic version.

Between 1943 and 1944, 'The White Rose' was a short-lived resistance movement in Germany which distributed anti-Nazi pamphlets. Although they were active for only a few months until they were all arrested and executed, they are still celebrated in Germany, especially in Munich where they were most active, and where a memorial plaque has been placed to commemorate them in the grounds of Ludwig Maximillian University.

Another enduring rose tradition belongs to the British Army. On 1 August each year, soldiers of several regiments wear a white 'Minden' rose in their berets to commemorate the Battle of Minden on the River Weser in Germany in the Seven Years War with France on that day in 1759. It was a resounding victory for the heavily outnumbered British troops. The story is that, as they made their way to the battlefield, they picked roses from the hedgerows and tucked them into their caps. Soldiers from the Rifle Regiment, which has Yorkshire connections, always wear a white rose, while the Lancastrian Fusiliers wear red, and the Royal Anglians, red and yellow. The Lancashire Fusiliers have a tradition – no one knows why – that the youngest officer in the mess has to eat a rose in the evening and the regimental band plays 'The Minden March'. The battle is also celebrated in several eighteenth-century folk tunes, most famously in 'The Lowlands of Holland', with the verse,

My love across the ocean
Wears a scarlet coat so fair,
With a musket at his shoulder
And roses in his hair.

From the battles of the eighteenth century to those of the twenty-first, roses remain a link. *R. damascena*'s name links it to Damascus, the capital of war-torn Syria. There was even a legend among some nineteenth-century English travellers that the name 'Syria' derives not from Assyria, as most scholars believe, but from Suristan, *suri* being the Persian for 'red rose', making Syria another 'land of roses', like Persia.

Watching the fighting in Syria on the television news every night as I was researching this book, this idea seemed impossible until a short film began to circulate about Abu Ward, who ran a rose nursery in the once magnificent city of Aleppo in northern Syria. His name means 'Father of the Flowers'. When his nursery was bombed, he began growing roses on roundabouts and giving away bunches to

local families. Interviewed for Channel 4 News in August 2016, he said he believed that, even among scenes of incredible devastation, 'flowers help the world and there is no greater beauty than flowers'.[10] Days later, before the film was broadcast, he was killed by a bomb, leaving behind a thirteen-year-old son, but his thoughtfulness and love of roses live on.

four
The Birth of the Modern Rose

<div align="center">⚜</div>

I n 1768 Philip Miller, chief gardener of London's Chelsea Physic
Garden, still listed only 46 roses in the eighth and final edition
of his *Gardeners Dictionary*. Yet just forty years later, in 1808, top
London nursery Lee & Kennedy was able to list 220 different varieties
and by 1818 its catalogue also included the first standard roses,
recently brought back from France by John Kennedy. The Duke of
Clarence, one of Kennedy's many royal customers, was so taken with
them that he ordered 1,000 at a guinea each. Thirty years on, in 1848,
rose grower William Paul was dividing the hundreds of varieties in
his catalogue into 38 distinct groups. He wrote, 'How has such a
change been wrought? Simply [through] a long course of careful
and systematic culture.'[1] Most of this had happened not over the
eighty years since Miller's *Dictionary* but far more recently, mainly
since the 1820s.

 The late eighteenth and early nineteenth centuries were an excit-
ing time for plant introductions to Europe. There was a stream of new
species, especially from North America and the Far East. Although
the first China roses had arrived in Italy, probably on packhorses via
the Silk Road, back in the sixteenth century, they had contributed
little to Western rose breeding at that time. But from 1792 four
China roses did cause a stir. They had all been cultivated for at least
a thousand years. What they brought was that most treasured of bene-
fits – a long flowering season. They also had a delicacy missing from
European roses, with fine stems, few thorns, new colours including

a soft yellow, and distinctive scents. The drawback of most of these beautiful roses was their tenderness. In their hot homelands they flowered continuously. But, while wealthy collectors could grow them in hothouses, there was still a need to produce hardier hybrids that could survive outdoors all year round in Europe.

The first of the four was 'Slater's Crimson China' in 1792. It was brought to England by an employee of Gilbert Slater, a director of the East India Trading Company. Slater successfully grew it in his glasshouse in Essex, where it flowered two years later. It was soon propagated and sent to growers across Europe, despite the small matter of the Napoleonic War.

The following year, 1793, two more roses were brought back by a member of Lord Macartney's embassy to China, an attempt to establish trading links with the notoriously closed country. Along with lavish gifts for the emperor, Macartney took two professional gardeners. On the return journey via Canton, the only Chinese port open to foreigners at the time, Lord Macartney's secretary, Sir George Staunton, a keen botanist, collected two roses. The first was a small, pale-pink double rose. The same rose had been brought to Europe around 1750 by a student of Linnaeus, but its potential was not recognized at that time. Only after its endless flowering ability became apparent in England in 1793 was it taken up by nurseries. Its early name, 'Parsons' Pink China', came from a Mr Parsons who grew it with great success in his garden in Rickmansworth, Hertfordshire. It soon became known as 'Old Blush' (*syn.* 'Common Monthly') and was the second of the four great 'stud China' roses. By 1823, says plant historian Alice Coats, 'it was in every cottage garden'.[2] It was also most likely the first Chinese rose to be sent to North America, in 1800. The other rose Staunton collected was *R. bracteata*, a single white climber he diplomatically named 'the Macartney Rose', evergreen with large single flowers.[3] It was not one of the Big Four but became the ancestor of the lovely yellow climber 'Mermaid' (1918), still seen covering many vicarage walls and in the Top Courtyard at Sissinghurst.

Rosa Indica Cruenta.

Rosier du Bengale

P. J. Redouté pinx!.

Imprimerie de Rémond

Langlois sculp!.

R. *indica cruenta* 'Slater's Crimson China' was the first 'stud China' rose;
Pierre-Joseph Redouté (1759–1840).

The third great introduction from China came in 1809 – 'Hume's Blush Tea-scented China', given the botanical name R. *indica odorata*. This variety, now extinct, was a valuable parent to the tea roses. Named after Sir Abraham Hume, to whom it was sent from the Fa-Te nurseries near Canton and who grew it in his garden, also in Hertfordshire, it had large, scented pale-pink flowers. In 1810, despite the English having blockaded the French ports, Hume managed to send

The second 'stud China' rose to arrive in Europe: *R. chinensis* 'Old Blush Climbing' (syn. *R. odorata* 'Old Blush').

a plant of his eponymous China to Empress Joséphine to add to her astounding collection of roses, of which more later.

Finally, 'Parks' Yellow Tea-scented China' was brought back by John Damper Parks in 1824 from an expedition organized by the Horticultural Society of London (later to become the Royal Horticultural Society). It was not the first yellow rose in Europe – that was *R. foetida*, a wild rose that arrived, probably from Persia, via the Netherlands in the seventeenth century – but strong yellow had been out of favour as a colour in the eighteenth century given its associations with plague and Jewry. However, 'Parks' Yellow China' was pale in tone and became highly fashionable. Both 'Parsons'' and 'Hume's' were soon widely grown under glass for the cut flower trade.

Known as the four stud Chinas, 'Slater's', 'Parsons'' ('Old Blush'), 'Hume's' and 'Parks'' were hybridized to produce some of the most delicate garden roses of the nineteenth century, including the original tea roses, prized for their ability, as with all China roses, to flower continuously – in the right climate. They were often referred to as Bengal roses because they were grown in the Calcutta Botanic Gardens

R. indica 'Bengale Thé hyménée'; Pierre-Joseph Redouté, 1835.

in the early nineteenth century. The problem was that although they flourished in Lyon where they were bred, and elsewhere with a Mediterranean climate, few places in Northern Europe could provide the warmth they needed. With the partial exception of 'Parsons'', which was hardier, these 'tea roses' were hothouse treasures grown only by the wealthy.

Rose historians still argue as to how tea roses came by their name. An early mention in Mrs Gore's 1838 *Rose Fancier's Manual*,

R. foetida, the Austrian Briar, was the first yellow rose to arrive in Europe in the 1600s.

'Lady Hillingdon' (1910), one of the few roses still with a true 'tea' fragrance.

describes one tea rose as 'very agreeably scented with the odour of Pekoe tea'.[4] Today, although the recognizable fragrance of China tea has been lost in most of their descendants such as the hybrid teas, it can still be found in a few, such as the pale apricot-yellow climber 'Lady Hillingdon' (1910).

With the arrival of these new China introductions, old roses such as 'the apothecary's rose' were soon overshadowed and overlooked. The new families of roses, mainly hybrid perpetuals and teas, developed by commercial nurserymen and some amateurs, brought an unprecedented variety of colour and growth. This was initially done by saving seed that had been randomly fertilized by bees. It was not until the late nineteenth century that growers started to understand the science behind breeding new varieties. Even then, they were largely working in the dark, selecting seedlings for qualities such as hardiness, flower shape or colour, with little understanding of their underlying heredity.

While the French Revolution and Napoleonic Wars hampered the trading of roses, several British, American, Dutch and French breeders managed to continue swapping plants throughout the

hostilities. French nurserymen such as André Du Pont (1756–1817) and Jacques-Louis Descemet (1761–1839), and later Louis-Joseph-Ghislain Parmentier (1782–1847) and Mme Hébert (c. 1830), a rare female breeder, all produced many new introductions during these unsettled times. Jean-François Boursault-Malherbes (1750–1842), an actor, playwright and revolutionary, also managed to keep his head and breed a small strain of roses classified as Boursault in the old rose group.

Laffay, Pernet *père* and Jean-Pierre Vibert, the latter with six hundred new introductions, dominated the French rose trade in the mid-nineteenth century. Vibert specialized in gallicas but also bred mosses, albas and damasks, many of which are still available, such as the clear pink damask 'Ville de Bruxelles' (1836) and the rose-pink gallica 'Duchesse d'Angoulême' (1821). Because of war and disease, Vibert had to move his nursery several times. Just before he died, he wrote:

> I have loved only Napoleon and roses . . . After all the trials from which I have suffered there remain to me only two objects of profound hatred, the English, who overthrew my idol, and the cockchafer grubs that destroyed my roses.[5]

From the middle of the nineteenth century, the number of professional growers across the Western world exploded. Garden writer Alice Steen described the period 1840–80 as 'the Great Forty Years'. This was the peak era of the hybrid perpetual.[6] These were crosses between the new Chinas and bourbons, themselves crosses between 'Old Blush' and an autumn damask, giving plants that were not only hardy but flowered repeatedly across the summer.

Lyon in southeast France was the top centre for rose growing, with a string of nurseries run by owners such as Alphonse Alégatière, Jean-Claude Ducher, Jean-Baptiste Guillot *père*, Antoine Levet, François Lacharme, Jean Pernet and Joseph Schwartz. The first great rose show was held there on 16 June 1845. Many of the new

Pierre-Joseph Redouté, *R. noisettiana* ('Rosier de Philippe Noisette',
now known as 'Blush Noisette'), from *Les Roses*, 1828.

introductions had the newly fashionable supplementary names added to their botanical stems. This often added to the confusion. Queen Victoria had eight roses named after her in Britain and France. The only way to distinguish between them was to know the breeder's name and the year of introduction, not always an easy task.

International connections were key to developing new rose varieties. An early example is the story of the noisettes. Sometime between 1800 and 1811 – no one is quite sure when – John Champneys, a rice grower in Charleston, South Carolina, successfully crossed 'Old Blush', the first stud China sent to America, with R. *moschata*, the musk rose. 'Champneys' Pink Cluster' was soon commercially available from William Prince's nursery in Flushing, New York. This was the first of the group of roses that became known as noisettes. They are still enormously popular today for their long flowering period and sweet scent, and gave birth to creamy yellow climbing noisettes such as 'Céline Forestier' (1858) and the more vigorous but no less beautiful 'Alister Stella Gray' (1894).

But why 'noisettes' and not 'Champneys'? The name has nothing to do with the shape of the small clustered flower heads, nor with the fact that *noisette* is the French word for hazelnut. Instead, it refers to the French nurseryman Philippe Noisette (1775–1835), director of the Charleston Botanical Garden and a successful nurseryman.

Most likely Champneys, the older man with little interest in commercial gain despite having supplied the rose to Prince's nursery, gave one also to Philippe Noisette. In 1814 Noisette sent a rose that he had bred from Champneys' original to his older brother Louis Claude, also a nurseryman, in Paris. Once it started flowering, Louis Claude was so delighted with it that he asked the famous rose painter Pierre-Joseph Redouté to paint it. In Redouté's elegant copperplate writing, so familiar to rose lovers the world over, he inscribed the painting with the words *Rosa Noisettiana* and *Rosier de Philippe Noisette*. Today we know it as 'Blush Noisette' or 'Noisette Carnée'.

This rose and its newly introduced siblings caused a sensation in both France and Britain. Within ten years, French breeders were

offering over a hundred different 'noisettes', soon crossed with tea roses to introduce even more colours. As well as Vibert's 'Aimée Vibert' (1828), and Jean Laffay's 'Bouquet Tout Fait' (1836), Joseph Schwartz introduced the near-white 'Mme Alfred Carrière' in 1879, which remains one of the most reliable scented climbers available, capable of flowering all year round in a warm climate. It was the first rose planted by Vita Sackville-West and her husband, Harold Nicolson, at Sissinghurst, before they had even moved in. It still grows there, up the wall of The Cottage.

Despite the success of British rose nurseries such as that owned by William Paul, France remained the centre of rose breeding in the mid-nineteenth century. In 1850 Jean-Baptiste Guillot, scion of one of the great Lyon rose-growing families, branched out on his own. Guillot *fils*, as he was known, was the first grower to use sweet briar seedlings as root stock. He concentrated on improving hybrid perpetuals and the more tender teas. In the mid-1860s one of his seedlings seemed to be something special, having repeat-flowering pale-pink blooms with unusually long petals. In 1867 he presented it to the Lyon judging committee, who were looking for a rose worthy of the illustrious name 'La France'. From 10,000 entries, this was the one chosen by a panel of fifty French rose growers. The popularity of 'La France' soared with this accolade, particularly in the cut flower and even artificial flower trades. It was immediately taken up in Britain as well, with court dresses becoming available garlanded with artificial 'La France' roses.

'La France' is acknowledged as the first hybrid tea, but its exact parentage remains uncertain – possibly the hybrid perpetual 'Mme Victor Verdier' (1863), bred by Eugène Verdier, and Guillot's tea 'Mme Bravy' (1846). Guillot was reluctant, or perhaps simply unable, to confirm this. Similar vagueness surrounded the parentage of many cultivars up to that time. Enter Henry Bennett, a Wiltshire farmer credited as the 'Father of the Hybrid Tea' for the ten roses he launched in 1879. Some fifteen years earlier he had begun a systematic study of roses, travelling to France and visiting nurseries in Lyon

'Mme Alfred Carrière' (1879), a climbing 'noisette' rose on the wall of
The Cottage at Sissinghurst, Kent.

and elsewhere. As a successful cattle breeder, he was amazed to find
that there seemed to be no scientific selective rose breeding pro-
gramme. It was, he said dismissively, and maybe unfairly, 'like cattle
breeding in Mexico, or horse breeding in the New Forest, simply
leaving Nature to herself and selecting the best of her produce'.[7] This
was indeed what happened. Hips were picked and stored until ripe,

'La France', the first hybrid tea rose, launched by Jean-Baptiste Guillot in 1867.

and the seed removed, mixed and sown in the ground. The patient grower waited two to three years before any results showed. It was all very hit and miss.

In sharp contrast Bennett set up a controlled propagation programme, growing his plants inside a glasshouse to avoid random pollination, and transferring pollen by brush. By 1879 he was able to introduce ten new varieties, which he called, using the language of the cattle breeder, 'Pedigree Hybrids of the Tea Rose'. For the first time, he claimed, it was possible to guarantee the parentage of a rose; all of his were crosses between the tea-scented family, which were derived from the great Chinas, and hybrid perpetuals.

Bennett did not do all this just for the love of roses. He was aiming to make money from his introductions. This air of commercialism was frowned on by the National Rose Society, formed in Britain three years earlier by a group of amateur rose lovers, many of them clerics, led by the Reverend Samuel Reynolds Hole. Unperturbed, Bennett accepted an invitation from the Horticultural Society of Lyon in 1880 to show his new roses. The Lyon judges agreed that he had produced

an entirely new class of rose, which would in future be known in France as *Hybrides de Thé*.

Three years later, Bennett presented one of his new varieties, 'Her Majesty' (1878), to the National Rose Society in London for consideration for its new Gold Medal classification. When it had been shown the previous year at the Crystal Palace Rose Show, it was described in *The Times* as 'very large and very delicate in its shade of tender pink'. Perhaps through gritted teeth, the committee had to agree that this enormous pink rose deserved their first ever Gold award. But, unlike the French professional growers, they refused to accept that it belonged to a new class. It remained, to them, a hybrid perpetual.

Several of Bennett's first pedigree hybrids were commercially successful, including 'Duchess of Connaught' (1879) and 'Lady Mary Fitzwilliam' (1882). Another, the cabbage-shaped mid-pink 'Mrs John Laing' (1885), following on from 'Her Majesty', scooped the NRS's second Gold Medal in 1887. There were bitter feelings, however, from British gardeners when it was found that Bennett had sold his entire stock to American nurseries.

A cross-section of *R. rugosa* 'Frau Dagmar Hastrup' hip, showing its seed content.

When Bennett died three years later, there was a blunt honesty in the NRS's tribute to him. 'He never, it is true, took kindly to the Society, and it is as a raiser of new Roses that he will most be missed.'[8] William Robinson's magazine *The Garden*, on the other hand, reported more generously, 'Had Mr Bennett only given us "Mrs John Laing", rose growers would have been grateful.'[9] In 1893, three years after Bennett's death, the NRS finally accepted the English translation of the French term for his crosses, hybrid teas, as a distinct new class. Later rosarians have had no hesitation in acknowledging his contribution. Rose historian Charles Quest-Ritson claims that 'there is scarcely a rose in our gardens today that does not descend from the hybrid teas of the Wiltshire "wizard"', while Jack Harkness of the famous British rose breeding family called him 'the man who transformed a profession'.[10]

'Mrs John Laing' (1885), one of the first English hybrid teas bred by Henry Bennett.

five
'Peace' and Propagation
❧

When Henry Bennett visited Lyon in 1880, he met a young Frenchman called Joseph Pernet. Pernet found Bennett's visit inspirational. He was already working for the Ducher rose nursery. Within a year he had married the late owner's daughter, changing his and the business's name to Pernet-Ducher, and begun an extensive rose-breeding programme using Bennett's methods. He produced two very successful hybrid teas – the globular silver-pink 'Mme Caroline Testout' (1890) and the elegant pale shell-pink 'Mme Abel Châtenay' (1895), which became one of the most successful florists' roses of all time. In the early twentieth century, nurserymen in the Lea Valley, north of London, were growing acres of 'Châtenay', sending metre-long stems to Paris throughout the year. But Pernet-Ducher's greatest dream was to create a yellow hybrid tea. While some of the teas and noisettes had pale-yellow variations, only *R. foetida*, the Austrian briar, with an unpleasant scent (hence its name), had the vibrant yellow missing from the hybrid tea catalogue. The double form had been brought to the West in 1838 by Sir Henry Willock from Persia, where the Persians were doubtless impressed with his title of Envoy Extraordinary and Minister Plenipotentiary.

Pernet-Ducher, as a disciple of Bennett, was careful to protect his pollinated roses with coned covers to avoid unintended cross-breeding. But when he finally found his 'new' yellow rose, it was as a random seedling from an earlier experiment with Sir Henry Willock's

Pernet-Ducher's 'Mme Abel Châtenay' (1895), one of the most
successful florists' roses of all time.

double *R. foetida* and a hybrid perpetual. Pernet-Ducher presented
this rose to the world in 1900 as 'Soleil d'Or'. Such was the excitement
over its introduction that the Lyon growers created a new division
for yellow hybrid teas called pernetiana, though once again, it was a
long time before the British followed suit. Every yellow rose grown
today owes a debt to 'Soleil d'Or'. Yet Pernet-Ducher always claimed
it was Henry Bennett who led the way.

While rose breeders were busy trying to create new varieties,
new species roses were being discovered by plant-hunting expedi-
tions, especially in China. Sometimes it took several visits before the
species reached the West. *R. moyesii* was first found in 1894 by A. E.
Pratt, near Kangding in west Sichuan. Ernest 'Chinese' Wilson saw
it again in the same area in 1903 and finally sent seeds back to the
Arnold Arboretum in Boston, Massachusetts, after a second expedi-
tion in 1911. *R. gigantea* was first discovered by Sir George Watt in
Manipur in northwest India in 1882 but early samples did not thrive

in England. It was later re-introduced by Frank Kingdon Ward after a later expedition in 1948.

In 1887, the year Henry Bennett won his second NRS Gold Medal with 'Mrs John Laing', Wilhelm Kordes, an ambitious 22-year-old German, started a nursery in Elmshorn, a small town 32 km north of Hamburg. Initially Kordes sold a wide range of plants, but he soon decided to specialize in his first love, roses. Later, his two sons joined him – Wilhelm II and Hermann. From the age of fourteen, the younger Wilhelm was fascinated with ways to improve rose breeding. Eager to learn, he worked as an apprentice in nurseries in Switzerland and France. In Lyon he met Joseph Pernet-Ducher, whom he called the 'Grand Master'. When he travelled to England in 1912, he was keen to make connections with the son of another of his heroes, Henry Bennett. Bennett's youngest son had left for Australia the previous year but Wilhelm followed in his footsteps, also working for the rose nursery Bide & Sons in Farnham, Surrey.

'Soleil d'Or', launched by French breeder Joseph Pernet-Ducher in 1900, the first to introduce yellow into hybrid teas.

Despite having a family nursery to return to, Wilhelm so enjoyed England that he and a friend, Max Krause, decided to stay and open their own rose nursery in 1913. Their timing was unlucky. Within a year, at the outbreak of the First World War, they were interned on the Isle of Man as enemy aliens.

Wilhelm used his time there wisely, however, reading and studying rose breeding in a depth that would not have been possible, he later said, if he had been running a nursery. It was also, he said generously, 'a chance for me to learn the King's English'.[1] After the war, he was deported back to Germany, taking his by now excellent theoretical knowledge of rose breeding with him. Together with his brother Hermann, and with their father now taking a back seat, they moved the nursery to nearby Sparrieshoop where it became W. Kordes' Söhne, still one of the world's great rose breeding nurseries. There are more roses bred by Kordes in Charles Quest-Ritson's RHS *Encyclopedia of Roses* than by any other breeder.

Wilhelm Kordes II was deeply influenced by the recently rediscovered work of Gregor Mendel (1822–1884), the father of genetics. Learning from Mendel's experiments on plant hybridization with the pea family, Kordes applied the same thinking to the development of stronger, healthier roses by systematically introducing new genetic material. His breeding programme produced so many good plants that, by 1939, the firm was selling over a million roses a year. Among their traditional hybrids, 'Crimson Glory' (1935) became enormously popular in both Europe and America while their late spring-flowering shrub roses, primrose-yellow 'Frühlingsgold' (1937) and pink 'Frühlingsmorgen' (1941), are among the world's hardiest. After the tough 1940s, in terms of both the war and harsh winters which wiped out thousands of roses, the firm's fortunes were transformed by the development of the 'Kordesii' climbing hybrids in the 1950s, especially the vibrant reds of 'Dortmund' (1955) and 'Parkdirektor Riggers' (1957). Other successful groups include the ground cover roses bred from Wichurana ramblers, and floribundas from hybrid musks. Wilhelm Kordes II's son Reimer produced the world's most

popular white rose, 'Scheewittchen' (1958), more widely known as 'Iceberg'.

In the United States, from 1930, the plant patents scheme enabled nurseries to receive payments for each registered plant sold. W. Kordes' Söhne was the first German nursery to benefit from the scheme, as did the Meilland nursery in France after the war, famous for breeding the world's most popular rose. In the words of rosarian Jack Harkness, 'only four words are needed . . . "They gave us Peace."'[2]

The story of 'Peace' is a dramatic one – or so legend has it. Like many rose breeding companies, Meilland was a family business. It was based in the village of Tassin-la-Demi-Lune near Lyon, with Antoine 'Papa' Meilland (1884–1971), helped by his son, Francis (1912–1958). Francis travelled to America in 1935 and did a deal with the Conard-Pyle Company in Pennsylvania to sell Meilland roses in the U.S. He was also interested in the American patent system, which he could see would benefit the family business back in France. He would have heard that the beautiful pale-pink climber 'New Dawn' (1930), the first rose to be patented, was already bringing a healthy financial return to Henry A. Dreer's Philadelphia nursery, which had introduced it.

On his return to the Meilland nursery, Francis began propagating one of his pollinating experiments, labelled '3-35-40' (3 noting a third cross, 35 its year of hybridization, 40 its number). It soon became clear that this was an outstanding rose, vigorous with dark healthy leaves and large pale-yellow blooms tinted with soft pink edges. In early 1939 Francis sent buds of it to colleagues in Germany, Italy and the U.S. Within months war broke out and the family was forced to produce vegetables rather than roses, not knowing whether their precious progeny had survived or even arrived. The story goes that one night a call came from an American friend in Lyon. He was flying out the next day on one of the last diplomatic planes to leave France and could take a small package with him. According to the legend,

'Crimson Glory', introduced by the German nursery W. Kordes' Söhne in 1935.

Francis Meilland's 'Peace' (1945), the world's most successful hybrid tea rose.

the back-up precious plant of this special rose was soon safely winging its way across the Atlantic to the Conard-Pyle Company. One way or another, the company were able to produce enough plants to distribute them to the United Nations delegates in April 1945.

Francis had managed to launch the rose in France as 'Mme A. Meilland' in 1942, named for his mother. Thereafter, there are two versions as to how the rose came by its eventual name. One version is that as the war was ending, Francis wrote to Field Marshal Alan Brooke (later Lord Alanbrooke), Britain's Chief of General Staff, to ask if he might rename the rose after him as a tribute to Brooke's part in the defeat of Nazi Germany and the liberation of France. Brooke reputedly declined the offer, suggesting the name 'Peace' as more appropriate. The more widely accepted version of the story is that, after the war, Robert Pyle of Conard-Pyle contacted the Meillands to inform them that, under the terms of the contract Francis had signed in 1935, the company had the right to name any Meilland introductions in the u.s. and had chosen 'Peace', announced on the day war ended in Europe. However it came about, it was a brilliant publicity

coup for a brilliant rose. 'I am convinced', wrote Pyle, 'it will be the greatest rose of the century.'[3]

What is in no doubt is that 'Peace' gave the Meillands the capital to build the business after the war. They have since produced hundreds of other successful roses, such as the landscaping roses snow-white 'Swany' (1978) and bright pink 'Bonica' (1985), and the Romantica® range. In later years Francis Meilland made himself unpopular with many in the trade by fighting to bring to Europe the legal trademark rights that were now standard for breeders in the U.S. He died tragically young, aged just 46, but the business continued under his son, Alain, and remains one of the world's largest rose growers, mainly producing long-stemmed roses for the cut flower trade as well as some for the garden.

A few breeders chose to devote themselves to improving just one group, as the Reverend Joseph Pemberton (1852–1926) did with his work with hybrid musks. Pemberton was yet another vicar who went on to become President of the National Rose Society, although unlike Revd Hole, who was otherwise kept busy once he was appointed Dean of Rochester in 1887, he devoted himself to serious rose breeding. At one point, Pemberton had 10,000 seedlings at his home in Havering-atte-Bower in Essex, 4,000 of which were of his own selections. He introduced nearly seventy in the early twentieth century, of which fifty remain. Hybrid musks, only distantly related to *R. moschata* despite their name, remain popular for their clusters of flower heads and delicate scent. One, a particular favourite of mine, is the apricot-coloured 'Buff Beauty' (1939), which can fill a garden with its perfume. This was bred by Pemberton's gardener, John Bentall, who carried on his employer's work, and was introduced by Bentall's wife just after his death.

Another specialist, the Barbier nursery near Orléans, bred in Wichurana ramblers with their long, flexible branches, giving us the popular pure white rambler 'Albéric Barbier' in 1900. The Poulsens in Denmark introduced the first floribundas, such as the dark-pink 'Ellen Poulsen' (1911), by crossing hybrid teas with polyanthas. The

French rosarian Dr J. H. Nicolas, who lived in America, coined the term 'floribunda' (Latin for 'many-flowered') for this new type of rose in 1930. Poulsens also produced roses that could cope with the tough Scandinavian climate. Such was their success that many modern varieties have added a touch of Poulsen to their pedigrees to improve viability in cold climates. The Poulsens produced many of the earliest ground coverers, such as 'White Bells' (1980) and 'Pink Bells' (1983). They now concentrate on breeding small roses suitable for windowsills and pots. Other breeders taking on the cold climate challenge include Hungarian Rudolf Geschwind (1829–1910) and, more recently, Dr Griffith Buck (1915–1991) in Iowa and Dr Felicitas Svejda (1920–2016) in Canada.

While the quest for the true-blue rose remains (thankfully, some might say) unfulfilled, Matthias Tantau Jnr (1912–2006) of the eponymous family nursery in Germany did introduce a new pigment into roses with the hybrid tea 'Super Star' (1960). The glowing orange colour was known as 'pelargonidin', reminiscent of vibrant vermilion bedding pelargoniums. The Tantaus followed this hit with another

Sweetly scented 'Buff Beauty' (Bentall, 1939), one of the best Hybrid Musks.

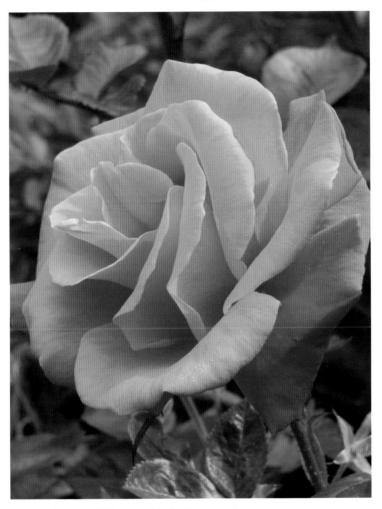

'Super Star' (Tantau, 1960), the first rose to have an orange pigment known as 'pelargonidin'.

hybrid tea, 'Fragrant Cloud' (1963), which lived up to its name, though yet again its orange colour was a bit too strident for many.

In Spain Catalan Pedro Dot (1885–1976) launched two roses in one year – 1927 – that were to become worldwide favourites, the pale cream shrub rose 'Nevada' and the flesh pink Modern Climber, 'Mme Grégoire Staechelin'. Early in his career he specialized in hybrid teas that were happiest in the warm climates of Spain and

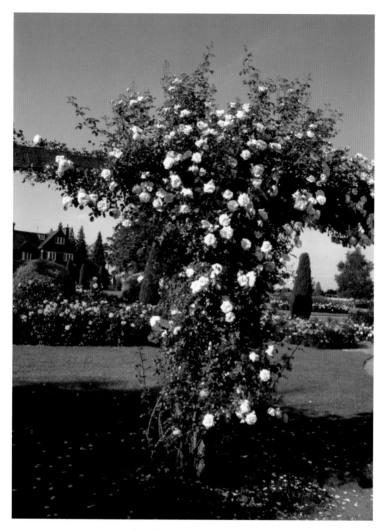

'Doctor W. van Fleet' (1910), a Wichurana rambler named after
one of North America's best-known breeders.

the southern U.S. states. But in the 1940s he turned to producing
miniature roses. These were also the passion of Californian nursery-
man Ralph Moore (1907–2009). In Italy Giovanni Casoretti
(1797–1846) was an early breeder of tea roses near Milan while
Dominico Aicardi (1878–1964), a mayor of San Remo, produced
several commercially successful forms. But the best-known Italian

rose growers are the Barni family of Tuscany, who began serious breeding in the 1970s and now dominate the production of large hybrid teas which are sold the world over. Although roses originated in the northern hemisphere, with improved transportation, they quickly found fans down under as well. In Australia Alister Clark (1864–1949) was a keen amateur rose breeder whose achievements include over a hundred varieties able to cope with Antipodean summers without constant watering.

But, of all the countries outside Europe, it is the United States that has always had the largest number of expert breeders. One of the most illustrious was Walter Van Fleet (1857–1922), a doctor who gave up medicine to begin rose breeding when he was thirty. His work with Wichuranas and rugosas at Glenn Dale, Maryland, for the U.S. Department of Agriculture was especially successful, producing the pale-pink Wichurana rambler 'Dr W. Van Fleet' (1910) and the mauve-pink rugosa 'Sara Van Fleet' (1926). The famous shell-pink climber 'New Dawn' is a repeat-flowering sport of 'Dr W. Van Fleet'. 'Sports' are canes growing anywhere on a plant that show different characteristics from the parent – maybe climbing, or repeat flowering or differing in colour. The sport can then be detached and rooted. Much earlier than 'New Dawn', pale-pink 'Kathleen Harrop' (1919), for example, occurred as a sport of the dark-pink bourbon climber 'Zéphirine Drouhin' (1868).

Van Fleet aimed to breed roses that every American family could grow, however humble their yard. After his death, he was idolized among the U.S. rose community, hailed as 'America's greatest hybridizer, perhaps the greatest plant breeder America had ever known'.[4] Other successful U.S. breeders include Ellwanger & Barry, Jackson & Perkins and the Armstrong Nurseries. For instance, the rich pink, multi-petalled modern climber 'Aloha' (1949) came from Eugene Boerner, charmingly known as 'Papa Floribunda', of J. & P., while Dr Walter Lammerts at Armstrong's produced the tall, strong pink 'Queen Elizabeth' (1954). In 1999 amateur rose breeder William Radler, of Greenfield, Wisconsin, introduced his 'Knock Out'® range

of low-growing, easy-maintenance landscape roses. As the country's most popular roses, they have made him a millionaire, a rare feat in horticulture.

Although Cants of Colchester was the oldest British commercial rose nursery, established in 1765, for several generations from the 1880s, it was the Dicksons and McGredy families, both based in Northern Ireland, who dominated the British rose trade, with roses such as hybrid teas 'Shot Silk' (1924) and 'Grandpa Dickson' (1966), floribunda 'Evelyn Fison' (1962) and the climber 'Dublin Bay' (1974). They were soon joined by the Cocker, Fryer, Harkness and Le Grice families in producing many of the most popular roses of the twentieth century. Cants introduced, among others, the highly successful apricot hybrid tea 'Just Joey' (1972), while Harkness's 'Ena Harkness' (1946), bred for them by Albert Norman, was, for a while, the world's best-selling red hybrid tea.

However, while the legacy of these growers remains, fashions change in the flowerbed as well as on the catwalk. Towards the end of the twentieth century, there was an increasing demand for roses that would grow comfortably in mixed borders. Hybrid teas and floribundas, the bread and butter of these old established rose family businesses, are traditionally best grown in dedicated beds. Increasingly, they have been displaced by a group of new shrub roses, which can be grown either in traditional formal rose gardens or mixed in with perennials. From the 1950s it was the ambition of Shropshire farmer David Austin to breed roses that combined the shape, fragrance and shrubby growth of old roses with the colour, repeat flowering and disease resistance of modern roses.

In 1961 he launched a pink, cabbage-like shrub rose, 'Constance Spry', named for the famous flower arranger and old rose collector. It was a cross between the highly scented pale-pink gallica 'Belle Isis' (1845) and the semi-double pink floribunda 'Dainty Maid' (1940), with a touch of Poulsen toughness. 'Constance Spry' achieved five of Austin's six aims. Her flaw, for some, is that she has but one, albeit glorious, flowering session. Since her launch, Austin has successfully

incorporated repeat flowering into his later introductions, which now have unrivalled popularity for their 'old rose' look. One of his earliest stars was the highly scented deep-pink 'Gertrude Jekyll' (1986), a cross between Austin's 'Wife of Bath' (1969) and the beautiful Portland rose 'Comte de Chambord' (1860). Although similar roses have been bred by French growers Guillot, with their Generosa® range, Meilland with Romanticas®, and the Poulsens in Denmark, with their Renaissance® roses, in English-speaking countries, Austin remains pre-eminent. His catalogue now covers a range of colour, size and shape that would have seemed almost unimaginable even fifty years ago. This unique class of roses, outside the UK often called Austin Roses, or David Austin's English Roses to avoid confusion

'Queen Elizabeth' (1954), bred by Lammerts in the U.S., where it is known as a Grandiflora.

'Constance Spry' (1961), the first of David Austin's shrub roses,
now known as English Roses.

with any rose from England, is now one of the best sellers around the
world.

While a few new roses achieve international success, most remain
available only in their countries of origin for reasons of climate or,
occasionally, import regulations. However, this has not reduced the
camaraderie that still links rose breeders across the world. One story
exemplifies this working friendship. In 2014 Matthew Biggs, a popu-
lar gardening expert from BBC Radio 4's *Gardeners' Question Time*,
wrote a letter to the Royal Horticultural Society's journal, *The Garden*,
about having seen the neglected grave of the esteemed plant hunter
Frank Kingdon Ward (1885–1958) in the grounds of Grantchester
Church, near Cambridge – the same church whose clock famously
stands at 'ten to three' in the poem by Rupert Brooke. The letter was

read by Girija and Vira Viraraghavan, rose breeders in Chennai (Madras) in southern India. They got in touch to say that they had bred a rose they had named 'Frank Kingdon Ward', a cross between the French hybrid tea 'Carmosine' (1995) and *R. gigantea*, one of the roses collected by Kingdon Ward during his expedition to Manipur in 1948. They asked Biggs if it might be possible for this rose to be planted on the grave in Grantchester. The idea was exciting but putting it into practice was not so easy. The rose was in short supply and available only in India, so the problem was to find a way to propagate it in England. Eventually, Michael Marriott at David Austin Roses took on the challenge and bud wood was flown to Britain. The first batch died in the cold aircraft hold. Lessons learned, more arrived in cabin comfort and Marriott successfully produced several plants.

With the agreement of Grantchester church and to the delight of the Kingdon Ward family, the rose was planted on a chilly February day in 2016. I can vouch for the temperature as I was there, alongside several British rose experts, including, of course, Michael Marriott, together with Peter Harkness and Robert Mattock, representing two great British rose dynasties.

Although modern rose breeders have transformed the rose family, this recent success would not have been possible without the foresight of earlier plant collectors, whether Crusaders, East India Company officials or plant hunters such as 'Chinese' Wilson and Frank Kingdon Ward. Rose breeding has also linked countries across the world. In the words of Girija and Vira Viraraghavan:

Surrounded by hundreds of blooms of *Rosa gigantea* in our garden, which we collected on the same slopes of Mount Sirohi where he found the rose, we wonder how the gardeners of the world can ever repay the debt they owe to this great plant hunter . . . We feel that the grave of Kingdon Ward could be described in the spirit of Rupert Brooke's 'The Soldier', as a corner of an English field which is forever the Himalayas.[5]

The climber rose 'Frank Kingdon Ward', growing in India
and now also on Ward's grave in Grantchester, Cambs.

As we left the church and drove through the Cambridgeshire lanes, we
were too early in the year to see Brooke's hedgerow 'English unofficial
rose' (possibly *R. canina*?). But, in spring 2017, 'Frank Kingdon Ward'
was getting ready to bloom in Grantchester and it is to be planted in
several important gardens, including Mount Stewart in Northern
Ireland, Borde Hill in Sussex and Mottisfont in Hampshire, home
to one of the most important rose collections in Britain.

six

From *Rosarium* to *La Roseraie*

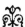

For around 3,000 years, roses have been taken from the wild and cultivated for pleasure and profit for their blooms and scent, often in an area of the garden dedicated just to them, from the *Gulistan* to the *Rosarium*, *La Roseraie* to the White House Rose Garden.

The idea of a garden specifically for roses was developed in the Middle East. To the Persians, the word 'paradise' meant a garden that is the nearest thing to heaven on earth, a walled 'garden of delights' filled with roses, prized for their scent and beauty. Given the semi-desert nature of most of the Middle East and Mughal India, water was precious and its inclusion in gardens a treasured luxury. The classic Islamic garden design was the *chahar bagh* – a large rectangular garden, quartered by rills, with a central pond. The earliest known example was at Pasargadae, the Persian capital built by Cyrus the Great (d. *c.* 530 BC), near Shiraz. This style of garden was planted predominantly with roses, often in vast quantities, a tradition that continued for many centuries. In 1593, 50,000 white roses were planted in Topkapi Palace in Istanbul.

The enclosed garden of medieval Europe – the *hortus conclusus* – was smaller, simpler and less exotic, without the emphasis on water. Yet it was seen as a haven of tranquillity nevertheless. The memory of medieval rose gardens as places of peace and contemplation with their singing birds and peacocks, enclosed first with walls and then with trellis interwoven with climbers, lives on through

Babur, founder of the Mughal Empire, supervising the laying out of the Garden of Fidelity, from the Baburnama, *c.* 1525–29.

early works of art and literature. Both types of rose gardens, the Islamic *chahar bagh* and the Christian *hortus conclusus*, continued to influence later rose gardens.

Formality ruled in sixteenth- and seventeenth-century European gardens. Roses were regularly included on nurserymen's lists but we know little about how they were used. It was thought that flower gardens then fell out of fashion in the wake of the English landscape movement, starting around 1720, but garden historian Mark Laird has shown that eighteenth-century gardens often included circular flower or 'nosegay' beds featuring scented plants such as pinks, stocks and, of course, roses. Roses continued to be popular in town gardens as well, as is confirmed in a 1734 letter from Mary Delany to her sister about her garden in London's Mayfair:

> You think, madam, I have no garden, perhaps? But that's a mistake. I *have one* as big as your parlour at Gloucester, and in it groweth *damask-roses, stocks* variegated and plain.[1]

In larger properties, flower borders may not have been in full view of the house but roses were still grown, particularly for cutting. The first edition of Philip Miller's *Gardeners Dictionary* (1735) recommends growing them against a warm wall to encourage early flowering. A 1751 planting plan for a 'Parsonage Flower Garden' includes unspecified varieties of rose alongside honeysuckle, while *R. canina*, the dog rose, and *R. rubiginosa*, the sweet briar, were recommended as underplanting for a grove in a Surrey garden in 1752. Another garden planned in Old Windsor included *R. centifolia*. Account books confirm the enduring use of roses. In 1756 a plant order from the Countess of Oxford for Welbeck Abbey included 34 varieties, mostly ordered in twos and fours. The cheapest, at 2*d.*, was *R. rubiginosa*, while the Countess's big extravagance was two plants of *R. centifolia* 'Muscosa', the 'Common Moss rose', costing twelve times as much at 2*s.* a plant. This had been available since at least 1724, when it was listed by Robert Furber's nursery in Kensington.

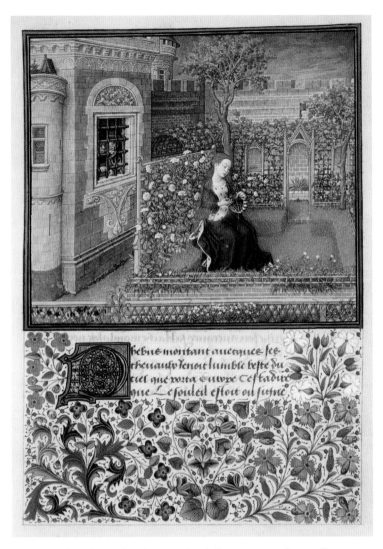

Emilia in her garden, showing red and white roses trained up a trellis;
Giovanni Boccaccio, Plate 22 from *La Teseida*, 1340–41.

After what John Harvey calls 'a period of stagnation in the rose trade', prices begin to increase in the late eighteenth century. By the time landscape designer Humphry Repton (1752–1818) tempted his clients with 'before' and 'after' illustrations in his famous 'Red Books', roses were once again front-of-stage garden plants, prices

and demand had increased, and there were specific mentions of areas of gardens dedicated to them. For instance, in one of Repton's last designs, *c.* 1813, he included a 'rosarium' for the Earl of Bridgewater at Ashridge in Hertfordshire.

Roses also remained a key town garden plant, as confirmed by an ambitious proposed plan for a London garden in 1791, which included *R. centifolia* 'Muscosa'; the moss rose; new varieties *R. centifolia pomponia*, 'Pompoon' and *R. centifolia* 'Unique', a white version introduced in 1777; *R. foetida* 'Bicolor', the Austrian copper; *R. moschata*, the musk rose; *R.* 'Rose de Meaux', introduced in France in the revolutionary year of 1789; and, finally, from across the Atlantic, *R. carolina*. Twenty-three years later, a German visitor to London in 1814 wrote of London's 'beautiful squares' where young children played 'among the roses'.[2]

The fascination with Persian gardens was fuelled at the turn of the nineteenth century by publications from intrepid British travellers. Elizabeth Kent quotes from one in her book *Flora Domestica* (1825), where Sir Robert Ker Porter, a landscape artist, described visiting a royal palace in Persia:

A formal garden with roses in *Hortus Floridus* by Crispin van de Passe, 1614–15.

Formal planting in the Rosary at Ashridge, Berkhamsted; J. Taylor, *The Rosary at Ashridge*, 1816, lithograph.

I was struck with the appearance of two rose-trees full fourteen feet high, laden with thousands of flowers, in every degree of expansion, and of a bloom and delicacy of scent that imbued the whole atmosphere with exquisite perfume. Indeed, I believe that in no country in the world does the rose grow in such perfection as in Persia; in no country is it so cultivated and prized by the natives. Their gardens and courts are crowded by its plants.[3]

While the Persians would have been growing traditional roses, across the Atlantic there was a keen interest in new varieties from around the world. Thomas Jefferson (1743–1826) was a passionate rose grower. In 1791 he ordered several from the William Prince Nursery in Flushing, New York, for his new home, Monticello, in Charlottesville, Virginia. Prince's was the first nursery in the United States to supply roses imported from England and France but offered only ten varieties. Jefferson was particularly keen on gallicas, especially 'Rosa Mundi', the elegant striped rose which he may well have

cut to display indoors. His order also included two 'Old Blush' and two *R. moschata*. The planting was not restricted to Monticello. On 1 November 1816 Jefferson wrote in one of his gardening notebooks that at his other Virginian estate, Poplar Forest, he had 'planted large roses of difft kinds in the oval bed in the N front. Dwarf roses in the NE oval . . .'.[4]

Despite the various hostilities between Britain, the USA and France, growers, botanists and nurserymen continued to correspond. Even more remarkably, leading London nurseryman John Kennedy was granted special clearance to cross the English Channel in 1810, at the height of the Napoleonic War, not just to deliver plants to Empress Joséphine's country estate of La Malmaison, on the outskirts of Paris, but to prune her roses. One of the plants he delivered was the much sought after 'Hume's Blush Tea-scented China', introduced from China the previous year.

Joséphine (1763–1814), was Napoleon's first wife. Born Marie-Joseph-Rose de Tascher de la Pagerie in Martinique, she travelled to Europe to marry her first husband, Alexandre de Beauharnais. It was Napoleon who changed her name from Rose, as she was known in her family, to Joséphine. She and Napoleon separated after she failed to give him a son and heir, and she retreated to La Malmaison, which he had bought for her. The house and six-hectare garden in Reuil, on the western outskirts of modern Paris, was some consolation after their divorce in 1810.

Joséphine was an inveterate plant collector and visitors marvelled at the variety of material she acquired. She received exotic plant seeds from botanical gardens in Europe, as well as new finds from Central and South America. In 1803 she bought plants costing £2,600, equivalent to more than £230,000 in 2017. A later order, personally delivered by Kennedy from his West London nursery, came to £700 (over £60,000). Napoleon's indulgence continued after their divorce. He wrote in 1810, in words many a partner would like to hear, 'I have allotted 100,000 francs . . . as a special sum for Malmaison. So you can plant anything you want and spend the money as you like.'[5]

While she may not have been personally getting her hands dirty in the garden, there is no question about the extent of her passion for plants. In the ten years before her death in 1814, it is thought that 184 new species of plants flowered at La Malmaison. She also commissioned the artist Pierre-Joseph Redouté to produce books on her botanical collections. His famous three-volume work on roses, *Les Roses* (1817–24), appeared after Joséphine's death, by which time the château and garden had passed to her son. There is a story, possibly apocryphal, suggesting that Redouté was at her bedside, together with her botanists, when she died of diphtheria at the château in 1814.

Legend has it that Joséphine aimed to collect all the then known varieties of rose. No lists of the roses at Malmaison have survived but it has been estimated that, with a dedication familiar to any plant enthusiast, she soon acquired over two hundred, including 167 gallicas. André du Pont, a postal worker turned rose nurseryman, was her main supplier, but she ordered them from across Europe. Given the reputation Malmaison later acquired as a famous rose garden, it is puzzling that contemporary visitors did not mention her roses, enthusing instead about other areas of her botanical collection. It is possible that the rose garden was partly a myth created at the end of the nineteenth century by Edouard André, the landscape architect chosen to restore the building and garden. There is no doubt Joséphine acquired many roses but it seems likely they were all grown in pots, which explains the absence of a planted rose garden. While only fragments of her letters survive, this appears to be confirmed by a note sent to her lady-in-waiting while Joséphine was visiting Bayonne in 1808, asking her to check at La Malmaison to see 'if my roses are being watered'.[6]

Joséphine constantly searched for roses to add to her collection. French rose historian François Joyaux has painstakingly pieced together a list of those we know she collected. One source for this is her correspondence with her former sister-in-law, Catharina of Württemberg, who was married to Bonaparte's younger brother,

Napoleon's first wife, Joséphine de Beauharnais, Empress of France, celebrated as one of the greatest rose lovers of her time; Francois Gerard, 1801.

Jérôme. Joséphine asked Catharina to send roses from her home, Schloss Weissenstein, near Kassel. Known as 'Napoleonshöhe' when Catharina lived there, it had an impressive rose garden created fifty years earlier by the estate gardener Daniel August Schwarzkopf. Catharina wrote to Joséphine that she was sending a consignment of roses, some of which may have been roses raised by Schwartzkopf that later appeared in Redouté's *Les Roses*. Redouté hardly mentioned Joséphine and Malmaison in his book but the political atmosphere in France at the time of publication, 1817–24, may have forced him to distance himself from his former patron. Volume II of his book includes 'Rosier de van Eeden', a deep claret-red rose Joséphine may

Charles-Paul Renouard, *Jules Gravereaux dans la roseraie de l'Haÿ, c.* 1907.

have bought from the eponymous Dutch grower, noting that 'After [her] death, this fine rose disappeared from Malmaison.'[7]

Sadly, that was to be the fate of many of the Malmaison roses. The château was sold in 1824 and ransacked after the Franco-Prussian War in 1871. When it was given to the state in 1904 to be turned into a museum, all the roses had gone. A large purplish-pink gallica 'Empress Joséphine' was introduced around 1815 by Jacques-Louis Descemet, who had been one of her suppliers, in defiant honour of his late client. That same year Descemet was forced to abandon his nursery in St Denis, then on the outskirts of Paris, as the first French Empire collapsed. His seedling stock was rescued by fellow grower Jean-Pierre Vibert, who escaped the allied advance and brought it safely to his nursery on the Marne to the East of Paris. We met the Napoleon-loving and English-hating Vibert in Chapter Four.

In 1823 Vibert, who was one of the most successful and prolific rose breeders of the time, launched a light pink alba, 'Joséphine Beauharnais', perhaps using the late empress's previous married name to dissociate her from Bonaparte. This was only one of several roses

named 'Joséphine' introduced shortly after her death, a testament to the esteem in which she was held by French rose growers. The sumptuous salmon-pink Bourbon 'Souvenir de la Malmaison' was introduced in Lyon in 1843 by Basile Béluze and named by a Russian prince who visited his nursery. It now grows in the restored gardens at Malmaison which were financed by Jules Gravereaux, wealthy co-owner of the elegant Parisian department store Bon Marché.

Gravereaux's lifetime passion was roses and when he retired in 1899, he concentrated on breeding them and creating a vast rose garden on his estate at L'Haÿ on the southeastern outskirts of Paris, aided by the landscape architect Edouard André. Gravereaux had acquired around 1,600 different roses, a collection that quickly grew to 3,200 by 1900, then the biggest in the world. He was especially fascinated by the rugosas from Japan and Kamchatka in Siberian Russia, working with Charles-Pierre-Marie Cochet-Cochet (1866–1936), who came from another long family line of rose growers. One of their joint breeding achievements was the deliciously scented magenta-purple rugosa 'Roseraie de L'Haÿ', introduced in 1901 through Cochet-Cochet's nursery. After Gravereaux's death in 1916, his family continued to maintain the garden until 1937, when it was bought by the local *département*. Today La Roseraie du Val de Marne remains one of the most important rose collections in the world and the local *commune* has been renamed L'Haÿ-les-Roses in its honour.

Across the city from La Roseraie du Val de Marne is the second garden that gives Paris a claim to be the rose garden capital of the world, the Parc de Bagatelle, tucked away in a quiet corner of the Bois de Boulogne. Its château was the result of a wager in 1777 between the Comte d'Artois and his sister-in-law, Queen Marie Antoinette, that he would not be able to rebuild the then ruined building in time for a fête two months later. He won. The Comte survived the French Revolution in exile. From 1832 the property was owned by a series of English aristocrats. In 1905 it was bought by the city of Paris and plans were made for the creation of a rose garden in the grounds, designed by Jean-Claude Nicolas Forestier, a

Re-planted at the start of the twentieth century,
Parc de Bagatelle is in Paris's Bois de Boulogne.

landscape designer best known for his work on the Champs de Mars
around the Eiffel Tower.

At Bagatelle, Forestier, in consultation with Jules Gravereaux,
created a formal garden with roses laid out in rectangular borders
but also incorporating vistas to many of the remaining statues and
small buildings on the estate. Individual roses are planted in circles
within the grassed beds, which are edged with box. Climbing roses
garland obelisks and pergolas while standard roses underplanted with
smaller roses add to the formality. Bagatelle has over 20,000 roses of
over 2,500 varieties. Since 1907 it has hosted an International Rose
Competition for new roses, inaugurated by Forestier and Gravereaux.
Forestier took pride in his role in re-introducing roses into parks,
writing in 1920, 'Barely twenty years ago, roses were snubbed and not

allowed in [them] and had no place in public gardens.'[8] Bagatelle has been described as 'Forestier's masterpiece'.[9] The garden's outstanding collection of historic roses, particularly from the early nineteenth century, still draws thousands of visitors every June and July.

'A Summer Rose Show': cartoon from the *Illustrated London News* in 1884, satirizing the popularity of public rose shows.

seven

The New Rose Garden

❦

I n 1858 the first National Rose Show, held in St James's Hall in London, with musical accompaniment by the band of the Coldstream Guards, attracted over 2,000 visitors. The driving force behind this, and later the National Rose Society started in 1876, was Reverend Samuel Reynolds Hole, President of the Society for its first 28 years. Hole, whose family money came from 'putting the spots onto cotton' in Manchester, eventually became Dean of Rochester Cathedral.[1] He combined his clerical career with a love of fox hunting and a passion for roses. Hole's idea of a competitive rose show caught on and soon became a regular feature each July in London's social calendar.

The 1861 show, so popular now that it was held in the vast Crystal Palace conservatory in South Kensington, with exhibition tables stretching for over 150 metres, was visited by the Duchess of Cambridge and Princess Mary. Hole would have been even more delighted by the attendance figures in 1862, when 5,787 visitors passed through the gates to see 4,000 roses, listen to military bands, and see – maybe the biggest draw of all – a low-rope performance by the famous French tightrope walker Charles Blondin. In 1868 Hole himself won fourteen out of sixteen first-prize places for his entries. For, although this was an arena for nurseries such as Pauls, Fryers and Cants to show off their new introductions, it also captured the imagination of enthusiastic amateur growers. Many gardeners, including a disproportionate number of men of the cloth, it seems

The style of rose gardening admired by Gertrude Jekyll in her book
Roses for English Gardens (1902).

from the prize lists, relished the competitive spirit of the shows and
viewed roses largely as exhibition items.

Not everyone agreed. In 1883 William Robinson's seminal *The
English Flower Garden* spurred a movement rejecting Victorian formal
bedding – and also the exclusion of roses from mainstream garden-
ing. Robinson included a full chapter on 'The New Rose Garden',
writing that 'the Rose must go back in the flower garden – its true
place, not only for its own sake, but to save the garden from ugliness
and hardness, and give it fragrance and dignity of leaf and flower.'[2]

Gertrude Jekyll (1843–1932), a close friend and collaborator,
carried forward Robinson's ideas with specific planting plans in 'New
Rose Gardens', the similarly titled first chapter of her best-selling
Roses for English Gardens (1902). Jekyll's gardening style was highly influ-
ential among the upper middle classes. Her genius was in producing
planting plans with detailed lists of suitable shrubs and perennials,
including, of course, roses.

Like Robinson, she believed that roses should be used through-
out the garden. She acknowledged that some people would still want
an area of garden purely for roses and – perhaps a bit reluctantly

– gave a couple of plans and some planting suggestions, with the following caveat: 'We are growing impatient of the usual Rose garden, generally a sort of target of concentric rings of beds placed upon turf, often with no special aim at connected design with the portions of the garden immediately about it, and filled with plants without a thought of their colour effect or any other worthy intention.'[3] If such a garden must be included, she suggested that a hedging of dark evergreens be used together with posts 'connected by chains on which are pillar and free-growing cluster Roses placed alternately'.[4] The colour palette of Jekyll's ideal rose garden was never violent, or even, as she put it, 'gorgeous'. 'The term is quite unfitting . . . The gorgeousness of brilliant bloom, fitly arranged, is for other plants and other portions of the garden; here we do not want the mind disturbed or distracted from the beauty and delightfulness of the Rose.'[5]

The National Rose Society held out for the earlier view. The world's oldest specialized plant society, it was slow to adopt new thinking.[6] Led by knowledgeable but mainly amateur rose growers, such as Dean Hole and his hard-working Honorary Secretary, Revd Henry D'Ombrain, its members continued to focus on growing varieties that would be prizewinners on the show bench, rather than

Exhibition roses being grown in the garden of Edward Mawley, Gertrude Jekyll's co-author. Note the protective cones over blooms.

Blooms arranged in an exhibition box, from Gertrude Jekyll's *Roses for English Gardens* (1902).

on integrating roses into the natural planting schemes proposed by Robinson and then Jekyll.

This split continued well into the twentieth century despite the arrival of floribundas. They were essentially a bedding rose. The floribunda was marketed for mass planting and much used in public gardens, where new chemical sprays made it easy to keep the surrounding earth clear of weeds. In a rainbow of colours but, in most cases, little scent, it seemed that gardeners around the world were moving back to dedicated rose gardens, or at least separate rose beds. The stiff, formal hybrid teas did not lend themselves to Robinson's and Jekyll's mixed planting schemes, but were popular in smaller gardens, where different varieties could be grown to provide a kaleidoscope, or, as Jekyll might have called it, a 'gorgeousness' – not a compliment – of colour across the summer. They were promoted by nurserymen such as the equally colourful Harry Wheatcroft (1898–1977) and

publications like Dr D. G. Hessayon's *The Rose Grower*, as cheap colour printing tempted buyers with ever more lurid and sometimes, it has to be said, unrealistic colours.

A time capsule from this mid-twentieth-century period is Queen Mary's Rose Garden in London's Regent's Park. First opened in 1935 by Queen Mary, wife of King George V, it remains London's largest rose garden with 12,000 roses. Initially these were all displayed in

An 1896 catalogue from Cants of Colchester, a leading British rose nursery since the 18th century.

formal beds with climbers trained along rope swags. Its stylized displays were then the height of rose-garden fashion. Today it also includes more mixed planting, including some species roses.

The aristocratic author and gardener Vita Sackville-West (1892–1962) and her diplomat husband Harold Nicolson were firmly in Robinson and Jekyll's camp. In the 1930s they created a garden around their newly bought home at Sissinghurst Castle in

Harry Wheatcroft's rose catalogue from 1970, as colourful as the grower himself.

Kent. Sackville-West rejected the popular and increasingly florid hybrid teas and floribundas, endorsing Robinson's view that 'formality is often essential to the plan of a garden, but never to the arrangement of its flowers or shrubs'.[7] Robinson, she said, used low-growing plants to carpet his rose beds, concealing every inch of soil under his roses at his home at Gravetye, West Sussex, now a five-star country house hotel. She also hated standard roses, 'top-heavy with their great blooms on one thin leg like a crane'.[8]

Vita Sackville-West set about collecting old roses, those grown before the influx of what she thought of as 'strong horrors [such] as Dorothy Perkins or American Pillar'.[9] Old roses were, she conceded, an acquired taste but one that, like oysters, 'once acquired increases to the point of greed'.[10] One she rescued was a dark maroon and highly scented rose she found growing in the orchard at Sissinghurst. She named it 'Sissinghurst Castle Rose' in 1947, but it is clearly much older, probably a sixteenth-century rose called 'Rose des Maures'. She also wrote about roses in her regular gardening column in *The Observer* newspaper and in her books. The gardens at Sissinghurst were by now regularly open to the public, or the 'Shillingses', as Sackville-West snobbishly called them, although she needed the money for her work in the garden.[11] By the time of her death in 1962, there were around three hundred different cultivars and species at Sissinghurst. It remains one of the most visited gardens in the world, but by 2013, only one hundred of Sackville-West's three hundred rose varieties remained. The current head gardener, Troy Scott Smith, is successfully using her garden notebooks to identify and reintroduce the missing varieties.

Sackville-West's efforts were part of a small but dedicated movement to revive the popularity of old roses and show that they were not all disease-ridden plants that flowered for only two weeks a year. Constance Spry, queen of British flower arranging, was another enthusiast. During the Second World War, she invited Graham Stuart Thomas to see her collection of old roses and he wrote later that he had seen 'nothing like them in horticulture'.

An arrangement of roses, inspired by the paintings of Fantin-Latour,
by Constance Spry, a passionate collector of old roses.

Thomas, a nurseryman for Hillings of Chobham, Surrey, for forty
years, and then an advisor to the National Trust on some of the great
English gardens, became the leading advocate for old roses. He had
been inspired by the writing of rosarian Edward Bunyard, in particu-
lar *Old Garden Roses* (1936). Yet Thomas was pragmatic about the need
to use a wide variety of roses, especially in gardens open to the public.
Famously fastidious, he had strong views on what should go where,
writing in *Shrub Roses of Today* (1962):

> Putting it simply, I like a slight sense of orderliness and prefer
> my Hybrid Teas, my Floribunda, or my Old Roses fairly near
> the house; they are man-made and assort well with seats and
> paths, vegetable plots, formal lawns, and flower beds. At the
> other end of the scale are the species roses, breathing of fresh
> air and freedom and the wild countryside; appealing but not
> perhaps showy; of a beauty which needs other natural things
> around it in herbaceous or woody plants.[12]

Thomas was first and foremost a nurseryman but he became a world authority on old roses, coining the term 'old shrub roses' to replace 'old garden roses' or 'old-fashioned roses', as they were previously known. His priority was always to collect those which were 'garden worthy' and, when he worked at Hilling's, saleable. During the Second World War, Hilling's rose list shrank from 1,250 to around four hundred, and many old varieties were dropped even by Thomas and lost forever. It was not until the late 1960s that Norfolk nurseryman Peter Beales established what was then the only nursery dedicated to preserving and selling old roses. One of his mentors, when he was a young apprentice gardener, had been Graham Stuart Thomas. David Austin also became a great friend and named one of his most popular roses, the rich yellow, tea-scented 'Graham Thomas', after him in 1983. Thomas's influence can still be seen across Britain, for example, at the National Trust gardens at Hidcote, Sissinghurst, Polesden Lacey and Mount Stewart. But it is at Mottisfont Abbey in Hampshire that he brought together his finest collection of old roses. Preparing for retirement in the early 1970s, he needed to find a home for his plants, mostly dating from before 1900. The old walled vegetable garden at Mottisfont was available and he added to it over many years. It is now home to the National Collection of Pre-1900 Old Roses.

While Mottisfont has around a thousand roses on display, its collection is dwarfed by those of several rose gardens in Continental Europe. A combination of wealthy amateur collectors and enthusiastic national rose associations has meant that most countries in Western Europe have at least one major rose garden. In addition to those of Paris, Lyon, the historic home to so many famous French rose breeders, has not one but two rose collections, at Parc de la Tête d'Or. Denmark has the Gerlev Rosenpark, near Copenhagen; Belgium, Coloma, in Sint-Pieters-Leeuw; and Italy, the huge Fineschi Garden near Florence, created by Gianfranco Fineschi (1923–2010), to name just a few.

The only garden with more roses on display than the Fineschi is the European Rose Garden at Sangerhausen, near Leipzig, in Germany.

Founded by the German Rose Society in 1898 and opened in 1903, it currently has around 80,000 rose bushes representing over 8,600 varieties. While it has many old cultivars, it focuses especially on early twentieth-century roses, with a vast range of ramblers, polyanthas, hybrid perpetuals and noisettes. When Sangerhausen became shut off behind the Iron Curtain in 1948, it was no longer easily accessible

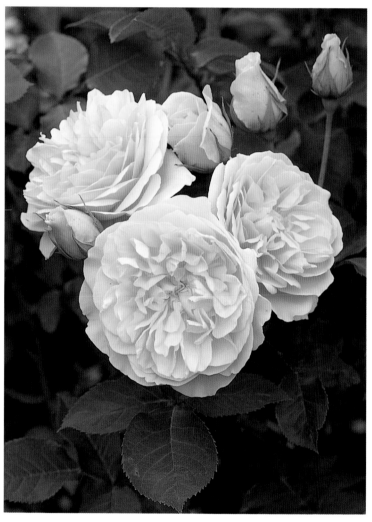

David Austin's 'Graham Thomas' (1983), celebrating the great rosarian whose collection is at Mottisfont, Hampshire.

The largest rose garden in Europe, at Sangerhausen, Germany. The coal heap in the distance is a reminder of its East German history.

by Western European rose enthusiasts. Despite becoming surrounded by the coal mines of East Germany, its dedicated staff managed to maintain its collection. Since unification in 1989, it has continued to grow. A West German version was opened in 1969 at the Westfalen-park in Dortmund, using themed gardens to show off over 50,000 roses. The German Rose Society also encourages towns and villages to feature roses in their public and front garden plantings, entitling them to use the term 'Rosenstadt' (Rose Town) or 'Rosendorf' (Rose Village) before their name.

The American city with the strongest claim to the title 'City of Roses' is Portland, Oregon. In 1905 it held its one and only world exposition and the organizers planted the sidewalks with 10,000 bushes of Pernet-Ducher's hybrid tea 'Mme Caroline Testout' (1892). The effect was dazzling, with this reliable rose producing its silvery-pink blooms across the summer. A rose festival followed in 1907, together with the establishment of a Rose Test Garden where new roses could be, and still are, sent for trial. Portland, with two other rose gardens, may not have the climate of the many Californian rose gardens, such as the outstanding Huntington Botanical Gardens in

San Marino, Los Angeles, but it remains a favourite. On the East Coast, the Elizabeth Park Rose Garden in Hartford, Connecticut, is the oldest municipal rose garden in the United States, opening a year before Portland's. It was also the first test ground for the American Rose Society (1912) and maintains over 15,000 rose bushes in eight hundred varieties.

The rose has been the most popular flower in the United States since its foundation. Although there are few native North American species, it was where the oldest rose fossils were found, and in 1986 the Senate passed a resolution adopting the rose as the country's official flower symbol. President Ronald Reagan, speaking at the formal proclamation, reminded the nation that their first president, George Washington, grew roses, adding in uncharacteristically flowery language, 'More often than any other flower, we hold the rose dear as the symbol of life and love and devotion, of beauty and eternity. For the love of man and woman, for the love of mankind and God, for the love of country, Americans who would speak the language of the heart do so with a rose.'[13] The nation was following in the footsteps of the State of New York, which chose the rose as its state symbol in 1955. Other states chose species roses specific to their area, such as Iowa in 1897 with the wild prairie rose, now called *R. arkansana*, and the Oklahoma rose adopted by its eponymous state in 2004. The State of Georgia chose the Cherokee rose (*R. laevigata*) as its symbol in 1916, although recent research shows that the Cherokee rose originates from China. Despite the popularity of the song 'The Yellow Rose of Texas', that state's official flower is the lupin, or bluebonnet, as it is known locally.

Many American presidents have been rose lovers. As Ronald Reagan mentioned, this goes back to George Washington, who had so many roses planted at his home, Mount Vernon in Virginia, that it took over a week to harvest the petals from which his wife made rosewater. As we heard earlier, at the start of the nineteenth century,

Pernet-Ducher's 'Mme Caroline Testout' (1892), 10,000 of which were planted in Portland, Oregon, in 1905, giving rise to its sobriquet 'City of Roses'.

The Rose Garden at the White House has always been a valued private and useful public space for presidential families.

Thomas Jefferson had roses in his gardens at Monticello, also in Virginia. Today's rose garden there, the Léonie Bell Noisette Rose Garden, is still based on the octagon shape he favoured in his designs and displays many varieties of noisette, tea noisette and China roses.

Roses have also been grown at the White House since the mid-nineteenth century. President Rutherford B. Hayes, a teetotaller, had a rose conservatory added in 1877, perhaps hoping to intoxicate his guests with their scent. While we do not know which roses were grown, they were presumably tender varieties that had to be grown under glass to protect them from the occasional harsh winter in Washington, DC, and they were to be used in arrangements in the White House. In 1893, under President Grover Cleveland, several thousand roses, including the pale-pink tea rose 'Catherine Mermet' (1869), were forced for winter table decorations. In 1900, under President William McKinley, the pink climber 'Empress of China' (1896) was another White House favourite, named for the first American clipper to reach that country in 1783.

The arrival of First Lady Edith Roosevelt in 1902 changed all this. To the despair of head gardener Henry Pfister, the greenhouses

and conservatories, including the rose house, were swept away as part of the 'West Wing' development, and a formal outdoor garden was created in their place. In 1913 Ellen Wilson, during her brief time as First Lady (she died in 1914), commissioned Beatrix Jones, niece of Edith Wharton and friend of Gertrude Jekyll, to redesign the garden. Influenced by Jekyll's style, Jones completely replanted the East Garden. She continued to design gardens after her marriage to historian Max Farrand, becoming one of North America's most influential designers and creating the famous rose garden at Dumbarton Oaks in Georgetown, DC.

When the Kennedys arrived in 1960, the gardens were looking increasingly dated, despite Harry and 'Bess' Truman's introduction of floribundas during their White House tenure (1945–53). One of the Kennedys' first projects was to have the Rose Garden redesigned in an eighteenth-century style that Jefferson would have recognized, with a formal grass lawn and evergreen box edging. The project was overseen by their close friend Rachel 'Bunny' Mellon, together with garden designer Perry Wheeler. In 1961 Mellon gave President Kennedy an edition of Thomas Jefferson's *Garden Book* and he relished consulting Jefferson's planting notes. Despite the Rose Garden's name, with Mellon's design, roses no longer dominated. Nevertheless, each incumbent family introduced a few of their favourites. For many years, 'Queen Elizabeth' was a stalwart, with 'Pat Nixon', 'Nancy Reagan' and 'Ronald Reagan' coming and going as one might expect as the White House changed hands.

The new Rose Garden became and remains a favourite spot for outdoor entertaining and the occasional presidential family wedding. It is big enough to host a thousand guests but secluded enough for the president to sit and have intimate conversations with other world leaders. It has even entered the political lexicon, with the 'Rose Garden Strategy' indicating the choice by a president to remain at the White House during a re-election campaign. As 'Bunny' Mellon commented, the rose is 'the one flower that unites all the occupants through the history of the White House'.[14]

eight
The Literary Rose
❧

In 1861 the painter and poet Dante Gabriel Rossetti and the poet Algernon Swinburne were strolling past Bernard Quaritch's bookshop in Grafton Street in London's Mayfair when they saw a stack of discounted copies of an illustrated poetry book: a translation of poems by the great Persian mathematician, astronomer and poet Omar Khayyám (1048–1131). Edward FitzGerald, the translator, had also commissioned a line drawing by Edward J. Sullivan for each of the 75 four-line verses, paid for the books to be printed, and persuaded Quaritch to take some copies for his shop – where they had languished unsold for two years. To get rid of them, Quaritch cut the price to one penny and put them on a table outside his shop. Rossetti and Swinburne each bought a copy. They were so enthralled by the verbal and visual imagery that they told all their friends, who quickly spread the word. FitzGerald's apparently rather free translation, under the title *The Rubáiyát of Omar Khayyám,* finally took off and has never been out of print with various illustrations, the best-known being by Edmund Dulac.

Given the importance of the rose in Persian culture, it is no surprise to find roses mentioned many times in *The Rubáiyát.* One of the most evocative quatrains is No. 13: 'Look to the Rose that blows about – "Lo, / Laughing," she says, "into the World I blow: / At once the silken tassel of my Purse / Tear, and its Treasure on the Garden throw."' The poem inspired both writers and artists such as the illustrator William Simpson, who visited Khayyám's grave in Nishapur

Edmund Dulac, illustration to the quatrain 'Look to the Blowing Rose About Us',
The Rubáiyát of Omar Khayyám (1909).

in northern Persia. On it he found a small, pink rose growing. He
brought back some seeds from the rose and sent them to the Royal
Botanic Gardens at Kew. The best of the resulting seedlings, a
summer-flowering damask, was planted by enthusiastic members of
the Omar Khayyám Club on FitzGerald's grave in Boulge, Suffolk,
on 7 October 1893.

The rose has always been part of the literary canon, from the Old Testament to the ancient Greeks and Romans, the Chinese Tang and Song dynasties, Shakespeare, the English Romantic poets and beyond. It has, at different times, symbolized many things, from courtly love to lust, mortality and the fragility of life, and God's love. The rose is rarely without its thorns, giving yet another literary metaphor for the price of such a litany of love. No other flower has inspired so many of the world's greatest writers. In the early thirteenth century Yang Meizi, empress of the Chinese Southern Song dynasty, composed quatrains on yellow roses:

> Snowy stamens dot the tender yellow [flowers];
> The rose is drenched with the morning dew that dampens
> my garment.
> As the west wind sweeps away the wild bees and butterflies,
> I alone, at the border of Heaven, keep company with the
> fragrant cassia tree.[1]

Persia was, for centuries, the centre of rose veneration and it featured widely in Persian literature. The tradition of books being called 'flower gardens' originates there. The rose is especially associated with the Persian poet and philosopher Sa'di (1194–1296). In the introduction to his most famous work, the 1258 *Gulistan* (The Rose Garden), he explains why:

> Of what use will be a dish of roses to thee?
> Take a leaf from my rose garden.
> A flower endures but five or six days
> But this rose garden is always delightful.

Similarly, poems by Hafez (1315–1390), still the most popular poet in Iran, overflow with roses.

From Spain to Japan, writers have long referred to collections of writings using horticultural terms such as 'gleanings', 'leaves' and

'Sa'di in a Rose Garden', an illustration from a 1645 edition
of the Persian poet Sa'di's *Gulistan* (Rose Garden).

The lover with a (rather large) rosebud in his hand from the *Roman de la rose*.

'verbal flowers'.[2] The metaphor of a book being a floral repository is a well-established Western literary tradition. The word 'anthology' comes from a Greek word meaning 'a gathering of flowers of verse'. The idea of the garden being a *locus amoenus* or 'idyllic, pleasant place' encouraged writers to draw in their readers with metaphors and stories. In particular, the metaphor of an enclosed garden or *hortus conclusus* goes back at least to the verse in the Old Testament's Song

of Solomon (4:12), 'A garden enclosed is my sister, my spouse, a garden locked, a fountain sealed.'

Medieval European literature was especially influenced by the *Roman de la rose*, a poem, initially of some 4,000 lines, written around 1230 by Guillaume de Lorris. Set in a walled garden, it depicts courtly love, with the rose representing both a woman and unobtainable love. Courtly love epitomized idealized chivalric behaviour. Based on Platonic ideas, it spoke of the young knight's adoration of a woman who remained unobtainable, usually because she was already married. Through carefully staged steps, he tries to win her, thus proving his worthiness in the face of her unavailability. Understanding, and perhaps even practising, courtly love was seen as an essential part of every young nobleman's education.

It has been assumed that de Lorris died before completing the *Roman de la rose*, as the original 4,000-line poem was left unfinished for over forty years until Jean de Meun added a monumental 17,000 extra lines in the 1270s. His complicated themes included debates between Reason, Genius and other personifications of philosophical ideas. The emphasis shifted from romantic idealism to a more overtly sexual message, with 'rosebud' now a physical, sensual symbol. There are about 130 extant manuscript copies. For three centuries the poem was Europe's most popular book, although it was not without its critics. For instance, in 1402 Christine de Pizan's *Dit de la rose* (The Debate on the *Roman de la rose*) objected to Jean de Meun's misogynistic portrayal of women.

Geoffrey Chaucer (*c.* 1343–1400) owned a copy of the *Roman* and translated large sections as the *Romaunt of the Rose*, 'romaunt' being Middle English for 'romance'. As in the original, the hero woos a young woman who is safely secreted in a walled garden, described as:

> So worthy is beloued to be,
> That well she ought, of prise and right,
> Be cleped Rose of every wight.

and with
eglantine."
Midsummer Night's
Dream, Act ii., Sc. 1

29. Oberon's words on where Titania sleeps, from Shakespeare's *A Midsummer Night's Dream*, as printed on a postcard from the early 1900s.

The *Roman* influenced Chaucer to portray his characters with a human and sometimes a sexual realism not seen in English writing before. *The Canterbury Tales* includes several borrowings from the *Romaunt*. For instance, the Wife of Bath speaks lines lifted directly from it and even the Prioress's table manners can be linked to the French text.

If the symbolism of the *Roman de la rose* is confusing and alien to the modern reader, then so is that of Dante Alighieri's (1265–1321) 'Mystic Rose'. Written in the early fourteenth century as the third part of his epic poem *The Divine Comedy*, 'The Mystic Rose' relates Dante's allegorical journey through hell, purgatory and finally paradise. His beloved muse, Beatrice, guides him through nine spheres towards God. Nearing the end of his journey, he sees a vision of an enormous single white rose with the company of saints standing on

the petals. With the Sun shining down, Beatrice takes her place on the rose, uniting human and divine love. The poem is loaded with horticultural metaphors – the saints are referred to as flowers, paradise is a garden and the scent of the white rose represents never-ending praise of God, who is, of course, 'the eternal Gardener'. Dante's mystic white rose came to represent heaven, confirming the rose's status as a religious symbol. Following Dante, Francesco Petrarch (1304–1374), who popularized the sonnet form, often used rose imagery in his love poems.

> This white rose born among sharp thorns,
> when shall we see its equal in this world,
> this glory of our age?

French poet Pierre de Ronsard's 'Ode a Cassandra – Mignonne, allons voir si la rose' (1545) is a famous seduction verse from the man called 'the prince of poets', who also wrote, 'The Rose is the bouquet of Cupid.'

Shakespeare, too, often wrote of roses. He was a country boy who, surely, loved plants and knew about growing them. In the words of Caroline Spurgeon in her pioneering 1935 analysis of his imagery,

> One occupation, one point of view, above all others, is naturally his, that of a gardener; watching, preserving, tending and caring for growing things, especially flowers and fruit. All through his plays he thinks most easily and readily of human life and action in terms of a gardener.[3]

There are over seventy references to roses in Shakespeare's plays and poems – more than any other plant. We've already heard about the York and Lancaster roses and how, thanks more to Shakespeare's imagination than the historical facts, these have become permanently associated with the fifteenth-century dynastic struggle we know as the Wars of the Roses.

Shakespeare's *Henry VI* and perhaps other early plays were first performed at the Rose Theatre, on London's Bankside. This was the first of the famous South Bank playhouses, built by Philip Henslowe in 1585 on the site of a tenement with two gardens known as the Little Rose by Rose Alley, but soon overshadowed in popularity by the Globe and closed in 1605. In 1989 well-preserved remains of the Rose Theatre were discovered and a campaign launched to protect them. Laurence Olivier, famous as a Shakespearean actor, gave his last public speech in support of the Rose Theatre project. Its foundations have been preserved but it looks unlikely that it will ever be rebuilt.

Shakespeare's most famous 'rose' quotation is Juliet's balcony speech in *Romeo and Juliet* (Act II, Sc. 2). It surely gives a shiver of familiarity to every gardener who hears it: 'What's in a name? That which we call a rose / By any other name would smell as sweet.' But Shakespeare knew his roses and mentions several by name. Brutus talks of the 'White and damask in / Their nicely-gawded cheeks' in *Coriolanus* (Act II, Sc. 1), and Autolycus in *The Winter's Tale* (Act IV, Sc. 3) speaks of 'gloves as sweet as damask roses'. In *A Midsummer Night's Dream,* both Oberon and Titania refer to Musk Roses. Oberon conjures up a scented dell, 'Quite o'er-canopied with luscious woodbine, / With sweet musk-roses and with eglantine' (Act II, Sc. 1), while the spellbound Titania, besotted with Bottom the weaver, despite his ass's head, chants, 'Stick musk-roses in thy sleek, smooth head' (Act IV, Sc. 1).

Shakespeare is also never shy of pointing out the sharper side of roses, as in Sonnet XXXV: 'Roses have thorns and silver fountains mud, / And loathsome canker lives in sweetest bud.' Othello, pondering whether or not to kill Desdemona, notes the fragility of life (Act VI, Sc. 2): 'When I have pluck'd the rose, / I cannot give it vital growth again.' Spurgeon argues that Shakespeare's hands-on experience as a practical gardener at his home in Stratford-upon-Avon sets him apart from the Oxbridge-educated poets and playwrights of the time. As Biron says in *Love's Labour's Lost* (Act I, Sc. 1):

At Christmas I no more desire a rose
Than wish a snow in May's new-fangled shows,
But like of each thing that in season grows.

Edmund Spenser (*c.* 1553–1599) crowns 'faire Elisa, Queen of Shepherdes all' with 'damaske Roses and Daffadillies', an unlikely combination, and other writers were also less skilled gardeners. Beaumont and Fletcher show 'real ignorance', in Spurgeon's view, by giving a character the lines 'In whose thou wert set / As roses are in rank weeds' in *The Tragedy of Valentinian* (*c.* 1647). Similarly, Andrew Marvell (1621–1678) wrote, in a stanza from 'The Nymph Complaining for the Death of her Fawn', 'I have a garden of my own, / but so with roses overgrown / And lilies, that you would it guess / To be a little wilderness . . .'

Although rose symbolism with any Catholic connections had been stamped out during the Reformation, in the mid-seventeenth century roses were rehabilitated by the puritan John Milton (1608–1674) in his epic poem *Paradise Lost*. Milton describes the hosts of heaven as 'Impurpled with celestial roses' and roses as among the 'Flowers worthy of Paradise'. Adam and Eve even sleep on a bed of roses and Adam tasks Eve with tending them. This parallels Shakespeare's frequent linking of roses and youth, and also relates the poem to the lost golden age of its title. The key rose image in *Paradise Lost* is the moment when Satan spots Eve 'veiled in a cloud of fragrance, where she stood, / Half spied, so thick the roses blushing round / About her glowed'. Again, roses are part of the couple's downfall when 'the garland wreathed for Eve / Down drops, and all the faded roses shed'.

We heard at the end of Chapter One how Robert Herrick borrowed from the Roman poet Ausonius for his verse 'To the Virgins, to Make Much of Time', reminding us to gather our rosebuds while we may. But roses are few and far between in the poetry of the Restoration and early eighteenth century, for example in the work of Swift, Dryden and Pope. In Pope's mock epic *The Rape of the Lock*, they

appear only as a sarcastic recollection of the 'rose-cheeked' youths so frequently found in Shakespeare:

There Affectation, with a sickly Mien
Shows in her Cheek the Roses of Eighteen,
Practis'd to Lisp, and hang the Head aside,
Faints into Airs, and languishes with Pride. (IV, 31–5)

The reason for this hiatus during the seventeenth and eighteenth centuries may have been a continuing concern about the rose's association with Catholicism. From the arrival of the Stuarts, the Tudor rose disappeared as a political symbol. Meanwhile, the scientific analysis of plants and flowers by Carl Linnaeus and others gradually removed roses from their religious and mystical associations, as what they represented became more straightforwardly emotional.

Among those again celebrating the romanticism of the rose in the late eighteenth century was the Scottish bard Robert Burns (1759–1796), most frequently in his ballad 'A Red, Red Rose' published in 1794. Many, and not only Scots, find it hard not to break into song (not always wisely) when they hear the opening lines – 'Oh my Luve is like a red, red rose / That's newly sprung in June.' Two other well-known references to roses both began as poems but are also now best known as nineteenth-century songs. Irish poet Thomas Moore's 'The Last Rose of Summer' (1805) was inspired by R. 'Old Blush'. It, in turn, inspired composers from Beethoven to Britten:

Tis the last rose of summer,
Left blooming alone;
All her lovely companions
Are faded and gone;
No flower of her kindred,
No rosebud is nigh,
To reflect back her blushes,
Or give sigh for sigh.

A postcard from the early 1900s of the musical adaptation of
Tennyson's poem 'Maud', 1855.

'Come into the Garden, Maud', which English readers of this book over a certain age can probably hum, started as an 1855 poem by Alfred, Lord Tennyson (1809–1892). Set to appropriately sentimental music by Michael Balfe two years later, it became an immensely popular parlour song, with piano accompaniment. References to roses in the poem, with Maud as 'Queen rose of the rosebud garden of

William Blake, illustration to the poem 'The Sick Rose', from *Songs of Experience* (1794).

girls', and the mounting tension as she finally arrives in the garden, evoke, at least to modern ears, suggestive echoes of the 'enclosed garden' of women's sexuality. William Blake (1757–1827), in contrast, conjures up a far less appealing image, both in words and in the illustration which he engraved to accompany it:

> O Rose thou art sick.
> The invisible worm,
> That flies in the night
> In the howling storm:
> Has found out thy bed
> Of crimson joy:
> And his dark secret love
> Does thy life destroy.

Blake preferred to find 'a heaven in a wild flower'.[4]

Like Blake, most of the early nineteenth-century Romantic poets resisted eulogizing cultivated garden roses because they drew their inspiration from nature. Not only did the prolific William Wordsworth (1770–1850) hardly mention roses, in 'To the Daisy' he contrasted them unfavourably with daisies ('the Poet's darling' and 'nature's favourite'): 'Proud be the rose, with rain and dews her head impearling'. In 1806, living at Home Farm, Coleorton Hall, in Leicestershire, and helping the owner, Sir George Beaumont, create a winter garden, he even wrote lines celebrating the cutting down of a rose to create space for a cedar tree to be planted.

But the lure of the rose was too strong to be ignored and one could fill a book with rose references by other Romantic poets, notably John Keats (1795–1821). In 'The Eve of St Agnes' (1820), he wrote: 'Sudden a thought came like a full-blown rose / Flushing his brow, and in his pained heart / Made purple riot.' The rose's ephemeral nature crops up in his 'La Belle Dame Sans Merci' (1819): 'And on thy cheeks a fading rose / Fast withereth too.' Similarly, his 'Ode to Melancholy' (1820) hints that 'when the melancholy fit shall fall … Then glut thy

Sir John Teniel, illustration showing the 'gardener cards' painting the white roses red in Lewis Carroll's *Alice's Adventures in Wonderland* (1865).

sorrow on a morning rose' and associates roses with the 'rainbow of the salt sand-wave . . . the wealth of globed peonies' and his mistress with 'her peerless eyes'. Once again, the fragile nature of roses, Keats suggests, 'dwell(s) with Beauty – Beauty that must die'. Roses represent both vitality and ephemerality.

Christina Rossetti (1830–1894) mourns 'among my scattered roses' in 'An October Garden', while Algernon Swinburne (1837–1900) finds 'The rose-thorn's prickle dangerous to touch' in 'The

Two Dreams (after Boccaccio)'. Percy Bysshe Shelley (1792–1822), too, links roses with mortality in 'Music, When Soft Voices Die':

> Rose leaves, when the rose is dead,
> Are heaped for the belovèd's bed;
> And so thy thoughts, when thou art gone,
> Love itself shall slumber on.

In 'Remembrance' Shelley catalogues flowers, but this time, it is the simple viola which wins:

> Lilies for a bridal bed –
> Roses for a matron's head –
> Violets for a maiden dead –
> Pansies let MY flowers be.

Throughout the nineteenth century, the rose makes appearances in all forms of literature, including stories for children. Many of the fairy tales of Hans Christian Andersen (1805–1875) feature roses, said to be his favourite flower. Tiny 'Thumbelina' (1835) is given a rose petal as a coverlet. In 'The Swineherd' (1841), it is the single flower that blooms only every five years that the young man sends to the Emperor's daughter. 'The Phoenix Bird' (1850) is born on the first rose bush in the Garden of Paradise.

Another enduring rose image from children's literature comes from Lewis Carroll's *Alice's Adventures in Wonderland* (1865). When Alice asks the three gardeners why they are painting roses, one replies, 'why, Miss, the fact is, this here ought to have been a red rose tree, and we put in a white one by mistake; and if the Queen was to find it out, we should all have our heads cut off.' They manage to avoid this fate but it is still a scene that can make children shriek in mock horror and anticipation.

The recurring romantic theme that tops and tails the nineteenth century is that Persian perennial, the nightingale and the rose, 'Gul

and Bulbul'. This was heightened by the travel writing of several European visitors to the country. The artist Robert Ker Porter described visiting a Persian palace garden:

> The eye and the smell are not the only senses regaled by the presence of the rose. The ear is enchanted by the wild and beautiful notes of multitudes of nightingales, whose warblings seem to increase in melody and softness with the unfolding of their favorite flowers. Here indeed the stranger is more

Louisa Stuart Costello, *The Rose Garden of Persia* (1887); just one of many Victorian texts by writers fascinated by the Orient.

Teisai Hokuba (1771–1844), *Roses and Bamboo with Nightingale*,
capturing the delicacy of the ancient fable.

powerfully reminded that he is in the genuine country of the
nightingale and the rose.[5]

Lord Byron's Eastern tale *The Bride of Abydos* (1813) reverses the trad-
itional roles, with the male lover representing the rose and the female,
the nightingale. Oscar Wilde brought the old Persian fable to a late
nineteenth-century audience in his short story collection *The Happy
Prince and other Tales* (1888). In 'The Nightingale and the Rose', the tale
is transposed to Oxford where a young student pines for a professor's
daughter. The familiar theme of the unsuccessful search for a red

rose, the nightingale piercing its heart to stain a white rose red, and the student's ultimate rejection by his inamorata, were a metaphor for what Wilde saw as the moral hypocrisy of Victorian society. Only the bird appreciates pure love and he gives his life for it. In his play *The Important of Being Earnest* (1895), Wilde named a particular variety of rose, 'Maréchal Niel', when Cecily offers Algernon a buttonhole. This was an extremely popular yellow noisette climber of 1864 whose name would have been well known to his audience, gardeners or no. Algernon, however, turns it down, asking for a pink one, 'because you are like a pink rose, Cecily'. He is rebuked for his forwardness.

It was W. B. Yeats who probably did most to turn the rose back from a romantic to a mystical symbol. Yeats was so fascinated by the Rosicrucians that in 1888 he joined the Order in London. He was not alone in having literary links to it. Scholars still debate the meaning of Goethe's 'The Mysteries' but there is little doubt that its line 'Who then wed roses to the cross?' refers to the Rosicrucians. Yeats believed that the rose was 'the western Flower of Life . . . and a symbol of Ireland'.[6] When he fell in love with Maud Gonne, her unattainability and his Rosicrucian beliefs drove him to make the rose a central theme in his poetry. As with so many before, the rose becomes a symbol of both the unavailable object of his earthly love, Maud, and a higher mystic state, the occult, together with his beloved Ireland.

The First World War destroyed any lingering echoes of medieval courtly love. The world of roses also changed. Between the wars, the romantic old roses almost disappeared from gardens as the hybrid teas and later floribundas took over. Some writers and poets clung to a disappearing imagery that many gardeners would not have recognized. Flowers, especially roses, are central to the character of Mrs Dalloway in Virginia Woolf's 1925 novel. It is 'roses – red and white roses' that her husband brings her, having come across London to tell her he loves her. When they meet, he is tongue-tied but the roses speak for him wordlessly.

From D. H. Lawrence to James Joyce, the rose was never far away. T. S. Eliot draws on imagery of the secret garden in 'Burnt Norton',

part of *Four Quartets* (1936). Flowing through this poem about a burnt-out house that Eliot had visited in 1934 are echoes of familiar themes such as the *locus amoenus* or 'idyllic, pleasant place'. There are many interpretations of this poem but always close to the surface is a familiar image: 'the door we never opened / Into the rose-garden', harking back once again to the *Roman de la rose* and its enclosed garden.

Given that this was a time when the ideas of Freud and Jung were being popularized, many twentieth-century literary references to roses are inevitably open to deeper psychological interpretations, as in Elizabeth Bowen's roses riddled with disease in her collection *Look at All Those Roses* (1941). However, sometimes a rose comes into a story for no more complicated reason than that the author likes it. Italian novelist Umberto Eco claimed that he chose the title of his bestselling book, *The Name of the Rose*, only because it was completely neutral.

Sometimes a writer clearly knows her roses. In 'The Beholder' (2016), a short story by Ali Smith, the narrator finds a rose growing out of her chest. (You need to read the story to understand the significance.) Despite the strangeness of this, once the rose comes into flower, she is delighted to identify it as David Austin's English Rose 'Young Lycidas' (2008), described in Austin's catalogue as 'magnificent, purple-magenta blooms of classic Old Rose beauty'. The origins of Smith's tale lie in the Scottish ballad 'Barbara Allen'. When the two lovers die, a red rose is planted on his grave and a briar rose on hers and the two intertwine to form the perfect lovers' knot. Once again, the rose becomes an enduring symbol of love.

There is a postscript to the story that began this chapter. The village of Boulge in Suffolk, where Edward FitzGerald is buried, is not far from my home, and I couldn't resist paying a pilgrimage to see where the rose of Omar Khayyám was honoured. It took me longer to find than I expected as the church lies outside the village on a private estate along unmade-up roads. The small rural churchyard is managed by the Suffolk Wildlife Trust and grasses and

The plaque commemorating the rose planted by the grave of Edward FitzGerald in Boulge, Suffolk, in memory of Omar Khayyám.

wildflowers are encouraged to grow waist-high, hiding many of the gravestones. But finally, in a corner shaded by tall spreading trees, I spotted the wire cage I knew enclosed the rose. Hanging from it was the commemorative plaque and, as I drew closer, I could see some twiggy growth inside. I had no great hopes of seeing the rose in bloom – it was an inhospitable spot shaded by the overhanging trees, not to mention that the rose had been planted 120 years ago. But as I approached, there was a flash of colour. Could this be the damask brought back from Khayyám's grave in Persia and propagated at Kew? I was agog to see the soft pink petals of this sweetly scented rose.

To my deep disappointment, the single bloom was yellow. I have no idea how it got there – maybe it was a sport or maybe some well-meaning local found that the old rose had died and offered to replace it. But with a yellow one? Perhaps he should have heeded Christina Rossetti's words:

When I am dead, my dearest,
Sing no sad songs for me;
Plant thou no roses at my head,
Nor shady cypress tree:
Be the green grass above me
With showers and dewdrops wet;
And if thou wilt, remember,
And if thou wilt, forget.

'

nine
'Only a Rose . . .'

<center>🌺</center>

'I Never Promised You a Rose Garden', 'The Last Rose of Summer', 'Roses are Red, My Love', 'Moonlight and Roses', 'Till Each Tear Becomes a Rose', 'Two Dozen Roses', 'There Is a Rose of Spanish Harlem': it may sound like a never-ending party game to see how many rose songs you can name (in the early 1950s, it was estimated there were 4,000) but the tradition goes back at least to the troubadours. In 1486 the birth of Henry VII's son, Arthur, was greeted with minstrels who sang 'Joyed may we be / Our prince to see, and roses three,' the three being, of course, the red rose of Lancaster, the white rose of York and the newly united Tudor rose combining the two colours which represented the dynasty that Arthur was never to inherit, and that went instead to his younger brother, Henry, on Arthur's early death in 1502.[1] There is a false legend that Henry VIII wrote the Tudor ballad 'Greensleeves' for Anne Boleyn, but his love of music is in no doubt. In around 1515 Richard Sampson, Bishop of Chichester, wrote a perpetual canon, better known to us today as a round, for two bass and two countertenor voices celebrating the union of York and Lancaster. Imaginatively scripted literally in the round, the manuscript features a single red rose with bud in its centre.

With its eternal associations with love and romance, the rose has been a perpetual favourite theme for lyrics. Poems such as Thomas Moore's 'The Last Rose of Summer' have become immortalized in song. (We already 'heard' Burns's 'A Red, Red Rose' and Tennyson's 'Maud' in the last chapter.) 'Drink to me only with thine eyes', with

Sheet music for a
canon (a round)
in honour of Henry
VIII, from *Motets*,
c. 1516.

its 'rosy wreath', is based on Ben Jonson's poem 'Song to Celia' (1616).
The rarely sung second verse suggests that the wreath, if returned,
would smell not of roses but of his beloved.

The rose was also a big part of the lexicon of nineteenth-century
Romantic classical music. In 1815 Franz Schubert took Goethe's
poem about a boy's unrequited love for a prickly rose, 'Heidenröslein'
(Rose on the Heath, 1799), to create one of his most famous
songs. Vincenzo Bellini followed with 'Vanne, o rosa fortunata' (Go,
Fortunate Rose, 1829) starting the, to some regrettable, Neapolitan
tradition of sentimental love songs, often involving roses. One of
Johann Strauss the Younger's most popular waltzes was 'Rosen aus
dem Süden' (Roses from the South, 1880). It can be heard not only
in the soundtrack of the 1982 movie *Sophie's Choice* but in an episode

Sheet music cover for *The Rose of Stamboul*, an operetta by
Leo Fall and Siegmund Romberg, 1916.

of *Star Trek* – and on a PlayStation video game. Four years later,
Gabriel Fauré set to music a poem by his friend, Leconte de Lisle,
'Les roses d'Ispahan' (1884). Isfahan had been one of the earliest
cities in the rose-growing area of Persia. This poem, in turn, was
inspired by the Greek Anacreon's ode 'The Rose'. The Persia theme
was taken up again by Sir Arthur Sullivan in his late operetta *The Rose*

of Persia (1899), with a libretto by Basil Hood, rather than Sullivan's usual partner, W. S. Gilbert. It was briefly successful and transferred to America.

The early 1900s saw the birth of Tin Pan Alley. Many of the songs mentioned roses, although one of the most famous, 'The Yellow Rose of Texas', is not about roses but about Emily West, a young mixed-race girl caught up in the American Civil War. With the racially loaded words bowdlerized over the decades, it remains one of the most popular 'cowboy' songs.

Most of these melodies were long forgotten as movies took over from the music hall, but a few had staying power: 'Roses of Picardy' (1916), with words by Fred Weatherly and music by Haydn Wood, became an emotional anthem of the First World War. It was later recorded by Mario Lanza, who also made hearts throb with 'Only a Rose' in *The Vagabond King* (1925). Every generation will have its favourites and there are many duplicate titles to add to the confusion. Perry Como released a song called 'Rambling Rose' in 1948 but, for many, it is Nat King Cole's 1962 'Ramblin' Rose', with words and music by the Sherman Brothers, that stays in the memory. After the

Schubert's 'Heidenröslein' ('Rose on the Heath' or 'Little Rose of the Field', 1815), inspired by Goethe's poem.

153

1980s, sentimentality was out of fashion and you were as likely to find roses in the names of heavy metal or indie bands as in songs – Guns n' Roses and The Stone Roses come to mind.

Arthur Sullivan had not been alone in having floral fun with operettas. Leo Fall wrote *The Rose of Stamboul* with Siegmund Romberg (1916), and Edward German's *Merrie England* (1902) included references to Elizabeth I as 'The Rose of England'. But none has remained as popular as Richard Strauss's comic opera *Der Rosenkavalier* (Knight of the Rose, 1911), set in 1740s Vienna. There are four main characters: the Marschallin (a field marshal's wife), Baron Ochs (her country cousin), Sophie von Faninal (the daughter of a wealthy merchant) and the young Count Octavian Rofrano (the Marschallin's lover).

The Count is a breeches role, scored for a mezzo-soprano. As with Cherubino in Mozart's *The Marriage of Figaro*, this conveniently enables him/her to gender-swap when caught by the Baron, causing similar confusion. But there is no confusion over the role of 'rose-bearer'. The young Count is chosen to present a silver engagement rose of love to the young Sophie on behalf of her fiancé, the much older and rather coarse Baron. Traditionally dressed in white,

IL CAVALIERE DELLA ROSA — 3.
Puro Estratto di Carne Liebig

Riproduzione vietata. Spiegazione a tergo.

Octavian presents the rose to Sophie von Faninal in Richard Strauss's opera *Die Rosenkavalier*, first performed in 1911.

Octavian presents Sophie with the silver rose and, in a touching duet, they instantly fall in love. There follows a series of mistaken identities, police chases and general skullduggery before the inevitable happy ending. The Baron exits, pursued not by a bear but by debt collectors, while the Marschallin accepts that her relationship with Octavian is ultimately doomed because of her age and releases him to fulfil his love of Sophie.

While *Der Rosenkavalier* treated the rose as a traditional, almost innocent, symbol of love, four months after its first performance, the ballet *Le Spectre de la rose*, and its star, Vaslav Nijinsky, gave it a sexual ardour not seen since Roman times. Based on a poem by Théophile Gautier, with music by Carl Maria von Weber and choreographed by Mikhail Fokine, *Le Spectre* is only eight minutes long. It was first performed by Nijinsky and Tamara Karsavina at the Monte Carlo Theatre in April 1911, moving to the Châtelet Theatre in Paris that summer. The audiences did not flock to see Karsavina, despite her grace and beauty; they came to see Nijinsky spring through the open window, 'not covered in roses, not a rose but the very essence of a rose'.[2] The story tells of a young girl returning from her first ball, dressed in virginal white, clutching the rose given her by an admirer. As she falls into a dream, *Le Spectre*, the spirit of her rose, appears to bring her dreams to life. Nijinsky's leaps drew gasps from the audience, one of whom later wrote, 'Nijinsky's existence contradicts Newton and frightens the very spirits by his effortless proof that gravity does not exist.'[3] His final single leap across the stage and back out of the window has become part of ballet history. (Don't try this at home.)

It was also Léon Bakst's costume for Nijinsky that made the ballet so memorable. Karsavina's long dress was traditional and modest but the same could not be said of Nijinsky's figure-hugging fine silk costume. He had to be sewn into it for each performance, with part of his torso left bare. Only then could the petals be stitched in place as directed by Bakst, with bands of rose petals around his biceps and a close-fitting cap of rose petals to finish the ensemble. Bakst cut the

rose petals from fine silk, dyed in a confection of rose-pinks, purples, reds, rose-violet and lavender. Some were 'ragged, as from a dying flower; others were stiff and firm; while still others curled even from his thighs'.[4] His make-up was also rose-themed. 'His face was like that of a celestial insect, his eyebrows suggesting some beautiful beetle which one might expect to find closest to the heart of a rose, and his mouth was like rose petals.'[5]

Women went mad for Nijinsky's passionate portrayal and not just for his breathtaking leaps. His puzzled dresser soon found out why rose petals were disappearing from the costume every night with new ones having to be applied. One of his assistants, Vassily Zuikov, was clipping them off to sell to Nijinsky's Parisian admirers and had soon allegedly earned enough to build a house his colleagues called 'Château du Spectre de la Rose'.[6]

Nijinsky's performance in Le Spectre was the first to put the male dancer centre stage. Before this, audiences were more used to seeing ballets such as La Sylphide (1832), with its troupe of female ballerinas in diaphanous dresses trimmed with roses floating across the stage. The famous Italian/Swedish ballerina Marie Taglioni (1804–1884) is supposed to have been the first to dance en pointe. After this, few ballets were without set pieces for dancers on pointe. 'Rose Adagio', from Tchaikovsky's 1890 The Sleeping Beauty, became a pinnacle of the female dancer's physical achievement in late nineteenth-century classical ballet. Margot Fonteyn (1919–1991), as Aurora, made it her own. She dances with four rose-bearing suitors, but they are there very much in supporting roles as she slowly pirouettes, balancing on a single pointe, seemingly for ages while the audience holds its breath, before passing her hand to the next suitor. From the rose each suitor hands her as a love token to the sweet briar that the Prince struggles through to wake her from her slumbers, there is no doubt about the symbolic status of the rose in this most romantic of fairy tales.

In the wake of the thousands of musical references, there is one more recent and poignant connection to the rose. It is estimated

Vaslav Nijinsky in Léon Bakst's revealing and erotic costume
for Fokine's short ballet *Le Spectre de la Rose*, 1911.

A traditional rose-adorned Marie Taglioni in *La Sylphide*, 1832.

that on 6 September 1997 two billion people worldwide watched the funeral of Princess Diana in Westminster Abbey where Elton John sang one of his most famous songs, 'Candle in the Wind', with words revised by lyricist Bernie Taupin, to honour Diana's memory. The congregation and the billions of viewers said goodbye to her not just as the 'People's Princess' but now also as 'England's Rose'.

Margot Fonteyn as Aurora with Michael Soames in Tchaikovsky's ballet
The Sleeping Beauty, 1955.

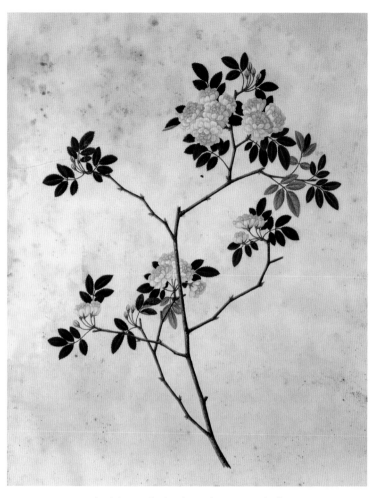

The delicacy of *R. lutea* by a Chinese artist (n.d.),
from the Reeves Collection, RHS London.

ten

The Rose in Art
and Decoration

I have always envied the artist's ability to put flowers on to canvas, or even paper. The desire to paint plants seems almost as old as the urge to grow them. Vases from Crete from around 1600 BC were decorated with rose images. The first illustrated herbal was Dioscorides' (*c.* AD 40–90) *De materia medica*, with accurate woodcuts of plants including a rose, copied for centuries by later botanists. Yet after the collapse of the Western Roman Empire in AD 476, there is little visual evidence of the rose in European art for many centuries.

On the other side of the world, realistic paintings of roses exist from the Chinese Xia dynasty, around 1500 BC. Other early images include the 'Old Blush' China rose in a picture by Huang Jian from AD 965, and most probably a double *R. rugosa* by Zhao Chang from around AD 1000. From the early ninth to the middle of the twelfth century, many Chinese artists drew on the imagery of the flower/bird story, providing invaluable rose images. The rose also became an important part of Persian and Ottoman visual culture and occurs in many Islamic decorative arts such as on tiles and carpets, but apparently with no clear religious significance. 'Rose' is also used to describe the elaborate round mosaics found in the domes of mosques throughout the Islamic world.

In the West, art gradually re-emerged during the early medieval period with flowers taking on strong religious symbolism. No other flower, not even the lily or the iris, appears as often as the rose in medieval European art and architecture, on stonework and, especially,

161

A rose window in the 14th-century Amiens Cathedral,
designed to dazzle worshippers.

on rose windows in churches. When rose windows first appeared in
the twelfth century, the rose was already associated with the Virgin
Mary. While some were built in Spain, Germany, Italy and England,
the greatest number are in France, mainly in and around Paris, includ-
ing spectacular examples at Chartres (1216–26), Notre-Dame de Paris
(c. 1220) and Reims (c. 1270), dating from the explosion of what later
came to be called the Gothic style of architecture.

When first seen, the spectacular use of coloured or 'stained' glass
within the 'petals', with the natural light pouring in from outside,

would have been dazzling for early worshippers. When Abbot Suger, its sponsor, first entered the finished pioneering Gothic abbey church of Saint-Denis in 1144, he felt himself transported into 'some strange region of the universe which neither exists entirely in the slime of the earth nor entirely in the purity of Heaven'.[1] But, eventually, with the arrival of the Renaissance, the rose window disappeared, with the rest of the Gothic style, 'budding in the twelfth century, flourishing in the thirteenth, and consumed in the flames of the fourteenth and fifteenth'.[2]

In contrast, by the fifteenth century roses frequently appear in paintings of the Madonna. One can look for clues as to which roses were grown, and how they were grown. The roses clambering up the trellis in Stefano da Zevio's *Madonna in the Rosary* (c. 1435) have been identified as white and pink double albas. They were steeped in

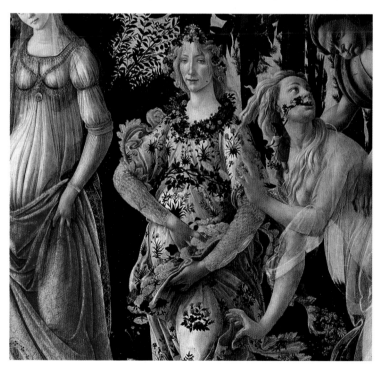

Roses are held in the left arm of Flora (Spring);
Sandro Botticelli, *Primavera*, c. 1481–2.

symbolism: for instance, the rose trellis represents the *hortus conclusus*, another reminder of the verse from the Song of Solomon (4:12): 'A garden enclosed is my sister, my spouse.' While the modern viewer might occasionally spot what they suppose to be a dark red single gallica (although it rarely makes an appearance at this time), educated contemporary viewers would have been able to decode the different coloured roses' links to the blood of Christ. Albas, with their references to purity and virginity, reappear regularly in paintings such as Bernardino Luini's *Madonna in the Rose Garden* (1510) and even in the unlikely battle setting of Paolo Uccello's *The Rout of San Romano* (1438–40).

The most famous rose painting of this period is Botticelli's *Birth of Venus* (1483–5). Rising from the water, the goddess appears wrapped in a girdle of R. *alba* shoots and leaves (possibly 'Maiden's Blush'). Occasionally a gallica will appear, such as the realistic one in the mouth of the figure clasping Flora in Botticelli's *Primavera* (1481–2). Dürer's *Feast of the Rose Garlands* was painted as an altarpiece in 1506, possibly to celebrate the recognition of the Confraternity of the Blessed Rosary in Venice that same year, the chubby cherubs armed with their pale-pink wreaths of roses.

For the lucky few, illuminated manuscripts allowed the rose to appear every time a prayer book was opened. In *The Isabella Breviary* (1490–97), a psalter for Queen Isabella I of Castile, there is a portrait of a woman in white praying in her garden, surrounded by red roses. The text and image are bordered with delicate white roses, some in bud, some in full flower, with butterflies and caterpillars climbing on their stems. Similarly, a Book of Hours of 1500–1515 has red roses with more bees and butterflies on its opening page. Many of the Tudor royalty, in particular the women, owned these precious books and the rose was one of the most prevalent of images to appear in them.

By the mid-sixteenth century a division had appeared between religious and botanical depictions of flowers, drawn for herbals to demonstrate the medicinal use of plants. These were predominantly

Nicholas Hilliard,
Young Man Among Roses,
c. 1585–95, miniature.

woodcuts, which enabled much cheaper and more reliable reproduction than manuscript illumination. One of the best known is Leonhart Fuchs's 1543 *New Kreüterbuch* (New Herbal). While the text was based on the much-copied work by Dioscorides from the first century AD, Fuchs's illustrations set the standard for later botanical works such as Gerard's 1597 *Herball*. Woodcuts were, in turn, eclipsed by the growing skill of etchers and metal engravers.

Given the symbolism of the red and white Tudor rose, most portraits of Henry VIII (1491–1547) and his daughter Elizabeth I include a rose, either held or, more often, as part of the embroidery on their dress. Elizabeth loved elaborate outfits. In 1578 she was reported as wearing 'a Gowne of clothe of golde with roses and honysuckles'.[3] For Elizabeth roses were more than her royal family

Jan Davidsz. de Heem, *Still-life with Flowers in a Glass Vase*, c. 1655.

emblem; the eglantine in particular symbolized the 'honour of virgins', Elizabeth herself being, of course, the Virgin Queen. In Nicholas Hilliard and Rowland Lockey's portrait of her (*c.* 1599) at Hardwick Hall in Derbyshire, she is surrounded by rose jewellery, roses embroidered on to a nearby chair, a fresh rose pinned to her ruff collar, and roses among many other flora and fauna embroidered or possibly painted on to her underskirt and bodice. Skilled embroiderers, such as her friend Bess of Hardwick, may even have used Gerard's *Herball*, published just two years before this portrait was painted, as a source for patterns.

Perhaps the most evocative portrait of the period is Hilliard's enigmatic miniature *Young Man Among Roses* (*c.* 1585–95), where the youth stands almost enveloped in the stems of a small, prickly white rose. Is the white rose that almost encases the youth *R. arvensis*, as some rosarians have argued? Or is it, despite its colouring, *R. rubiginosa* the eglantine, as thought by many art historians, because of its symbolism? Given Queen Elizabeth's passion for the sweet briar, more could be read into this exquisite miniature if it is the latter, transforming the painting into a message of royal devotion or even love.

The line of division in flowers in oil painting is drawn as much by religion as by country. By 1600 Protestant Holland was an economic powerhouse with a merchant class eager to display its wealth. While roses were never in the same league as the 1630s 'tulipomania', they featured strongly in floral painting, at which the Dutch excelled. Starting with Jan Brueghel (1568–1625), Dutch and Flemish artists astounded the world with the realism of their paintings. In particular, Jan van Huysum's (1682–1749) flower paintings looked 'so real that you feel as if you could pick them off the canvas'.[4]

Art historians have established that these vast, overflowing bouquets of flowers were imaginary with individual studies of flowers in blooms being painted and used for reference, most likely painted in watercolour for speed and accuracy. Sadly, these watercolours were usually discarded and few remain. There were also many

vanitas paintings, depicting the shortness and frailty of life – roses with falling petals, holes made by insects and the insects themselves. Jan Davidsz. de Heem (1606–1684) was a particular master at this macabre genre.

Dutch and Flemish artists regularly visited London. Seeing their work must have influenced the English botanical artist Alexander Marshall, whose dropped petals of the Austrian copper rose (*R. foetida* 'Bicolor') show the fragility of the rose in his late seventeenth-century *Florilegium*.

There is exquisite detail in many of these flower paintings and there have been regular attempts to identify which roses they portray. Graham Stuart Thomas concluded that the large white rose seen in many paintings by van Huysum and others must be *R. alba* 'Maxima'. Thomas has established that *R. centifolia*, the cabbage rose, was the most popular variety among the later flower painters of the Low Countries, together with damasks and red gallicas. The Austrian copper was popular with Daniel Seghers (1590–1661), famous for his flower garland paintings, and in a work by Rachel Ruysch (1664–1750) now in the Rijksmuseum, Amsterdam. Seghers was unusual in only painting flowers but Ruysch was even more unusual in managing a long and successful career as a female artist while married to Juriaen Pool, a portrait painter, and bringing up ten children.

By the eighteenth century, the rose had lost most of its heraldic significance and painters had largely moved away from religious topics. Roses now appeared most often as a symbol of femininity and, sometimes, sensuality. Jean-Honoré Fragonard (1732–1806) painted a series of rosy panels for Louis XV's mistress, Madame du Barry, while François Boucher (1703–1770) often included roses to please his patron, Louis XV's *chief* mistress, Madame de Pompadour.

In 1730 the first illustrated plant list, *Catalogus plantarum*, was produced by the Society of Gardeners, founded in London six years earlier. It had engravings by Jan van Huysum's younger brother, Jacob, who had settled in England in 1721. Jacob's painting style was similar to his brother's but his lifestyle was more dissolute – perhaps

Alexander Marshal, *Flowers in a Delft Jar*, 1663.

the reason he left Holland. Nevertheless, he contributed accurate and charming illustrations of several popular roses of the time, including what were known at the time as 'Austrian Rose' (*R. gallica pumila*), 'Red Provence Rose' (*R. centifolia*) and 'Double Yellow Rose' (*R. hemisphaerica*).

Shortly after this, Georg Dionysius Ehret (1708–1770), another talented young botanical artist, arrived in London from Heidelberg. His best-known work is of new 'exoticks' brought back to England by plant hunters such as Joseph Banks, and for collectors, in particular Margaret Cavendish Bentinck, Duchess of Portland (1715–1785), after whom the Portland rose group is supposedly named. Ehret set a new standard for the illustration of roses, surpassed only by Pierre-Joseph Redouté.

Redouté was born in the Belgian Ardennes and became a pupil of Gerard van Spaendonck, a Dutchman appointed Professeur de peinture de fleurs at the Jardin des Plantes in Paris in 1780. Both van Spaendonck and Redouté himself were strongly influenced by Jan

R. damascena (York and Lancaster Rose), from Mary Lawrance's *A Collection of Roses from Nature* (1799), one of the rarest rose books.

van Huysum, producing sumptuous floral displays with meticulous botanical detail. Redouté's most famous work, *Les Roses*, was published in three volumes between 1817 and 1824. As we heard earlier, he probably wisely chose to distance himself from Empress Joséphine, his former patron, although he did mention that his illustration for *R. berberifolia* had been painted 'several years ago, of a very vigorous plant which was cultivated in the gardens of Malmaison'.[5] The roses were painted in many different gardens and were chosen to depict particular collections, aiming to include all varieties available in France at the time.

In addition to the paintings, Redouté also added a generous bibliography listing previous works by others, including the work of English artist Mary Lawrance, whose *A Collection of Roses from Nature* (1796–9) is now one of the rarest rose books in the world, and Henry Charles Andrews's *Roses; or, A Monograph of the Genus Rosa* (1805). Andrews married the daughter of John Kennedy, Empress Joséphine's British rose supplier, so he would have had ample access to plant

material. Although Redouté continued to have a successful career until his death in 1840, none of his later works surpassed *Les Roses* and you will find his illustrations throughout this book.

The eighteenth century was also the peak time for silk weaving. Anna Marie Garthwaite (1688–1753), the Spitalfields silk designer, produced sumptuous and realistic fabrics for fashionable court dresses, including for Martha Dandridge, later the first First Lady after marrying George Washington in 1759. Men's waistcoats were also elaborately embroidered with floral designs. Meanwhile, in Italy, *rose mezzaro* (from the Arabic *mi-zar* or veil) was a well-known Indian-style printed cloth shawl worn by aristocratic women, featuring the rose on a tree of life motif and around the border.

Roses were also popular motifs for embroidery. One of the most skilled amateurs in this field was Mary Delany. Best known for her exquisitely detailed paper flower collages, now in the British Museum, she was also an astoundingly talented needlewoman. In 1759 she described in a letter to her sister how she was embroidering seat covers in chenille. 'My pattern [is] a border of *oak-branches, and all sorts of roses (except yellow)*, which I work without any pattern, just as they come into my head.'[6] Delany was very unusual in being able to work without templates, which most women used to improve both their embroidery and their painting skills. Botanical painting was considered an important female accomplishment in the eighteenth and nineteenth centuries, and young girls would have been familiar with 'step-by-step' books by skilled botanical artists, such as James Sowerby's *An Easy Introduction to Drawing Flowers According to Nature* (1789).

While genteel young ladies were learning how to paint roses from Sowerby's books, a new group of artists was making its name with a more romantic, relaxed style of painting. Henri Fantin-Latour (1836–1904) is best known for his depictions of luscious tea roses, 'his colours glow[ing] as if the light were coming through the petals'.[7] Many years after his death, he was commemorated by a cupped pink rose, *R.* 'Fantin-Latour'. A chance seedling found in the 1930s by Edward Bunyard and introduced by Graham Stuart Thomas's

nursery, Hilling's, in 1945, it has the look of a centifolia but is classed as a modern shrub rose.

In Britain, Victorian flower painting ranged from the twee to the dramatic, exemplified by the murals by Henry A. Payne commissioned for the East Corridor of the Houses of Parliament, such as *Plucking the Red and White Roses in the Old Temple Gardens* (1910). Similarly, Sir Lawrence Alma-Tadema showered his subjects with thousands of rose petals in *The Roses of Heliogabalus* (1888) and with bouquets of pink and white roses in *Summer Offering* (1911). His scenes of Roman everyday life gave him the reputation of being 'the painter who inspired Hollywood'.

For me, this was confirmed by an exhibition of his works in London in 2017 where his compositions were compared to stills from films including Cecil B. DeMille's *The Ten Commandments* (1956) and Ridley Scott's *Gladiator* (2000). But in 1911, a year before Alma-Tadema died, French filmmaker Louis Feuillade said he was inspired by *The Roses of Heliogabalus* for his short film *L'Orgie romaine* (1911),

Henri Fantin-Latour, *Fleurs roses (Rosario)*, 1864.

Henry Payne, *Plucking the Red and White Roses in the Old Temple Gardens*, fresco perpetuating Shakespeare's version of the Wars of the Roses, hangs in the Palace of Westminster (1910).

though without the palette of pinks in those days of black-and-white movies. The rose appeared in more than a third of Alma-Tadema's classical paintings. I was lucky to see *The Roses of Heliogabalus* in London before it returned to its permanent home at the Colección Pérez Simón in Mexico. When he was working on the painting, Sir Lawrence had baskets of roses sent to him from the South of France every week for four months to ensure that he always captured their freshness. This is reflected in the accuracy of not just each rose petal but the stemmed rosebuds and whole roses that are sadly hard to pick out in the numerous reproductions of this painting.

Alma-Tadema was a member of the Broadway Group of artists, who used to meet at the home of another member, Alfred Parsons (1847–1920). Parsons also painted roses but in a way that could not have been more different to what some might call Sir Lawrence's over-the-top confections. A leading watercolourist at the end of the nineteenth century, Parsons had been introduced to the wealthy plantswoman Ellen Willmott. Among her many horticultural extravagances, she commissioned him to paint the illustrations for her book *The Genus Rosa*. This was to cover all known species roses – no hybrids or cultivars. There were arguments at every stage and, although Parsons had finished forty plates by 1901, the work was not published until 1914, bad timing for such a costly publication. It is now a highly sought-after collector's item, but only a quarter of the 1,000 copies had been sold by 1920. Despite inheriting a fortune when she was thirty, Willmott's passion for publishing and gardening (she employed 104 gardeners at her home, Warley Place, in Essex) eventually ruined her.

Around the turn of the twentieth century, realistic depictions of roses fell out of fashion, replaced by stylized depictions in Art Nouveau and the work of stained-glass artists such as Emile Gallé

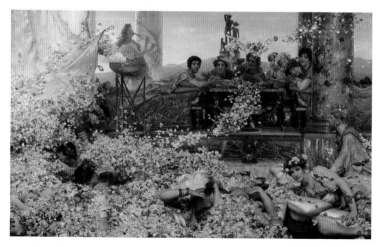

Regular basketfuls of rose petals from the South of France helped Sir Lawrence Alma-Tadema with *The Roses of Heliogabalus* (1888).

Georgia O'Keeffe, *Rose*, 1957.

in France and Louis Comfort Tiffany in New York. As the years passed, perhaps because hybrid teas and floribundas grew in every suburban garden, roses also fell out of favour with professional artists, although surrealist René Magritte featured a large white rose in his typically enigmatic *Pandora's Box* (1951) and Georgia O'Keeffe (1887–1986) took the painting of roses forward with her vast close-up blooms. This was a style carried on by Cy Twombly with *Roses* (2008) and Robert Mapplethorpe with his striking black-and-white photographic studies.

In the domestic setting, however, there was no stopping the rose. Since the eighteenth century, porcelain companies such as Bow, Chelsea, Derby, Lowestoft and Spode have found roses to be one of their most constantly popular motifs. Lowestoft's china was decorated by the appropriately named Thomas Rose. On the Continent Meissen and Nymphenburg also often featured roses. This tradition continues today. Among the rarest collectors' items is Susie Cooper's 1950s

'Moss Rose', one of Wedgwood's most popular classical designs (1945).

'Pink Rose' series. Wedgwood's popular 'Hathaway Rose' was launched in the 1970s following their 1945 'Moss Rose' series. Moss roses, first mentioned in a German horticultural book in 1699 but not widely available until the early nineteenth century, became a favourite for fabric and ceramic designers. My parents were delighted to have Wedgwood's classic 'Moss Rose' dinner service on their wedding list in the 1950s.

In the late nineteenth-century Arts and Crafts group, William Morris's 'Sweet Briar' fabric design was inspired by his fascination with the *Sleeping Beauty* story. His stated preference was for the simple, wild forms of roses such as the eglantine, dismissing some of the late nineteenth-century introductions as 'being as big as a moderate Savoy cabbage'.[8] Yet Morris did use cabbage roses in the Kelmscott Press's illustrated edition of Chaucer's *The Romaunt of the Rose* (1896).

Morris's fabrics are classics, popular to this day, but the wider vogue for floral fabrics peaked in the 1980s. This was a time when it seemed every living room had cabbage rose curtains and a Redouté rose print on the wall, while guests were served tea from a Royal Albert 'Moss Rose' bone china cup. But just as hybrid teas and floribundas have fallen from fashion, interior designers too have 'chucked out the chintz'.

ROSE THÉ:___Candeur. Innocence.

'October, Tea Rose, Candour, Innocence', an illustration from *The Language of Flowers*, in which each month represents a month associated with a flower and an emotion.

eleven

Posies, Petals and Perfume

❦

E very Valentine's Day, the world over, millions of red roses are given to loved ones. There is little doubt about the message they send – 'I love you' – it needs no translation. But supposing the bouquet also contained white roses, or a damask, or heaven forbid, a yellow rose? Would the recipient have any idea of the message? The language of flowers – using flowers to spell out a message – is lost to us now. But for much of the nineteenth century, young middle-class girls would have had a 'dictionary' to decode admirers' offerings. They would know that the white rose meant 'I am worthy of you', the damask, the compliment 'Priceless Beauty', and the dreaded yellow rose, an accusation of infidelity.[1]

Flowers have had meanings attached to them for centuries – no-one is surprised to hear Ophelia in *Hamlet* say, 'There's Rosemary – that's for remembrance'. Lady Mary Wortley Montagu wrote in 1763 that Turkish women gave a meaning in verse to every flower. The most detailed codification was written by Louise Cortambert using the pen name 'Charlotte de la Tour' and published as *Le Langage des fleurs* in 1819. Published in Britain in 1825 as *Floral Emblems* by Henry Phillips, it fell out of fashion only in the early twentieth century.

What has never fallen out of fashion is the desire to bring roses into the home, whether as a bunch of cut flowers or in a bottle of perfume on your dressing table. As Gertrude Jekyll says, 'There is scarcely any Rose that we can wish to have in our gardens that is not also delightful in the cut state.' But, as she adds, 'the only weak

point about cut Roses is that their life is short.'[2] This was not a problem for the rich. The Rothschilds, passionate tea rose collectors, produced 3,000 blooms from their own greenhouses for a family wedding in 1878. For less wealthy households, one reason for the popularity of hybrid teas in the late nineteenth century was their ability to last more than a couple of days in water, helping to make the rose the most popular cut flower in the world.

Constance Spry grew old roses for her flower arrangements, but she was able to cut them only for a few weeks a year. Today we can buy roses at any time. This is down to three factors: cheap air freight, efficient cold storage and 'post-harvest' treatments that can keep flowers in a sort of suspended animation for nearly two weeks. Just 48 hours before a rose reaches the European florist's shop or supermarket shelf, it will have been growing in Kenya, Uganda, Zambia or Israel. After 24 hours, it will be at one of the two major Dutch flower auctions, Aalsmeer or Rijnsburg. Sold within a few hours of arrival, it will be on its way again and within a day or so, will be gracing someone's home – these days, most likely as part of a 'mixed bouquet'.

Most roses for the cut flower market are grown hydroponically in vast greenhouses where everything can be controlled. Depending on the season, they are picked up to six times a day. The skill of knowing when and where to cut each bloom is crucial. Harvest it too soon and it will not open, too late and it will be sent to the 'seconds' market. A long stem is vital, but cut too low and there won't be enough eyes for further flower growth. The longer the stem, and the larger the bloom, the higher the price, as lovelorn swains on 13 February will be only too aware. The best Valentine's Day sellers include the deep-red 'Naomi' and 'Avalanche'. With its classic pointed bud opening to an inviting circle of curved petals, 'Avalanche' has a clutch of cousins in pastel colours, making the family one of the most reliable and popular choices throughout the year, along with the 'Akito' group. These are roses that you will rarely come across in rose catalogues since they have been bred specifically for the commercial cut flower market.

'Edith', one of David Austin's range of scented roses developed
for events and weddings.

The disadvantage of these always available, long-lasting roses is
their lack of scent. It's an almost automatic reaction to bury one's nose
in a bouquet of roses hoping it will smell delicious but, nowadays, it
rarely does. Do that at a society event or wedding, however, and you
may be pleasantly surprised. At the very top end of the market, breed-
ers are responding to the demand for scented cut roses, especially for
occasions where vase life is not an issue. David Austin in the UK and
Meilland in France, in particular, have selected suitable candidates
from their garden varieties and built parallel cut flower businesses.
David Austin's 'Beatrice', 'Constance' and 'Edith' are now grown
widely for the luxury event market. Colombia and Ecuador are emerg-
ing as major suppliers specializing in scented roses, mainly for the
U.S. market. The fertile savannah soil, cold nights and warm days
make for perfect growing conditions. A rose grown in Bogotá can be
in a wedding chapel in Baltimore or even London within 48 hours
of cutting.

The use of rose petals to scent the home did not disappear with
the Romans. In countries with an abundance of roses such as Persia, it
was common practice into the nineteenth century to welcome guests

Rose petals being sorted in Rajasthan for sale and export.

with lavish displays of petals. The orientalist Sir William Ouseley described visiting the home of a wealthy Persian in around 1810 with his brother, who was British ambassador.

> It might have been styled a Feast of Roses . . . roses decorated all the candlesticks . . . the surface of the *hawz*, or reservoir of water was . . . so entirely covered with rose-leaves, that the water was visible only when stirred by the air, and that the servants . . . were continually scattering fresh roses both upon the waters and the floor of the hall.[3]

Rose petals are still used in Arab homes, though are now mainly imported. Around the city of Ajmer in India's Rajasthan (the 'Desert State'), fragrant red roses are grown in the surrounding fields. Their petals are dried and then exported daily to the Middle East. The air in Ajmer is full of rose fragrance because the petals are dried on rooftops and wherever there are flat stretches of land.

'A rose without a fragrance', wrote Alphonse Karr, the nineteenth-century French writer and gardener, 'is half a rose at most.'[4] It is,

above all, their perfume that sets roses apart from other garden flowers. No other flower has such a variety of both colour and scent. Among modern roses, one of the most highly rated for scent among the growers I have spoken to is Harkness's pale apricot-pink 'Chandos Beauty' (2005). A personal favourite is Peter Beales's charming small white 'Macmillan Nurse' (1998). But scent is so personal and also impossible to describe. This is because the chemical composition of rose fragrances is beyond the comprehension of non-specialists. For instance, *R. damascena* 'Trigintipetala', grown in Bulgaria and Turkey to produce the attar of rose oil so highly prized by perfumers, has around 450 different chemical components. None of them is unique to the rose family, yet four stand out as defining the essence of the old rose fragrance: nerol, geraniol, phenylethyl alcohol and citronellol (not the same as citronella). While a trained 'nose' or perfumer can detect small differences between rose varieties, the amateur is more likely to categorize rose fragrances into, at best, five groups: old rose, fruity, musk (the fragrance coming from the stamens), myrrh and, perhaps most famously, tea. Sometimes they occur in combination.

Generations of hybridized roses have produced new scents as well as new flower shapes and habits. In the nineteenth century bourbons acquired their characteristic fruity fragrance from their mixture of China and European ancestry. Try burying your nose into an open flower of the deep-pink bourbon 'Mme Isaac Pereire' (1881). In contrast, musk roses can announce their presence before you even see them. The small pink flowered 'Paul's Himalayan Musk' (1916), with its clove-like scent, can waft its perfume across a garden on a warm still summer afternoon. Time of day is another factor. The delicate fragrance of 'Mme Alfred Carrière' sniffed in the morning can be quite different by the evening as temperature and humidity change. Her blooms develop a strong smell of grapefruit as they mature. And it isn't just the chemical make-up that alters from variety to variety but also the sensitivity of the noses that smell them. One person's 'fruity myrrh', redolent of anise, can be another's 'household cleaner'. There is also some evidence that gender plays a part in fragrance preferences.

Like so much of the rose story, extracting the essential oils has its roots in ancient Persia. From there it was exported around the Islamic world and to China. Rugs in the palace of Sultan al-Mutawakkil (d. 861) at Samarra in Iraq were regularly sprayed with rosewater. 'I am the king of all sultans,' he declared, 'as the rose is the king of all fragrances.'[5] As we heard earlier, the Al-Aqsa Mosque in Jerusalem and the Church of Hagia Sophia in Constantinople were also washed

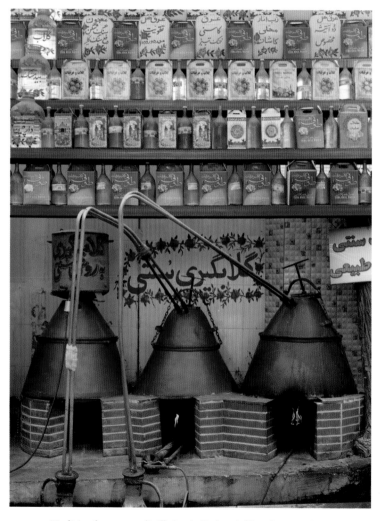

Traditional rosewater distillation in Kashan, Isfahan Province, Iran.

down with rosewater, such was the belief in its purifying power. Mecca, the most sacred place in the Muslim word, is still annually washed with rosewater from Ghamsar in the Iranian district of Kashan, the heart of damask rose growing, where an annual festival attracts tens of thousands of people to see the ritual of rosewater production.

The health benefits of the rose have been known since at least the time of Pliny. He listed 32 different disorders that it was thought could be treated with roses. For centuries, apothecaries and herbalists recommended roses for a variety of ailments. A favourite comes from *Askham's Herbal* of 1550: 'Drye roses put to the nose to smell do comforte the braine and the harte and quencheth sprites.' In addition to quenching sprites, roses were used for driving out other domestic evils. The Elizabethans used rosewater-scented gloves to hold up to their noses. In 1594 Sir Hugh Platt included a recipe for 'Sweet Water of the Best Kind' in his *Delights for Ladies*. This extravagantly involved taking 'a thousand Damask Roses . . .'. The wealthiest European homes would welcome 'perfumers' who would clear rooms of musty smells by burning embers which had been soaked in rosewater.

In 1661, a time when outbreaks of plague were increasingly common, the diarist John Evelyn believed that the smoky and poisonous air around London could be purified by the damask rose. Evelyn's friend the poet Abraham Cowley agreed:

> Who, that has reason, and his smell,
> Would not among roses and jasmine dwell,
> Rather than all his spirits choke
> With exhalations of dirt and smoke?[6]

Tragically, sweet smells did not prevent the deaths of nearly 70,000 Londoners in the Great Plague of 1665. However, the rose's own capacity to succumb to disease has proved useful, as when they are planted at the end of rows of grapevines in wine regions from Tuscany to Australia's Barossa Valley to act as an early warning system.

· IIIaqua rolacca ·

Aqua rolaca. ɔplo. ca. a ftiptica. Clecɔ q̃ fit ex rolis b̄n odoꝛifeus. fine mvtioꝰ aq̃. uuuami. pı̃tat uı:tuitbꝫ ꝼ vftruꝰ fenfuum. coꝛ ꝯfoꝛtat. ficopı ꝯʒuatuꝛ ꝉ ipã: fedat. ꝉ eunitnm crafpar. pcerꝰ fumpta i potu. Remõ nocti cum cãoꝛo intep. Quio g̃at nutrimeum modicu. Con ueir mag̃. ea. iuuenibꝫ eftate ꝼ regione feptentrioali. aꝉ mꝺꝛionalı ꝛ̃

Illustration showing women picking roses to make rosewater, from
Tacuinum Sanitatis (14th century), a medieval handbook of health.

One of the most popular use for roses in the home is in pot-pourri, a term which comes from the French, literally translating as 'rotten mixture'. It has been used at least since the eighteenth century when Lady Luxborough described it as 'a potful of all kinds of flowers which are severally perfumes [sic] and when mixt and rotten, smell very ill'. Pot-pourris were used in all but the poorest households, with recipes being handed down from mother to daughter and housekeeper to housemaid. Rose petals have always been the main ingredient of both wet and dry pot-pourri. The wet – a mixture of flowers, salt and

spices – is rarely made these days since it has no 'eye appeal', although it retains its perfume the longest.

There are almost as many recipes for dry pot-pourri as there are rose varieties. In *Home and Garden* (1900), Gertrude Jekyll thought little of this method, calling it 'lazier and less effective' than wet pot-pourri. Herbalist Eleanour Sinclair Rohde recommended adding some *Sedum rhodiola*, with a scent she thought was similar to 'the apothecary's rose', honeysuckle, carnation, lemon verbena and

The full health benefits of rose hips only became understood
in the 20th century.

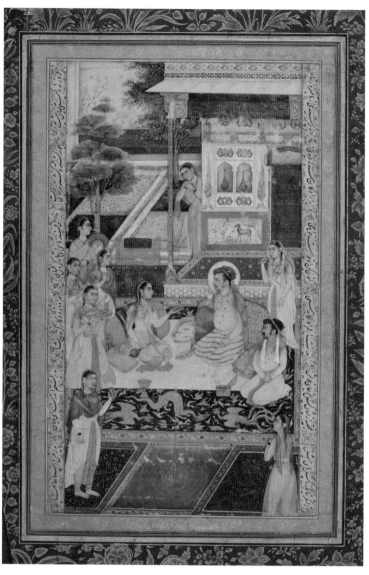

Emperor Jahangir and Prince Khurram are entertained by the emperor's wife Nur Jahan, reputed to have discovered how to distil rose oil (India, *c.* 1624).

philadelphus. Plantswoman Beth Chatto grinds her own orris root from the tubers of *Iris germanica* or *I. florentina* and adds a few strands of marigold for contrasting colour. She warns against adding too many spices in case the mixture ends up smelling like mincemeat rather than pot-pourri.

While not as ornamental as rose petals, the rose hip has long been prized for the making of conserves but it was not until the UK food shortage during the Second World War that its high concentration of vitamin C was discovered. It is said that, in the autumn of 1941, the government organized Scottish women and Boy Scouts to scour the hedgerows for the hips for the production of rose hip syrup. They gathered an amazing 134 million hips – 200 tonnes of dog rose hips (R. *canina*), enough for 600,000 bottles. With oranges and other citrus fruit unavailable until well into the 1950s, rose hips were and still are a precious source of this vital vitamin. They are also recommended by herbalists to boost the immune system and improve mobility in osteoarthritis. In Turkey, more usually associated with its sweet 'Delight', rose tea made from rose hips is widely drunk not just for its delicious flavour but also for its health-giving properties. There is a custom in Poland, and Polish communities across the world, that *paczki*, a type of doughnut eaten traditionally the day before Ash Wednesday, are best filled with jam made from rose hips.

Rosewater is relatively simple to produce but extracting the highly prized attar of rose is more complicated. 'Attar' comes from an ancient Persian word for perfume, *'atr*. The skill of distillation goes back at least to the ninth century and maybe long before. The plains surrounding the palace of Ardeshir I (r. 226–240) at Firuzabad, south of Shiraz, were said to be a sea of red roses grown for attar for export to Egypt, India and China. A mind-boggling 30,000 bottles were delivered from Persia to the Caliph in Baghdad between AD 810 and 817. By the sixteenth century, there was a very basic knowledge of the distilling technique in Italy, but it was more usual for essences to be brought from Persia and India via Venice and then sold on to the rest of Europe.

Several countries have fables about the discovery of rose oil distillation. One tells how the beautiful, but high-maintenance, Mughal princess Nur Jahan's desire to have the canals of her palace at Aram Bagh, Agra, filled with rosewater in the early seventeenth century led to the discovery of rose oil in India. As the Princess and her husband, the ferocious Emperor Jahangir (1569–1627), watched the rosewater evaporate in the heat, the oily residue had 'the most delicate perfume known in India'.[7] Jahangir claimed, 'there is no other scent of equal excellence to it!'[8]

However, the extraction process was already known in the fifteenth century in Eastern Roumelia, then an Ottoman province but now the Kazanlik region of Bulgaria and the world centre for the production of attar of rose. The combination of soil conditions, rainfall and temperature is perfect for growing R. damascena 'Trigintipetala', known locally as R. damascena 'Kazanlik'. The second-largest growing area is around Isparta and Burdur in southwestern Turkey, introduced by a Bulgarian immigrant in 1894. In both countries 'Trigintipetala' remains the dominant variety grown, with smaller harvests of R. gallica and R. centifolia. Petal collection starts every morning as soon as the flowers have opened and stops as soon as the dew has dried under the sun. Flowers picked before nine in the morning produce the best attar. The whole head is used, since all parts, not just the petals, contain the precious oil.

For centuries, it was extracted using basic equipment ('peasant production'), but efficient factories now dominate the industry. There are two main production methods: solvent extraction using chemicals, now the main method to produce what is called rose 'absolute', the most concentrated oil; and steam distillation. The older steam distillation process produces both rosewater, with only a fraction of the fragrance, and 'attar of rose' oil, which separates out on top of the water. The season is short and labour-intensive because the flower heads have to be picked by hand. In both Bulgaria and Turkey women – it is mostly women – rise early to fill wicker baskets with the heady blooms. Visitors during the annual Rose Festivals are astounded by

A heavily perfumed rose petal sorting hall in Grasse, 1898.

the intoxicating, heavily perfumed air and the pickers' nimble fingers. There are dances and parades to celebrate the annual harvest before the products are sent around the world, to be added to anything from Turkish Delight to top-label perfumes. Both 'absolute' and attar are widely used in fine perfumes and cosmetic creams. Ten thousand petals are needed to fill a 5 ml bottle of rose otto, as attar of rose is usually known today, making it one of the most precious of fragrance and cosmetic oils.

In France, where most of these luxury fragrances were developed, there were attempts to grow *R. damascena* 'Trigintipetala' in the late nineteenth century, but it did not adjust well to the more temperate climate. At his famous rose garden on the outskirts of Paris, Jules Gravereaux bred *R. rugosa* 'Rose à parfum de L'Haÿ' (1901), hoping it would be taken up as a French replacement to 'Trigintipetala'. A thousand years earlier, the Chinese had also used *R. rugosa* as a source for scent, but it proved not to be economically viable for the French growers. There is some rose-growing for the French perfume industry at Grasse in the South of France, centred on *R.* × *damascena*, but it has never competed internationally with Bulgaria and Turkey. Its reputation rests primarily on the creation of perfumes.

North India and Pakistan also grow enormous numbers of fragrant damask roses for local use in garlands and as loose petals for worship. Both countries have industries making rosewater and rose oil for domestic consumption and for export. There are significant sales of attar and absolute or *rul al gulab* (literally 'soul of the rose') to the Middle East from India, especially from the region around Kannauj in Uttar Pradesh. It goes mainly to Saudi Arabia and Kuwait. Rose oils are particularly valued among Muslims because they can be used straight on the skin and do not have alcohol added to them, unlike most Western perfumes in sprays or atomizers. In Kuwait *rul al gulab* is worn by men and increasingly by women. Attars are believed to mature with age and are often bought as wedding presents to be 'put down' in much the same way as one might lay down wine. A BBC online news item in 2017 reported that the value of fragrance sales in Saudi Arabia in 2014 was \$1.4 billion (£1.1 billion), with the average customer spending \$700 (£550) per month just on attars.[9]

In the West, quite apart from cost considerations, pure rose absolute is not worn as a single scent because it is considered too

Labels from rose-scented cosmetics, *c.* 1840.

strong in comparison to perfumes, which are a blend of different fragrances. The skill of the perfumer is to find the right combination of essences. As perfume expert Lizzie Ostrom says, 'rose oil does not smell like a rose.'[10] Robert Calkin, who spent a lifetime as a 'nose' and now advises David Austin on rose scents, told me that, in its pure form, it is not a 'sexy' scent but, when mixed with other components such as jasmine, it becomes one of the most appealing perfumes for women. That has made it a key ingredient for top-label moisturizers and many of the most famous perfumes of the twentieth century.

It all started when one of the first great commercial perfumers, François Coty, staged a publicity stunt to launch his new fragrance, 'La Rose Jacqueminot', named after the velvety red R. 'Général Jacqueminot' (1853), a highly scented French rose and one of the grandparents of Gravereaux's 'Rose à parfum de L'Haÿ'. Coty visited a Parisian department store and 'accidentally' dropped a bottle on the floor. Women flocked to find the source of the scent and shops clamoured to stock it. There followed, and continue to appear, dozens of Rose 'soliflores' – perfumes with rose as their central ingredient and in their title: Rose (Caron), China Rose (Floris), Rose d'Amour (Les Parfums de Rosine), Rykiel Rose (Sonia Rykiel) and two Rose Absolues (Annick Goutal and Yves Rocher). There are even more that point to their origins or history: Eau d'Italie's Paestum Rose and Creed's Fleurs de Bulgarie. But the most successful rose fragrances of the second half of the twentieth century have less obvious branding: Patou's Joy, Chanel's No. 18, Guerlain's Nahéma and Estée Lauder's Beautiful all rely on rose for their top notes. The great perfumier Serge Lutens described his Rose de Nuit as 'a true carpet of roses'.[11] But controversial scent critic Luca Turin feels that after the arrival of Yves Saint Laurent's heady Paris in the 1980s, it was 'not possible to make a louder, bigger, more complicated rose [perfume]'.[12]

For the true scent of roses captured indoors, I recommend a visit to the Officina Farmaceutica di Santa Maria Novella, in a back street in Florence close to the well-known church and the main railway station, all of the same name. They have been producing rosewater

since at least 1391 and since 1612 have sold traditionally made rose products to the public. Take a deep breath as you enter and you inhale the essence of rose, just as the privileged did a few centuries ago.

When the nuns of Santa Maria Novella started making rose-water in 1391, the world known to Europeans was a much smaller place: no America, no southern hemisphere, and only travellers' tales of the Far East. Even Florence was still wholly medieval and it was forty years before Filippo Brunelleschi started on the Duomo. In England the Plantagenet king Richard II was still on the throne, over a hundred years after the rose became the symbol of England and a hundred more before it became the Tudor rose. It was almost 1,000

Rose-scented products from the Officina Farmaceutica di Santa Maria Novella in Florence.

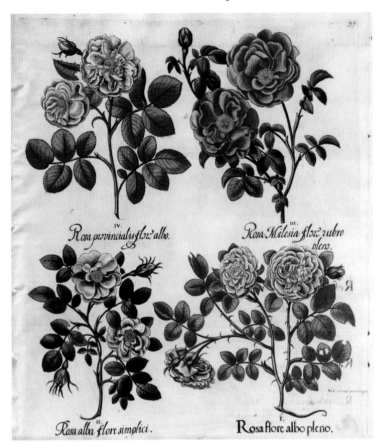

IV.
Rosa provincialis flor: albo.

III.
Rosa Milesia flor: rubro oleno.

II.
Rosa alba flore simplici.

I.
Rosa flore albo pleno.

White and red roses shown in great accuracy from Basilius Besler's *Hortus Eystettensis* (Garden of Eichstätt), Nuremberg, 1613.

years since the church had dropped its antipathy to roses, previously associated with Roman pagan excess.

In 1613, the year after the nuns started selling rose products to the public, printing had improved so much that *Hortus Eystettensis* was able to show roses growing in the garden of the bishop of Eichstätt in Bavaria in exquisite detail. Sixteen years later, John Parkinson wrote about 24 different roses available in England. One hundred and fifty years later, the four great stud roses arrived from China and changed rose breeding forever. The introduction of hybrid teas in the second half of the nineteenth century and floribundas in the

early twentieth century brought an explosion of colour, shape, style and scent that still shows no sign of slowing. The latest online edition of *Find That Rose*, a 34-year labour of love by Angela Pawsey of the Cant family, lists 3,580 different rose varieties available from forty UK growers. While some disappear each year, 140 new ones were introduced in 2016. The love affair with the world's favourite flower is never-ending.

Appendix 1: The Rose Family and Its Groups

❧

Roses belong to the large Rosaceae botanical family of 107 genera, containing over 3,000 species (specific naturally occurring plants). As well as roses, it includes many well-known edible fruits such as almonds, apples, apricots, blackberries, pears, plums, raspberries, strawberries and even quince and medlar; many popular garden shrubs, such as cotoneasters and pyracanthas; and herbaceous perennials such as potentillas and *Alchemilla mollis*.

Rose Names and Registered Code Names

Every rose has at least two names. The first is always the *generic* name *Rosa*. The second is of one of two sorts: a *species* name, always written in italics, showing that it was a rose originally found in the wild; or, if the second name is in quotation marks, as in *Rosa* 'Peace', a *hybrid cultivar*, meaning that it was bred artificially. If it also has a third name in quotation marks, it is a particular variety (whether naturally occurring or bred) of a species rose, for example *Rosa gallica* 'Officinalis', telling us the generic type of plant (rose), the species (a gallica) and the variety ('Officinalis').

Rose names occasionally vary from country to country. For example, the white ground cover rose 'Schneeflocke' ('Snowflake'), bred by Werner Noack in 1991, is widely known outside its native Germany by its Anglophone name 'White Flower Carpet', and has also been sold in some countries as 'Ophalia' (sic) or 'Emera Blanc'.

To add to the confusion, another completely different variety, *R. rugosa* 'Schneekoppe' ('Snow Pavement'), is also sometimes sold as 'Schneeflocke'. To help gardeners know they are buying the right rose, a new global system of Registered Code Names was adopted by rose breeders in the late 1970s. Any rose registered since then has a code name, which first identifies the breeder with three capital letters, such as NOA for Noack, followed by a second code, in smaller capital letters, for the particular rose. This convention is barely visible in the retail world but allows every rose to be uniquely identified in whichever country it is put on sale. The plant label for 'White Flower Carpet' should show its official trade name, NOASCHNEE – unpronounceable but helpful to know you are getting the right variety. Usually, this made-up word is unrelated to its popular name. For example, the trade name for Harkness's Shrub Rose 'Jacqueline du Pré' (1988) is HARWANN. Occasionally, there may be a hint. AUSQUAKER is the trade name for David Austin's apricot 'Dame Judi Dench' (2017). Fans of Dame Judi might know that she comes from the famous Quaker city of York and went to a Quaker girls' school.

Species Roses, Old Roses and Modern Roses

Species Roses encircle the northern hemisphere, with none found in the southern hemisphere. Of the two hundred known species roses, 40 per cent are found in China. While a few, such as *R. glauca* and *R. moyesii*, are grown in gardens, others are used in rose breeding. Most roses found in gardens today are descended from sixteen species roses:
R. arvensis (field rose); *R. blanda* (prairie rose); *R. canina* (dog rose); *R. chinensis* (China rose); *R. fedtschenkoana*; *R. foetida* (Austrian briar or Persian yellow rose); *R. gallica*; *R. gigantea*; *R. moschata* (musk rose); *R. multiflora* (Japanese rose); *R. pimpinellifolia* (Burnet rose or Scottish rose); *R. rubiginosa* (eglantine, sweet briar); *R. rugosa*; *R. sempervirens* (evergreen rose); *R. setigera* (prairie rose); *R. wichurana*.

Rosa damascena coccinea, 'The Portland Rose', Pierre-Joseph Redouté, 1817–24.

Old Rose Groups

Old Roses, also known as 'Heritage or 'Historic' roses, are members of groups dating back to before 1867 when the first HYBRID TEA was introduced. Their origins are often obscure. The following are the most widely available groups, divided into Summer or Once-flowering and Repeat-flowering:

Summer or Once-flowering Old Roses

ALBAS are always white or pale pink, and grow into large bushes with bluish leaves. One of the oldest and toughest is R. × *alba* 'Alba Semi-plena', thought to be the original white rose of York. They derive from R. *canina* and R. *gallica*.

CENTIFOLIAS, the 'Cabbage' or 'Provence' Roses, much loved by artists, are a small group, famed for their large pink multi-petalled flower heads. They were promoted by Carolus Clusius at the Leiden Botanic Garden in the 1590s. Their origins are unknown but they may come from crosses between gallicas and damasks.

DAMASKS were grown for centuries across the Islamic world, but R. *damascena* was a relatively late introduction to the West. Summer damasks include the striped 'Versicolor', known as 'York and Lancaster' (*c.* 1550), and the pure white 'Mme Hardy' (1832).

GALLICAS are possibly some of the most ancient roses. R. *gallica* 'Officinalis', 'Rose of Provins', the semi-double red rose, is most probably the red rose of Lancaster. It was used in vast quantities around Europe for medicinal, cosmetic and culinary purposes. Hybrid gallicas became hugely popular in the mid-nineteenth century although most are no longer grown. The deep crimson 'Charles de Mills' (*c.* 1790) was an early introduction that remains popular, as does the maroon 'Tuscany Superb' (1837).

MOSS ROSES, with the mutation of a soft moss-like covering on their sepals and sometimes down their stems, were a popular pink variation on CENTIFOLIAS and occasionally DAMASKS in the nineteenth century, especially in France. They have a delicious resinous smell and are sticky to the touch. Colours range from the dark crimson of 'William Lobb' (1855) to the clear pink of the original 'Common Moss' (*c.* 1700).

Repeat-flowering Old Roses

AUTUMN DAMASKS: The origins of *R. damascena* var. *semperflorens* or 'Bifera', also known as 'Four Seasons' or 'Quatre Saisons', are still obscure although it is thought to have been a sport of the summer-flowering variety. Quite when it arrived in Western Europe is also unclear. It is mentioned by Giovanni Ferrari in *De florum cultura* (1633) but may have been known to the ancient Greeks and Romans. There is a white variety as well as the original pink.

BOURBONS and CLIMBING BOURBONS came about as a chance cross on the island of Réunion in the Indian Ocean. Before the opening of the Suez Canal in the late 1860s, Réunion, then known as Île de Bourbon, was a regular stopping-off point for ships trading between Europe and the Far East. In 1817 the botanist Nicolas Bréon noticed a seedling in a hedge between the pink CHINA rose 'Old Blush' and the deep-pink AUTUMN DAMASK 'Quatre Saisons'. He transplanted it and then sent its seed to Antoine Jacques, a Paris nurseryman. Jacques worked on crosses but they were never as hardy as the HYBRID PERPETUALS. Famous varieties include the rich pink 'Louise Odier' (1851) and the beautifully cupped pale-pink 'Mme Pierre Oger' (1878).

CHINAS (*R. chinensis*) are the oldest known roses in the world but did not arrive in England and France until the late eighteenth century. The four 'stud Chinas' (see Chapter Four) led to the breeding of hybrid Chinas and TEA ROSES during the nineteenth century and,

through them, to the development of many of the modern rose groups. Although some require a warm climate to thrive, 'Old Blush', known as 'The Monthly Rose', is widely grown.

HYBRID PERPETUALS were crosses and re-crosses with Chinas and other early varieties such as BOURBONS and PORTLAND roses, mainly in the mid-nineteenth century. They produced generally reliable repeat-flowering outdoor roses. Their large blooms made them popular for showing, but they had a limited colour palette of mostly muted mauves. Thousands were introduced, of which only a few survived the onslaught of the HYBRID TEAS and FLORIBUNDAS, including the deep-pink 'La Reine' (1842) and rich mauve 'Reine des Violettes' (1860).

NOISETTES came from a cross made in America in the early nineteenth century between R. moschata, the musk rose, and 'Old Blush', one of the four stud Chinas. One of the most enduring of this group is 'Blush Noisette' usually grown as a climber, as well as the pale shell-pink 'Mme Alfred Carrière' (1879).

PORTLANDS are a small group but include some very garden-worthy varieties such as the dark-mauve 'Indigo' (1830) and the deep-pink 'Jacques Cartier' (1868). The original 'Portland Rose' (c. 1750) was most likely a cross between a DAMASK and R. gallica. It is traditionally thought to be named for the great plantswoman Margaret Cavendish Bentinck, 2nd Duchess of Portland (1715–1785), although there is no direct evidence for this.

TEA ROSES (Rosa × odorata) are crosses between R. gigantea and R. chinensis. In the West, where they are tender except in the warmest climates, most are descended from 'Hume's Blush Tea-scented China' and 'Parks' Yellow Tea-scented China'. They were the most popular rose for the cut flower trade in the nineteenth century, in particular, the light-pink 'Catherine Mermet' (1869).

Modern Rose Groups

Modern roses are those in groups which were introduced in or after 1867, when the first HYBRID TEA, 'La France', was introduced. Classifications may vary from country to country. The following are the most widely grown groups, many of which have climbing forms.

FLORIBUNDAS and CLIMBING FLORIBUNDAS (also known as 'cluster-flowering roses') were introduced in the early twentieth century by the Poulsen nursery in Denmark. They come from crosses between HYBRID TEAS – long-stemmed roses with single large blooms – and POLYANTHAS. The hybrid tea increased the size of the polyantha's flowers, producing plants covered in many large blooms. Having multiple flowers on each stem makes floribundas less suitable for cutting or showing but popular for large planting schemes where impact is needed.

'The Fairy' (1932), polyantha rose.

GRANDIFLORAS and CLIMBING GRANDIFLORAS (U.S. only) are tall, large-flowering floribundas such as the strong pink 'Queen Elizabeth' (1954).

GROUND COVER ROSES, developed in Britain and Germany, include the 'County' range from Kordes. In America, where they are known as landscape roses, the Knock Out® roses are widely popular.

HYBRID MUSKS were developed by Rev. Joseph Pemberton and later by his gardener John Bentall in England and by Peter Lambert in Germany in the early twentieth century. Distantly related to the musk rose, R. *moschata*, they are a fragrant, multi-headed group which includes pale-pink 'Cornelia' (1925) and rose-pink 'Felicia' (1928).

HYBRID TEAS and CLIMBING HYBRID TEAS (also known as 'large-flowered') were created by crossing the two most popular nineteenth-century groups, TEA ROSES and HYBRID PERPETUALS. They are the epitome of the twentieth-century rose: healthy, dark-green foliage with long, single-stemmed roses, which repeat well and are perfect for cutting. For over a hundred years they dominated the rose world, and for many they still epitomize the ideal rose for colour and shape. There are also many climbers in this group.

MULTIFLORA, SEMPERVIRENS and WICHURANA RAMBLERS are some of the most valuable rambling roses and cross the date boundary between old and modern roses. Examples include the white 'Albéric Barbier' (1860) and the pale shell-pink 'New Dawn' (1930), both Wichuranas.

POLYANTHAS and CLIMBING POLYANTHAS are a late nineteenth-century group with masses of tiny flowers on each stem, which led to the development of FLORIBUNDAS. One of the most widely grown is the mid-pink 'The Fairy' (1932).

RUGOSA HYBRIDS are tough roses crossed with R. *rugosa* found in China, Japan, Korea and Siberia. They are often used for hedging because they are virtually disease-free. Many have heady scents, such as the deep magenta 'Roseraie de l'Haÿ' (1901).

SHRUB ROSES is a term used for various roses that do not easily fit into other old or modern rose groups, for example, 'Golden Wings' (1958) or 'Cardinal Hume' (1984). It is especially applied to modern roses such as David Austin's English Roses which have a looser growth and are able to be grown in mixed borders.

Appendix II: Recipes

※

With all these recipes, make sure that the roses you use have not been sprayed with pesticides. Always check for lurking insects and discard any petals that are not perfect.

Edible Rose Recipes

Rosewater

Put rose petals, preferably from a damask rose, into a saucepan. Add just enough distilled water to cover the petals. Cover with a lid and simmer gently over a low heat until any colour has transferred from the petals to the water. It is important not to bring the water to a boil. Strain the rosewater through a muslin cloth into clean bottles. It will keep in a refrigerator for several weeks for culinary or cosmetic use.

Rose Petal Jam

Gather together scented red or pink rose petals, sugar, the juice of two lemons, pectin, water – recommended quantities vary from recipe to recipe and need not be exact. For 500 g (2 cups) of sugar and 1 litre (350 fl. oz) of water, allow 100–200 g (¾ of a cup) of rose petals.

Collect rose petals from unsprayed roses. The darker the petals, the darker the jam. Place the petals in a bowl with a good sprinkling

of sugar. Crush them by hand, scrunching them with the sugar. Cover the bowl with plastic film and leave somewhere cool overnight.

Heat the rest of the sugar, the lemon juice, a little pectin and water, stirring all the time. Just before the syrup comes to the boil, add the rose petal mixture and simmer, stirring constantly for 20 minutes. The petals may be strained off after a few minutes if preferred. Finally, boil for 5 minutes, testing at this point for setting by sampling on a cool plate. Allow to cool slightly and then transfer into sterilized jars. Seal and store.

Candied Rose Petals

Collect some rose petals and pat them dry between two sheets of paper towel. Whisk an egg white until fluffy. Holding each petal with tweezers, use a small paintbrush to paint each side thinly with the egg white. Dip the petal in a shallow bowl of caster sugar, coating well on both sides. Place on a tray lined with a sheet of greaseproof paper or baking parchment and sprinkle lightly with more sugar. Repeat with as many petals as are needed. Leave overnight to dry and then store in a sealed container at room temperature until needed.

Rose Vodka

This recipe comes with thanks to Mark Diacono of the Otter Farm Kitchen Garden School in Devon:

Put a litre (34 fl. oz) of vodka in a wide-necked jar, add about an inch of sugar and a handful of R. *rugosa* or other fragrant rose petals. Leave for three days – the colour leaches into the alcohol. Strain to remove the petals. Serve chilled either as is or lengthened with some form of fizz.

Rose Hip Syrup

Chop the rose hips in a blender and then place in saucepan with 1.25 litres (40 fl. oz) of water. Simmer for 15 minutes and then strain the juice through a clean muslin cloth into a bowl, leaving for at least half an hour to ensure all the liquid has been extracted. Discard hips. In a large saucepan, add 325 g (1¼ cups) of sugar for every 500 ml (20 fl. oz) of juice. Slowly bring to the boil and simmer until the sugar has dissolved, stirring constantly. Pour into sterilized bottles, seal and store for up to three months. Refrigerate once opened.

Rose Hip Jam

Cover the fresh rose hips with water and boil until the fruit is soft. Sieve to remove seeds. Allow the same weight of sugar as pulp and boil to make jam as above.

Rose Hip Syrup Jam

Wash, top and tail, and cut in half 800 g (4 cups) of rose hips. Remove seeds with a melon baller or small spoon. Place rose hips and 200 g (1 cup) of sugar in a saucepan, cover and leave to infuse overnight. The following day, add 150 ml (5 fl. oz) of water and the same amount of orange juice, and simmer for approximately 15–20 minutes until soft. Stir in the juice of one untreated lemon, 1 cinnamon stick and 200 g (1 cup) of jam sugar, and simmer for a further 5 minutes. Strain and pour into prepared jam jars while still hot.

Rose Hip Tea

This can be made with either fresh or dried rose hips. Place a large spoonful of fresh rose hips or a small spoonful of dried hip in a pot of boiling water and steep for 15 minutes. Strain the hips from the tea. Add a spoonful of honey to taste.

Drying Rose Hips

Hips are easily dried. After picking, wash and dry with paper towels. Line a tray with greaseproof paper or baking parchment and spread the hips so they are not touching. Leave to dry in a dark place for two weeks. The shrunken hips can then be stored in jars for later use.

Scented Roses in the Home

Wet pot-pourri

Pick the roses when they are fully open and dry, in the middle of a sunny day. Immediately spread them out on a cloth or old sheet somewhere warm and sheltered. The next day, take a suitable china or pottery container with a lid (not glass, since light must be excluded) and begin to layer the rose petals with sea salt, tamping down each layer firmly. Every third or fourth layer, add some lemon verbena, bay or sweet geranium leaves, and lavender flowers. This can be done over several days or even weeks, since the flowers will slowly sink to allow topping up especially if weighed down. After about six weeks, when ready to use, add the spices – 15 g (½ oz) each of ground cinnamon, mace, nutmeg and pounded lemon peel, 60 g (2 oz) of orris root power, and, if available, 30 g (1 oz) of gum benzoin. A few drops of rose or rose geranium oil may also be added. By this stage, the flowers will have turned into a mush. That is how they are supposed to be. Transfer to pot-pourri pots with perforated lids and stir regularly to release perfumes into the room.

Dry pot-pourri

It is a matter of taste and the available flowers but all the experts agree that the main ingredient should be rose petals and that they must be thoroughly dried. So the choice is yours as long as the majority are

rose petals. Dry and mix, add a little orris root as a fixative and a few drops of rose oil regularly to heighten the scent.

Dried Rosebuds

The desire to have roses in the house throughout the year in one form or another is nothing new. In Elizabethan times, according to Eleanour Sinclair Rohde, roses were dried in sand. Today silica gel is widely available and easy to use.

Half fill an old biscuit tin or plastic box with the silica. Then place the individual rosebuds on the granules, brushing the silica into any openings. Sprinkle more silica over the rosebuds until they are completely buried. Cover with a lid and leave for at least a week in a warm, dry place. The silica will change colour slightly as it absorbs the moisture from the rosebuds. They can be checked and re-buried. When ready, remove and brush any remaining silica away with a soft paintbrush. The silica can be dried in an oven at a low heat and reused many times.

For short-term use, bought bunches of roses may be dried by hanging upside down in a warm, dark place.

Timeline

40m years ago	Roses fossilize in North America, to be discovered in the twentieth century
1500 BC	Roses in paintings from the Xia dynasty
AD 77–9	Pliny the Elder's *Natural History* lists 32 different ailments that can be treated with roses
170	Rose wreath placed in a tomb at Hawara in Lower Egypt, discovered in the 1880s
818	Charlemagne's son, Louis the Pious, plants *R. canina* against the wall of Hildesheim Cathedral, where it still grows, claiming its title 'The Thousand-year Rose'
1239/40	*R. gallica* 'Officinalis' brought back to France from the Crusades, possibly in the helmet of Thibault IV, King of Navarre and Count of Champagne
c. 1435	White and pink double albas climb the trellis in Stefano da Zevio's painting *Madonna in the Rosary*
1597	John Gerard mentions 'the Holland Rose' in his *Herball*, later named *R. centifolia* by Carl Linnaeus in 1753
c. 1750	Linnaeus receives a dried and a living form of *R. chinensis* 'Old Blush' from Canton but it is not thought significant

1792	First of the stud Chinas, 'Slater's Crimson China', arrives in England
1793	The second stud China, *R. chinensis*, 'Parsons' Pink China', soon known as 'Old Blush', re-introduced from China
1800	'Old Blush' sent to America
1809	The third Stud China, 'Hume's Blush Tea-scented China' – now extinct – arrives in England from the East Indies
1810	London nurseryman John Kennedy granted special permission to cross enemy lines to deliver roses to Empress Joséphine at her home, Malmaison, near Paris
c. 1811	John Champneys of Charleston, South Carolina, discovers a new rose in his rice field, named 'Champneys' Pink Cluster', a cross between *R. chinensis* and *R. moschata*
1814	Phillipe Noisette, director of the Charleston Botanical Garden, breeds the first noisette rose from 'Champneys Pink Cluster' and sends it to his brother, Louis Claude, in Paris
1817	Nicolas Bréon discovers the natural cross between *R. damascena* and *R. chinensis* in his garden on the Île de Bourbon (now Réunion), which becomes parent to the Bourbon group
1819	Louis Claude Noisette launches the noisette rose 'Blush Noisette' in France
1824	'Parks' Yellow Tea-scented China', the fourth stud China, is brought back from a plant hunting expedition by John Damper Parks
1838	Sir Henry Willock returns from Persia with the double form of *R. foetida*
1840–80	'The Great Forty Years', including the peak era of hybrid perpetuals and when over three hundred different damask roses become available

1867	'La France', later recognized as the first hybrid tea rose, is bred by Jean-Baptiste Guillot. This year becomes the cut-off date declared by the American Rose Society (ARS) in 1966 to differentiate between 'Old Rose' ['Heritage Rose'] and 'Modern Rose' groups
1876	The National Rose Society is established in Britain with Revd Samuel Reynolds Hole as its first President
1880	English rose grower Henry Bennett shows ten new roses at the Horticultural Society of Lyon as 'Pedigrees Hybrids of the Tea Rose'. The Lyon Committee agrees he has created a new class of rose, henceforth known as *Hybrides de Thé*, or hybrid teas
1893	The National Rose Society finally accepts the term hybrid tea to describe the class of roses created by Henry Bennett, the 'Wiltshire Wizard'
1898	The European Rose Garden at Sangerhausen in Germany is founded by the German Rose Society
1899	Jules Gravereaux, owner of the Bon Marché department store in Paris, retires to concentrate on his garden at L'Haÿ-les-Roses, just outside Paris, later named La Roseraie de L'Haÿ
1900	Joseph Pernet-Ducher launches 'Soleil d'Or', creating a new division among hybrid teas called Pernetiana
1901	Plant hunter and explorer Ernest H. 'Chinese' Wilson discovers R. omeiensis, later bringing back eighteen more roses for the Royal Botanic Gardens, Kew, and the Arnold Arboretum, Boston, Massachusetts
1905	Portland, Oregon, holds a World Exposition and plants its sidewalks with 10,000 bushes of the hybrid tea 'Mme Caroline Testout'
1907	The world's first test garden is established in La Roseraie de Bagatelle in the Bois de Boulogne, Paris
1911	Danish nurseryman Dines Poulsen develops floribundas, initially known as hybrid polyanthas, continuously flowering crosses

1930	U.S.-based French rosarian Dr J. H. Nicolas coins the name 'Floribunda' for crosses made between hybrid teas and polyanthas; the U.S. Plant Patent Act allows rose breeders to earn royalties for the first time
1932	The National Rose Garden established in London's Regent's Park, becoming Queen Mary's Rose Garden in 1935
1945	'Peace', the world's most successful rose, introduced in France by its breeder, Francis Meilland, and in America by the Conard-Pyle Company
1960	'Super Star', bred by Matthias Tantau Jr in Germany, becomes the first rose to contain the vermilion pigment 'pelargonidin'
1961	David Austin launches once-flowering shrub rose 'Constance Spry', the first of his family of English Roses
1970s	Graham Stuart Thomas moves his collection of old roses to Mottisfont, Hampshire, owned by the National Trust, where it becomes the National Plant Collection of pre-1900 shrub roses
1986	President Ronald Reagan announces that the rose is to be the official flower of the USA; the rose also becomes the symbol of the British Labour Party
1999	The 'Knock Out'® range of roses is launched in the U.S. by amateur rose breeder William Radler, of Greenfield, Wisconsin, and becomes one of the most popular in the country
2016	R. 'Frank Kingdon Ward' planted on Ward's grave in Grantchester, Cambridge, bred in India from a R. gigantea collected by him on the slopes of Mount Sirohi in northwest India
2017	BBC Gardeners' World viewers select the rose as the most important and influential plant of the last fifty years

References

Introduction

1 Carl Linnaeus quoted in Roy E. Shepherd, *History of the Rose* (New York, 1954), p. 4.
2 T. Su, et al., 'A Miocene Leaf Fossil Record of Rosa (*R. fortuita* n. sp.) from its Modern Diversity Center in SW China', *Palaeoworld* (2015), http.//dx.doi.org.10.1016/j.palwor.2015.05.019.
3 Edward A. Bunyard, *Old Garden Roses* (London and New York, 1936), p. ix.

1 The Classical Rose

1 Pierre Cochet quoted in Roger Phillips and Martyn Rix, *The Quest for the Rose* (London, 1996), p. 10.
2 Ruth Borchard, 'Did Abraham know the Rose?', *Rose Annual*, XI (1962), pp. 128–9.
3 Oxyrhyncos Papyrus, 3313, quoted in Naphtali Lewis, *Life in Egypt Under Roman Rule* (Oxford, 1985), p. 80.
4 Martial quoted in Jack Goody, *The Culture of Flowers* (Cambridge, 1993), p. 63.
5 Ibid., p. 56.
6 Peter Harkness, 'The Muse of Lesvos and the Queen of Flowers', *Historic Rose Journal*, XXI (2006), p. 5.
7 Herodotus, *The Histories,* trans. Aubrey de Selincourt (London, 1976), p. 138.
8 Gerd Krüssmann, 'The Centenary International Rose Conference 5–8 July 1976: The Rose in Art and History', *Rose Annual*, LXXI (1977), p. 71.
9 Linda Farrar, *Ancient Roman Gardens* (Stroud, 1998), p. 138.
10 *Roman Farm Management: The Treatises of Cato and Varro* [1918], ebook, trans. Fairfax Harrison.
11 Lesley C. Evans, 'Roses of Ancient Rome', *Rose Annual*, LXXII (1978), p. 37.
12 Wilhelmina F. Jashemski, 'The Flower Industry at Pompeii', *Archaeology*, XVI/2 (1963), p. 120.
13 Jennifer Potter, *The Rose* (London, 2011), p. 30.

14 Farrar, *Ancient Roman Gardens*, p. 138.
15 Wilhelmena F. Jashemski, "'The Garden of Hercules at Pompeii" (II.VIII.6): The Discovery of a Commercial Flower Garden', *American Journal of Archaeology*, LXXXIII/4 (1979), p. 409.
16 Dionysius the Sophist quoted in Goody, *The Culture of Flowers*, p. 59.
17 Alison Keith, *Propertius: Poet of Love and Leisure* (London, 2008), p. 33.
18 Ausonius, Epigrammata 'Rosa', 2:49: 'De rosis naescentibus'.

2 A Rose without a Thorn

1 Alice Coats, *Garden Shrubs and their Histories* (London, 1963), p. 290.
2 Penelope Hobhouse, *Gardens of Persia* (London, 2006), p. 34.
3 Edward A. Bunyard, *Old Garden Roses* (London and New York, 1936), p. 22.
4 Paedogogus II, 71, 4 quoted in Asaph Goor, *History of the Rose in the Holy Land Throughout the Ages* (Pittsburg, PA, 1981), p. 109.
5 Clement of Alexandria quoted in Eithne Wilkins, *The Rose-Garden Game: The Symbolic Background to the European Prayer-beads* (London, 1969), p. 116.
6 Story of St Alban, at www.stalbanscathedral.org, accessed 6 December 2017.
7 Anthony Lyman-Dixon, 'Radegund's Roses', *Historic Gardens Review*, 21 (2009), p. 31.
8 Ibid.
9 Ibid., p. 32.
10 Peter Harkness, 'Royalty and Roses', *Rose Annual*, CI (2007), p. 74.
11 Jack Goody, *The Culture of Flowers* (Cambridge, 1993), p. 150.

3 The Royal Rose

1 Peter D. A. Boyd, 'The Towton Rose: Fact, Fancy and Fiction (Part I)', *Historic Rose Journal* (2011), p. 10.
2 Ibid.
3 Thomas Penn, *Winter King: The Dawn of Tudor England* (London, 2011), ebook.
4 Ibid.
5 Ibid.
6 John Harvey, *Early Nurserymen: With Reprints of Documents and Lists* (London, 1974), p. 29.
7 John Gerarde, 'John Gerarde on Roses (Part 1 of 2)', *Rose Annual* (1981), p. 107.
8 Ibid., pp. 108–9. This is confirmed by François Joyaux, 'History of Roses in Cultivation: European (Pre-1800)', in *Encyclopedia of Rose Science*, ed. A. V. Roberts (Amsterdam, 2003), p. 397.
9 John Gerarde, 'John Gerarde on Roses (Part 2 of 2)', *Rose Annual* (1982), p. 117.
10 'Aleppo: The Life of a Flower-seller', www.channel4.com (UK), 22 August 2016.

4 The Birth of the Modern Rose

1 William Paul, *The Rose Garden* (London, 1848), p. 5.
2 Alice Coats, *Garden Shrubs and their Histories* (London, 1963), p. 299.
3 This should not be confused with R. 'The McCartney Rose' (1991), a hybrid tea which has won numerous awards for its scent.
4 I am grateful to Robert Calkin for drawing my attention to Mrs Gore. Robert Calkin, 'The Tea Fragrance', *Rose Annual*, C (2006), p. 76.
5 Roger Phillips and Martyn Rix, *The Quest for the Rose* (London, 1996), p. 105.
6 Ethelyne Emery Keays, *Old Roses* (London, 1978), p. 171.
7 Jack Harkness, *The Makers of Heavenly Roses* (London, 1985), p. 23.
8 Ibid., p. 32.
9 Ibid.
10 Charles Quest-Ritson and Brigid Quest-Ritson, *The Royal Horticultural Society Encyclopedia of Roses* (London, 2003), p. 57. Harkness, *Makers of Heavenly Roses*, p. 32.

5 'Peace' and Propagation

1 Jack Harkness, *The Makers of Heavenly Roses* (London, 1985), p. 100.
2 Ibid., p. 121.
3 Ibid., p. 63.
4 Charles Quest-Ritson and Brigid Quest-Ritson, *The Royal Horticultural Society Encyclopedia of Roses* (London, 2003), p. 409.
5 Personal correspondence with Girija and Vira Viraraghavan.

6 From *Rosarium* to *La Roseraie*

1 Quoted in Todd Longstaffe-Gowan, *The London Town Garden, 1740–1840* (New Haven, CT, and London, 2001), p. 102.
2 Ibid., p. 220.
3 Sir Robert Ker Porter, *Persia in Miniature*, vol. III, quoted in [Elizabeth Kent], *Flora Domestica* (London, 1825), p. 371.
4 'Thomas Jefferson's Notes on Poplar Forest Plantings and Geography, 1 February 1811–6 October 1821', founders.archives.gov, 28 December 2016.
5 Anna Pavord, 'A rose by any other name just won't do', *The Independent*, 27 November 1993.
6 François Joyaux, 'Roses of the Empress Joséphine', *Historic Rose Journal*, XIX (2000), p. 21.
7 Ibid., p. 25.
8 Nadine Villalobos, *A Treasury in L'Haÿ-les-Roses: The Roseraie du Val-de-Marne* (Paris, 2006), p. 40.
9 Charles Quest-Ritson and Brigid Quest-Ritson, *The Royal Horticultural Society Encyclopedia of Roses* (London, 2003), p. 47.

7 The New Rose Garden

1 Graham Rose, P. King and D. Squire, *The Love of Roses* (London, 1990), p. 66.
2 William Robinson, *The English Flower Garden* (London, 1883), p. 184.
3 Gertrude Jekyll and E. Mawley, *Roses for English Gardens* (London, 1902), p. 66.
4 Ibid., p. 70.
5 Ibid. p. 71.
6 The Royal National Rose Society went into liquidation in 2017.
7 Vita Sackville-West, 'Roses in the Garden', *Journal of the Royal Horticultural Society*, LXXXVI (1961), p. 426.
8 Vita Sackville-West and Sarah Raven, *Vita Sackville-West's Sissinghurst* (London, 2014), p. xiv.
9 Vita Sackville-West, 'Old Garden Roses', *Rose Annual* (1947), p. 81.
10 Sackville-West, 'Roses in the Garden', p. 431.
11 Catherine Horwood, '1940–59: A New Era', in *The Gardens of England: Treasures of the National Gardens Scheme*, ed. G. Plumptre (London, 2013), p. 68.
12 Graham Stuart Thomas, *Shrub Roses of Today* (London, 1974), p. 32.
13 Proclamation 5574 – Designation of the Rose as the National Floral Emblem of the United States of America, www.reaganlibrary.archives.gov, 20 November 1986.
14 Marta McDowell, *All the President's Gardens* (Portland, OR, 2016), pp. 213–14.

8 The Literary Rose

1 Quatrain by Empress Yang Meizi (r. 1202–24), at http://metmuseum.org/art/collection, accessed 6 December 2017.
2 See R. L. Anderson, 'Metaphors of the Book as Garden in the English Renaissance', *Yearbook of English Studies*, XXXIII (2003), pp. 248–61.
3 Caroline Spurgeon, *Shakespeare's Imagery and What It Tells Us* (Cambridge, 1968), p. 86.
4 Barbara Seward, *The Symbolic Rose* [1954] (Dallas, TX, 1989), p. 63.
5 Sir Robert Ker Porter, *Persia in Miniature*, vol. III, quoted in [Elizabeth Kent], *Flora Domestica* (London, 1825), p. 371.
6 W. B. Yeats, 'The Wind Among the Reeds' (1899), quoted in Seward, *The Symbolic Rose*, p. 92.

9 'Only a Rose . . .'

1 John E. Stevens, *Music and Poetry in the Early Tudor Court*, pp. 364–5, quoted in Thomas Penn, *Winter King: The Dawn of Tudor England* (London, 2011), ebook.
2 Valentine Hugo quoted in Françoise Reiss, *Nijinsky: A Biography*, trans. H. and S. Haskell (London, 1960), p. 89.
3 Ibid., p. 90.
4 Romola Nijinsky, *Nijinsky and The Last Years of Nijinsky* (London, 1980), p. 137.

5 Ibid.
6 Ibid.

10 The Rose in Art and Decoration

1 Painton Cowen, *Rose Windows* (London, 1990), p. 7.
2 Ibid., p. 91.
3 Jane Ashelford, *The Art of Dress: Clothes and Society, 1500–1914* (London, 1996), pp. 40–41.
4 Graham Stuart Thomas, *The Graham Stuart Thomas Rose Book* (London, 2004), p. 21.
5 Quoted in Marianne Roland Michel, 'Is Botany an Art?', in *The Floral Art of Pierre-Joseph Redouté*, ed. M. R. Michel (London, 2002), p. 19.
6 Mary Delany to Anne Dewes, 15 September 1759, quoted in Clare Browne, 'Mary Delany's Embroidered Court Dress', in *Mrs Delany and Her Circle*, ed. Mark Laird and Alicia Weisberg-Roberts (New Haven, CT, and London, 2009), p. 79.
7 Edward Bunyard, 'The Rose in Art', *Rose Annual* (1938), p. 47.
8 William Morris quoted in Thomasina Beck, *The Embroiderer's Flowers* (Newton Abbot, 1992), p. 142.

11 Posies, Petals and Perfume

1 *The Young Ladies' Journal Language of Flowers* (London, 1869), p. 222.
2 Gertrude Jekyll and E. Mawley, *Roses for English Gardens* (London, 1902), p. 73.
3 Sir William Ouseley, *Travels in the East*, vol. III, pp. 352–3, quoted in [Elizabeth Kent] *Flora Domestica* (London, 1825), pp. 372.
4 Nadine Villalobos, *A Treasury in L'Haÿ-les-Roses: The Roseraie du Val-de-Marne* (Paris, 2006), p. 102.
5 P. A. van de Pol, 'History of Roses in Cultivation: History of the Perfume Industry', *Encyclopedia of Rose Science*, vol. I, ed. A. V. Roberts (Amsterdam, 2003), p. 411.
6 Quoted in Margaret Willes, *The Gardens of the British Working Class* (New Haven, CT, and London, 2014), p. 142.
7 Mark P. Widrlechner, 'History and Utilization of *Rosa damascena*', *Economic Botany*, XXXV/1 (1981), p. 47.
8 Michael R. Hayward, 'The Roses of Perfumery', *Hortus*, VII/2 (1993), p. 44.
9 'The Soul of the Rose', www.bbc.co.uk/news, 23 August 2017.
10 Lizzie Ostrom, *Perfume* (London, 2015).
11 Inna Dufour Nannelli, *Roses: The Sweet Scent of Flowers*, trans. Katharine S. Bennett-Powell (Milan, 2002).
12 Luca Turin and Tania Sanchez, *Perfumes: The A–Z Guide* (ebook, 2010).

Select Bibliography

❦

Austin, David, *Old Roses and English Roses* (Woodbridge, 1992)
—, *Shrub Roses and Climbing Roses: With Hybrid Tea and Floribunda Roses* (Woodbridge, 1993)
Beales, Peter, *Classic Roses: An Illustrated Encyclopaedia and Grower's Manual of Old Roses, Shrub Roses and Climbers* (London, 1997)
Bunyard, Edward, *Old Garden Roses* (London, 1936)
Cairns, Tommy, ed., *Modern Roses XI: The World Encyclopedia of Roses* (San Diego, CA, 2000)
Dickerson, B., *The Old Rose Advisor* (Portland, OR, 1992)
—, *The Old Rose Adventurer* (Portland, OR, 1999)
Elliott, Brent, *The Rose* (London, 2016)
Fisher, Celia, *Flowers of the Renaissance* (London, 2011)
Genders, Roy, *A History of Scent* (London, 1972)
Goor, A., *History of the Rose in the Holy Land throughout the Ages* (Tel Aviv, 1981)
Griffiths, Trevor, *A Celebration of Old Roses* (London, 1991)
Harkness, Jack, *The Makers of Heavenly Roses* (London, 1985)
Harkness, Peter, *The Rose: A Colourful Inheritance* (London, 2003)
Hobhouse, Penelope, *Gardens of Persia* (London, 2006)
—, *Plants in Garden History* (London, 1992)
Jekyll, Gertrude, and E. Mawley, *Roses for English Gardens* (London, 1902)
Krüssmann, Gerd, *The Complete Book of Roses*, trans. Gerd Krüssmann and N. Raban (London, 1982)
Laird, Mark, *A Natural History of English Gardening, 1650–1800* (New Haven, CT, 2015)
Landsberg, Sylvia, *The Medieval Garden* (London, 1995)
Le Rougetel, Hazel, *A Heritage of Roses* (London, 1988)
Pal, B. P., *The Rose in India* (New Delhi, 1966)
Paterson, Allen, *A History of the Fragrant Rose* (London, 2004)
Phillips, Roger, and Martyn Rix, *The Quest for the Rose* (London, 1996)
Potter, Jennifer, *The Rose: A True History* (London, 2011)

Quest-Ritson, Charles, and Brigid Quest-Ritson, *The Royal Horticultural Society Encyclopedia of Roses* (London, 2003)
Rose, Graham, Peter King and David Squire, *The Love of Roses* (London, 1990)
Shepherd, Roy E., *History of the Rose* (New York, 1954)
Thomas, Graham Stuart, *The Graham Stuart Thomas Rose Book* (London, 2004)
Villalobos, Nadine, *A Treasury in L'Haÿ-les-Roses: The Roseraie du Val-de-Marne* (Paris, 2006)

Associations and Websites

AMERICAN ROSE SOCIETY
www.rose.org

EUROPA-ROSARIUM, SANGERHAUSEN
www.europa-rosarium.de

HERITAGE ROSE FOUNDATION
www.heritagerosefoundation.org

HISTORIC ROSES GROUP
www.historicroses.org

MOTTISFONT
National Collection of Old-fashioned Roses
www.nationaltrust.org.uk/mottisfont/features/mottisfonts-rose-garden

SOCIÉTÉ FRANÇAISE DES ROSES
www.societefrancaisedesroses.asso.fr

WORLD FEDERATION OF ROSE SOCIETIES
www.worldrose.org

Suppliers

DAVID AUSTIN ROSES
www.davidaustinroses.co.uk
www.davidaustinroses.com (U.S.)

JACKSON & PERKINS (U.S.)
www.jacksonandperkins.com

MEILLAND (FR)
www.meilland.com

PETER BEALES
www.classicroses.co.uk

POCOCKS ROSES
www.garden-roses.co.uk

Other

FIND THAT ROSE
www.findthatrose.net

HELP ME FIND
www.helpmefind.com/roses

Acknowledgements

❦

When I started work on this book, I thought I knew something about roses. I know a great deal more now about this complicated family. For that, I am enormously grateful for the support and encouragement I have received from many of those involved in the rose and horticultural world; in particular Charles Quest-Ritson, who was so generous with his knowledge of roses and their history. I would like to thank Michael Marriott of David Austin Roses, Angela and Roger Pawsey of Cant's of Colchester, Stewart Pocock of Pocock's Roses, and Robert Calkin, for their time and advice. I am also grateful for their help and patience to Jenny Sargent at the Cory Library, Cambridge University Botanic Garden; Tom Pink at the RHS London Lindley Library; Abigail Barker at the RHS Science Library at Wisley; and, as always, staff at the London Library. Thanks also to Matthew Biggs, Stephen Crisp, Melanie De Vore, Mark Diacono, Madeleine Dubeil, Alexandra Federa, Gillian Mawrey, Kathleen Pigg, Barbara Segall, Tuo Su, Amanda Vickery, Girija and Viri Viraraghavan, and Travis Wellman, and to Jennifer Potter, for her words of encouragement. My consistently cheerful editor, Matt Milton, has been a pleasure to work with.

The story of the rose has caught the imagination of many friends and family members. In particular, I would like to thank Gillian Bray for her helpful and constructive comments, Siobhan Franklin for details of her experience running a rose farm in Zambia, and Hester Vickery Styles for her literary suggestions. Among family members, thanks go to Ros Barwise for her input on rose petal collecting in Turkey and Julia Georget for her donation of a treasured volume of rose recipes. But most of all, my eternal gratitude goes to Paddy Barwise, my 'copy-editor-in-residence' whose patience and tenacity seems to know no bounds.

One of the many complications of the rose family is that even among experts, there is inconsistency over the spelling of some varieties. Wherever possible, I have followed the format given in the RHS *Encyclopedia of Roses*. Any errors and omissions are my own.

Photo Acknowledgements

❀

The author and the publishers wish to express their thanks to the below sources of illustrative material and/or permission to reproduce it.

Alamy: pp. 6 (John Glover), 18 (Josh Westrich), 19 (PBL Collection), 38 (Paul Fearn), 47 (Hercules Milas), 68 (Rex May), 70–71 (Avalon/Photoshot Licence), 72 (GKSFlorapics), 77 (Paul Mogford), 78 (Roger Phillips), 80 (Steffen Hauser/botanikfoto), 83 (Garden World Images Ltd), 84 (Mauritius images GmbH), 87 (Dorling Kindersley Ltd), 88 (Kim Carlson), 90 (Garden World), 91 (Garden World Images Ltd), 92 (Avalon/Photoshot License), 95 (Universal Images Group North America LLC/DeAgostini), 110 (Moskwa), 117 (Amoret Tanner), 125 (Garden Photo World), 134 (Chronicle), 139 (Lebrecht Music and Arts Photo Library), 152 (Matthew Kiernan), 153 (Chronicle), 154 (Chronicle), 157 (Paul Fearn), 159 (Everett Collection Inc.), 175 (Heritage Image Partnership/© Georgia O'Keeffe Museum/DACS 2018), 182 (Eunan Sweeney), 184 (Eric Lafforgue), 186 (Prisma Archivo), 192 (Amoret Tanner), 203 (blinkwinkel); Archives du Val de Marne: p. 108; Author's collection: pp. 10, 12, 44, 55, 79, 112, 114, 115, 116, 118, 144, 176, 187, 194; David Austin Roses, www.davidaustinroses.com: pp. 96, 112, 181; British Library, London: pp. 52, 57, 151; Europa-Rosarium Sangerhausen: p. 123; Freer Art Gallery, Washington, DC: p. 188; Getty Images: pp. 120 (Carlton/Picture Post/Hulton Archive), 132 (DeAgostini); Kenton Greening: p. 13; Library of Congress, Washington, DC: p. 41; Metropolitan Museum of Art, New York: pp. 54, 140, 145; James Mitchell: p. 162; New York Public Library: pp. 14, 170; Official White House Photo: p. 126 (Pete Souza); REX Shutterstock: pp. 29 (Alfredo Dagli Orti), 33 (British Library/Robana) 46 (Alessandro Serrano), 61 (The Art Archive), 142 (British Library/Robana), 160, 178 (Kharbine-Tapabor); Rijksmuseum, Amsterdam: p. 166; Shutterstock: pp. 74, 199 (the palms); Girija and Vira Viraraghavan: p. 98; Victoria and Albert Museum, London: pp. 158, 165; Yale Center for British Art, Paul Mellon Collection: p. 169.

Index

Page numbers in *italics* refer to illustrations

Al-Aqsa Mosque 34, 184
al-Mutawkkil, Sultan 184
Alanbrooke, Lord 88
Alban, St 37
albas 9, 39, 73, 163, 164, 200
Albertus Magnus 40
alchemy 46, 146
Alcuin 39–40
Alexander the Great 20
allegory
 Chastel d'Amour (Castle of Love) 53
 Dante 134–5
Alma-Tadema, Sir Lawrence 22
 The Meeting of Antony and Cleopatra 22
 The Roses of Heliogabalus 30, 172–4,
 174
 Summer Offering 172
American Rose Society 124, 214
Anacreon 23, 152
Andersen, Hans Christian 143
André, Edouard 106, 109
Andrews, Henry Charles 170–71
Aphrodite 23, 48
apothecary's rose *see Rosa gallica*
 'Officinalis'
Arabs 15, 34, 35, 36
Ardeshir I 189
Armstrong Nurseries 93
Arnold Arboretum, Boston, MA 83,
 214
Ashridge, Hertfordshire 103, *104*
Assyria 20, 63

attar of rose 15, 27, 36, 183, 189,
 190–92
Ausonius 30–31, 137
Austin, David 94–5, 121, 147, 181,
 193, 198, 215
autumn damasks *see Rosa damascena* var.
 semperflorens

Bagatelle, Parc du, Paris 109–11, *110*,
 214
Banks, Joseph 169
Barbier nursery 89
Barni nursery 93
Barry, Madame du 168
Bakst, Léon 155–6
Beales, Peter 121, 183
Beethoven, Ludwig van 138
Benedict, St 37
Bengal roses 68
Bennett, Henry 76–81, 82–3, 84,
 214
Bentall, John 89, 204
Bérenger, Raimond, count of
 Provence 50
Besler, Basilius, *Hortus Eystettensis* 195,
 195
Biggs, Matthew 96
Blake, William, 'The Sick Rose' *140*,
 141
Botticelli, Sandro
 Birth of Venus 25
 Primavera 163, 164

Boucher, François 168
Bourbon roses 73, 183, 201, 202, 213
Boursault-Malherbes, Jean-François 73
Bréon, Nicolas 201, 213
Britten, Benjamin 138
Brueghel, Jan 167
Buck, Griffith 90
Bulgaria 8, 15, 183, 190, 191
Bunyard, Edward 13, 25, 33, 120, 172
Burns, Robert 138
Byron, Lord 145

cabbage roses *see Rosa centifolia*
Calcutta Botanic Gardens 68
Calkin, Robert 193
Cambridge University Botanic Garden 11
Cants of Colchester 94, *117*, 196
Carroll, Lewis, *Alice's Adventures in Wonderland 142*, 143
Catholicism 14, 37, 41, 43–5, 62, 137–8
Cato the Elder 30
chahar bagh 100–101
Champneys, John 75, 213
chaplets 24, 28, 30, 34, 45, 52
Charlemagne, Emperor 39–40, 212
Charleston Botanic Garden, South Carolina 75, 213
Chastel d'amour (Castle of Love) *52, 53, 54*
Chatto, Beth 189
Chaucer, Geoffrey 133–4, 176
Cherokee rose *see Rosa laevigata*
China 18–19, 65, 83, 183, 184, 189, 191, 195, 205, 212
 Fa-Te nursery, Canton 67
 fossils 9
 in paintings 161, 212
 poetry 129
 stud Chinas 195, 213
china, designs on 175–6
Christianity 32

Clement of Alexandria 36
 Orthodox Christianity 43
 rose festivals 45, 46
 Song of Solomon 36, 164
Cicero 29–30
Cleopatra 21, 22
Clusius, Carolus (Charles de l'Ecluse) 200
Coats, Alice 32, 66
Cochet-Cochet, Charles-Pierre-Marie 109
Cochet, Pierre 17
Conard-Pyle Company 58, 88, 215
Confucius 18
Constantinople 32, 184
 see also Istanbul
Coty, François 193
Crete 19–20, 161
crusaders 7, 15, 34, 40, 97, 212
Culpeper, Nicholas 15
cut flower trade 37, 82, 180–81
Cyprian, St 37

Damascus 34, 40, 63
damasks 9, 52, 58, 59, 73, 136, 168, 185, 200, 201, 202, 206
Dandridge, Martha 171
Dante Alighieri, *The Divine Comedy* 134–5
de Rupe, Alanus 43
death 7, 14, 21, 30
Delany, Mary 102, 171
Descemet, Jacques-Louis 73, 108
Diana, Princess of Wales 158
Dicksons nursery 94
Dionysus 29
Dioscorides 161
distillation 21, 27, 184, 189–90
dog rose *see Rosa canina*
Dominic, St 43
Dorothy, St 37
Dot, Pedro 91
Ducher, Jean-Claude 73

Edward I, king of England 50, 53
Edward IV, king of England 53

Edward VI, king of England 58
Edward VII, king of England 62
Eglantine *see Rosa rubiginosa*
Egypt 17, 21–2, 27, 28, 189
Ehret, Georg Dionysius 169
 Rosa gallica 'Versicolor' (Rosa
 Mundi) *61*
Eleanor of Aquitaine, Queen 60
Eleanor of Provence, Queen 50
Eliot, T. S. 146–47
Elizabeth I, queen of England 59–
 60, 154, 165–7
Elizabeth II, queen of England 15, 62
Elizabeth Park Rose Garden,
 Hartford, Connecticut 124
Elizabeth, St, queen of Hungary 44
Ellwanger & Barry nursery 93
English roses 12, 95, 147, 205
Eros 48
Europa-Rosarium, Sangerhausen
 121–2, *123*, 214
Evelyn, John 185

Fantin-Latour, Henri 171–2
 Fleurs roses (Rosario) 172
Farrand (Jones), Beatrix 127
Farrar, Linda 25
Farrokhi 34
Fauré, Gabriel 152
Ferrari, Giovanni, *De florum cultura* 201
festivals 25, 45, 123, 185, 190
Find That Rose 196
Fitzgerald, Edward 147–8
 Rubáiyát of Omar Khayyám 35, 128
Fleet, Walter van 93
floribundas 11–12, 85, 89, 94, 116,
 177, 195, 202, 203, 214, 215
Fonteyn, Margot 156, *159*
Forestier, Jean-Claude Nicolas
 109–11
Fortunus, Venantius 39
fossils, rose 8–9, 202
Fragonard, Jean-Honoré 168
fragrance 21, 24, 27, 42, 72, 114, 137,
 144, 151, 181–6, 189, 192–3, 201
Frederick the Wise of Saxony 45

Gallé, Emile 174–5
gallicas 9, 39, 58, 73, 104, 168, 200
Gardener, John, *Feat of Gardening* 58
garlands 22, 24, 26, 28, 30, 36, 43, 76,
 137, 168, 192
 Dürer, *Feast of the Rose Garlands*
 164
Garthwaite, Anna Marie 171
genetic research 11, 85
Gerard, John, *Herball* 59–60, 212
German Rose Society 122–3
Geschwind, Rudolf 90
Gnosticism 49
Goethe, 'The Mysteries' 146
gol see gul
golden rose 45–6, *47,* 50
Gore, Mrs, *Rose Fancier's Manual* 69
grandiflora roses 204
grapevines 185
Grasse 191, *191*
Gravereaux, Jules *108,* 109, 110, 191,
 193, 214
Greece 21, 201
Gregory, St 37–38
Guillot, Jean-Baptiste, *père* 73
Guillot, Jean-Baptiste 76, 78, 214
gul 32, 143–4
gulistan 34, 99
 Sa'di, *Gulistan* 35, 130, *131*

Hagia Sophia 34, 184
Harkness nursery 183, 198
Harkness, Jack 81
Harkness, Peter 97
Harpocrates 48
Harvey, John 102
Hawara 17–18, 30, 202, 212
health benefits 185, 189
Hébert, Mme 73
Heem, Jan Davidsz. de 168
 Still-life 166
Heliogabalus, Emperor 30
Henry II, king of England 60
Henry VII, king of England *55,* 58, 150
Henry VIII, king of England 45, 58,
 150, 165

heraldry 52–3
herbals 164
 Askham's Herbal 185
 Fuchs, Leonhard, *New Kreüterbuch* 165
 Gerard, John, *Herball* 59–60, 165
Herodotus 24
Herrick, Robert 31, 137
Hessayon, Dr D. G., *The Rose Grower* 117
Hibiscus rosa sinensis 43
Hildesheim Cathedral 40, *41*, 212
Hilliard, Nicholas
 'Pelican Portrait' 59
 Portrait of Elizabeth I 56
 Young Man Among Roses 165, 167
Hinduism 43
Hobhouse, Penelope 32
Hole, Samuel 7, 78, 89, 113, 115, 214
Holland 40, 167, 180
Holland rose *see Rosa centifolia*
hortus conclusus 99, 101, 132, 164
Hume, Sir Abraham 67
Huntington Botanical Gardens, California 123
Hurst, Charles Chamberlain 11
Huysum, Jacob van 168–9
Huysum, Jan van 167, 169–170
hybrid musks 85, 89, 204
hybrid perpetuals 73, 76, 78, 83, 202, 204, 213
hybrid teas 11–12, 76, 79, 82, 89, 91, 94, 177, 195, 200, 202, 203, 204, 214

illuminated manuscripts *38*, 45, 164, 165
India 68, 83, 97, *182*, 189, 190, 192, 215
Innocent IV, Pope 50
Iran
 Firuzabad, Shiraz 189
 Ghamsar, Kashan 185
Isfahan 152
 see also Persia

Iraq 184
Isabella I, queen of Castile 45, 164
Islam 33–34, 36, 43, 99, 101, 161, 184, 185, 192, 200
Istanbul 99
 see also Constantinople
Italy 29, 39, 45, 53, 65, 86, 92, 121, 162, 171, 189

Jackson & Perkins nursery 93
Jacques, Antoine 201
Jahangir, Emperor *188*, 190
James I, king of England 60
James II, king of England 62
Japan 8, 9, 11, 109, 130, 198, 205
Jefferson, Thomas 104–5, 126
 Garden Book 127
Jekyll, Gertrude 114–16, 127, 179–80
 Home and Garden 187
 Roses for English Gardens 114, *114*, *115*, *116*
Jerome, St 37
Jerusalem 34
Jonson, Ben 151
Joséphine, Empress 11, 15, 105–7, *107*, 170
 Malmaison 15, 105–8, 170, 213
Joyaux, François 106
Joyce, James 146
Judaism 36

Karr, Alphonse 182
Keats, John 141–2
Kennedy, John 127
Kennedy, John, nurseryman 105, 171, 213
Kent, Elizabeth, *Flora Domestica* 103
Kew, Royal Botanic Gardens 17, 129, 214
Khayyám, Omar 15, 128, 147–8
Knock Out® roses 12, 93, 204, 215
Knollys, Sir Robert 55
Knossos 19–20, *20*
Kordes, Wilhelm 84–6
Krüssmann, Gerd 24
Kuwait 192

Laffay, Jean 73, 76
Laird, Mark 101
Lancaster, House of 51, 57, 58
language of flowers 178, 179
Lawrance, Mary 170, 170
Lawrence, D. H. 146
Lee & Kennedy nursery 65
Leiden Botanic Garden 200
Léonie Bell Noisette Rose Garden,
 Virginia 126
Linnaeus, Carl 8, 66, 138, 212
Louis the Pious, king of the Franks
 40, 212
Lyon, Horticultural Society of 78

Macartney, Lord 66
Madonna *see* Mary, Virgin
Magritte, René 175
Malmaison *see* Joséphine, Empress
Mapplethorpe, Robert 175
Marriott, Michael 97
Marshall, Alexander 168, 169
Marvell, Andrew 137
Mary I, queen of England 46
Mary, Queen of Scots 46
Mary, Virgin 37, 42, 43, 44, 162,
 163–4, 212
Mattock, Robert 97
McGredy family 94
McIntosh, Christopher 49
medieval gardens *see hortus conclusus*
Mehmet II, Sultan 34, 35
Meilland nursery 86, 95
Meilland, Francis 11, 86, 215
Mellon, Rachel 127
Mendel, Gregor 85
Midas, King 24
Miller, Philip 65
 Gardeners Dictionary 101
Milton, John, *Paradise Lost* 137
monastery gardens 39
Montagu, Lady Mary Wortley
 179
Monticello, Virginia 104–5, 126
Moore, Ralph 92
Moore, Thomas 138, 150

More, Thomas 58
Morris, William 176–7
moss roses 73, 201
Mottisfont, Hampshire 98, 121, 215
Mount Vernon, Virginia 124
multiflora roses 204
musk roses 60, 136, 183

naming of roses 197–98
Napoleon 11, 73, 105, 108
National Rose Society 7, 78–9, 89,
 115
Nero, Emperor 28
Nicolas, Dr J. H. 90, 215
Nicolson, Harold 76, 118
Nijinsky, Vaslav 156–7, 157
Noack, Werner 197
Noisette roses 75–6, 146, 202
Noisette, Louis Claude 11, 75
Noisette, Philippe 11, 75, 213
Nur Jahan, Empress 188, 190

O'Keeffe, Georgia 175
 Rose 175
Officina Farmaceutica di Santa Maria
 Novella 193–4, 194
Ostrom, Lizzie 193
Ottoman Empire 14, 34, 35, 44, 161,
 190
Ouseley, Sir William 182

Pakistan 192
Palladius 26
paradise gardens 21, 34, 99, 135, 143
Parkinson, John 195
 Paradisi in sole paradisus terrestris 60
Parks, John Damper 68
Parmentier, Louis-Joseph-Ghislain
 73
Parsons, Alfred 174
Paul, William 65, 76
Pawsey, Angela 196
Payne, Henry A., *Plucking the Red and
 White Roses in the Old Temple Gardens*
 172, 173
pelargonidin 90, 91, 215

Pemberton, Joseph 89, 204
Penn, William 57
perfumed oils 21, 26, 27, 28, 184,
 188, 191–92
perfumery *see also* rosewater 21,
 191–93
Pernet, Jean 73
Pernet-Ducher, Joseph 82, 84,
 214
Pernetiana roses 214
Persia 20, 21, 27, 28, 32–34, 82, 161,
 181–2, 184, 189
 mythology, art and literature
 13–14
 poetry 129
 see also Iran
Petrarch, Francesco 135
Petrie, William Flinders 17
Pio, Padre 42, *44*
Pizan, Christine de 133
Platt, Sir Hugh 185
Pliny the Elder 24–5, 27, 185, 212
Poland 46, 189
politics
 New Labour 62, 215
 'Rose Garden Strategy' 127
 'White Rose' movement, Munich
 62
polyantha roses 89, 203, 204, 214
Pompeii 26–7
Pont, André du 73, 106
Pope, Alexander 137–8
Porter, Sir Robert Ker 103, 144
Portland roses *see R. damascena coccinea*
Portland, 2nd duchess of 169, 202
Portland, Oregon 123, 214
pot-pourri 186–9, 209–10
Poulsen nursery 89, 94, 95, 203
Poulsen, Dines 214
Prince, William, nursery, Flushing,
 NY 75
Propertius 29
Provins 40, 51
Rose de Provins *see Rosa gallica*
 'Officinalis'
Pyle, Robert 58, 88–9

Queen Mary's Rose Garden, London
 117, 215
Quest-Ritson, Charles 81
 RHS Encyclopedia of Roses 85

Radegund, St *38*, 39
Radler, William 12, 93–4, 215
Reagan, Ronald 124, 215
Redouté, Pierre-Joseph *14*, 75,
 169–71, 177
 Les Roses 16, 106–7
 R. damascena coccinea, 'The Portland
 Rose' 199
 R. indica 'Bengale Thé hyménée'
 69
 R. noisettiana 74
religious symbolism 161
repeat-flowering 34, 76, 93, 94, 95,
 201, 202
Repton, Humphrey 102
Réunion 201, 213
Rita, St 44
Robert Furber nursery, Kensington
 101
Robinson, William 81
 The English Flower Garden 114
Rohde, Eleanour Sinclair 187–9,
 210
Roman de la rose 16, *132*, 133
Romaunt of the Rose 133–4, 177
Rome 25–31, 32, 201
Ronsard, Pierre de 135
Rosa
 alba 24, 40, 58, 59
 alba 'Maxima' 168
 × *alba* 'Alba Semi-plena' 200
 arvensis 40, 198
 banksiae 19
 berberifolia 170
 bifera 34
 bifera ssp. *damascena* 25
 blanda 198
 bracteata 66
 californica 9
 canina 9, 11, *12*, 19, 25, 37, 40, 101,
 189, 198, 200

centifolia (Holland Rose, cabbage rose) 9, 24, 25, 60, 101, 168, 169, 177, 190, 200, 201, 212
'Muscosa' 101, 103
pomponia 'Pompoon' 103
'Unique' 103
chinensis 198, 201, 202, 213
cinnamonae 60
damascena 9, 40, 63, *170*, 191, 200, 213
'Kazanlik' 190
'Mme Hardy' 200
'Trigintipetala' 190, 191
'Versicolor' ('York and Lancaster') 136, 200
'Trigintipetala' 183
coccinea (The Portland Rose) 169, *199*, 202
var. *semperflorens* (Autumn Damask, 'Quatre Saisons') 9, 34, 73, 201
fedtschenkoana 198
foetida 70–71, 82, 198, 213
'Bicolor' 103, 168
fortuita n. sp. 9, *10*
gallica 11, *14*, 19, 24, 25, 40, 190, 198, 200, 202
'Charles de Mills' 200
'Officinalis' ('Provins rose') 40, 41, 51, 59, 72, 187, 197, 200, 212
pumila ('Austrian Rose') 169
'Versicolor' (Rosa Mundi) 60, *61*, 104
pumila ('Austrian Rose') 169
gigantea 83, 97, 198, 202, 215
glauca 198
helenae 9
hemisphaerica 169
indica odorata (*see also* 'Hume's Blush Tea-scented China') 67
(Redouté) *69*
laevigata (Cherokee rose) 124
lutea 60, 160
moschata 11, 25, 75, 89, 103, 105, 198, 202, 204, 213
moyesii 83, 198

multiflora 198
noisettiana 74
× *odorata* 202
omeiensis 214
phoenicea 25
pimpinellifolia 198
provincialis (Gerard) 59
× *richardii* 17, 18
rubiginosa (Eglantine, sweet briar) 40, 59, 60, 101, *134*, 136, 156, 167, 176, 198
rugosa 9, 161, 191, 198, 205, 207
'Frau Dagmar Hastrup' *79*
'Rose à parfum de l'Haÿ' 191, 193
'Roseraie de l'Haÿ' 109, 205
'Schneekoppe' ('Snow Pavement') 197
sancta 17, 18
sempervirens (evergreen rose) 198
setigera 198
spinosissima 54
wichurana 198
Rosa Mundi *see R. gallica* 'Versicolor'
Rosamund, Fair 60
rosary 14, 42–4, 164
rose
'Aimée Vibert' 76
'Albéric Barbier' 89, 204
'Alister Stella Gray' 75
'Aloha' 93
'Avalanche' 180
'Beatrice' 181
'Belle Isis' 94
'Blush Noisette' 75, 202
'Bonica' 89
'Bouquet Tout Fait' 76
'Buff Beauty' 89, *90*
'Cardinal Hume' 205
'Carmosine' 97
'Catherine Mermet' 126, 202
'Céline Forestier' 75
'Champneys' Pink Cluster' 75, 213
'Chandos Beauty' 183
'Comte de Chambord' 95
'Constance Spry' 94, *96*, 215

'Constance' 181
'Cornelia' 204
'Crimson Glory' 85, *87*
'Dainty Maid' 94
'Dame Judi Dench' 198
'Dortmund' 85
'Dr W. Van Fleet' *92, 93*
'Dublin Bay' 94
'Duchess of Connaught' 79
'Duchesse de'Angoulême' 73
'Edith' 181, *181*
'Ellen Poulsen' 89
'Emera Blanc' 197
'Empress Joséphine' 108
'Empress of China' 126
'Ena Harkness' 94
'Evelyn Fison' 94
'Fantin-Latour' 172
'Felicia' 204
'Fragrant Cloud' 91
'Frank Kingdon Ward' 97, *98*, 215
'Frühlingsgold' 85
'Frühlingsmorgen' 85
'Général Jacqueminot' 193
'Gertrude Jekyll' 95
'Golden Wings' 205
'Graham Thomas' 121, *122*
'Grandpa Dickson' 94
'Her Majesty' 79
'Hume's Blush Tea-scented
China' 67–8, 202, 213
'Iceberg' 86
'Indigo' 202
'Jacqueline du Pré' 198
'Jacques Cartier' 202
'Joséphine Beauharnais' 108
'Just Joey' 94
'Kathleen Harrop' 93
'La France' 11, 76, *78*, 203, 214
'La Reine' 202
'Lady Hillingdon' 72, *72*
'Lady Mary Fitzwilliam' 79
'Louise Odier' 201
'Macmillan Nurse' 183
'Maréchal Niel' 146
'Mermaid' 66

'Mme Abel Châtenay' 82, *83*
'Mme Alfred Carrière' 76, *77*, 183,
202
'Mme Bravy' 76
'Mme Caroline Testout' 82, 123,
125, 214
'Mme Grégoire Staechelin' 91
'Mme Isaac Pereire' 183
'Mme Pierre Oger' 201
'Mme Victor Verdier' 76
'Mrs John Laing' 79, *80*, 81, 84
'Naomi' 180
'Nevada' 91
'New Dawn' *6*, 8, 93, 204
'Old Blush' 66, 75, 105, 138, 161,
201, 202, 212, 213
'Ophalia' 197
'Parkdirektor Riggers' 85
'Parks' Yellow Tea-scented China'
8, 68, 202, 213
'Parsons' Pink China' 69
 see also 'Old Blush'
'Paul's Himalayan Musk' 183
'Peace' 11, 58, 86–9, *88*, 197, 215
'Pink Bells' 90
'Queen Elizabeth' 93, *95*, 127, 204
'Reine des Violettes' 202
'Rose de Meaux' 103
'Rosier de van Eeden' 107
'Sarah Van Fleet' 93
'Schneeflocke' 197–8
'Shot Silk' 94
'Sissinghurst Castle Rose' ('Rose
des Maures') 119
'Slater's Crimson China' 65, *67*,
213
'Soleil d'Or' 83, *84*, 214
'Souvenir de la Malmaison' 109
'Super Star' 90, *91*, 215
'Swany' 89
'The Fairy' *203*, 204
'Tuscany Superb' 200
'Ville de Bruxelles' 73
'White Bells' 90
'White Flower Carpet' 197
'Wife of Bath' 95

'Young Lycidas' 147
'Zéphirine Drouhin' 93
rose absolute 190–93
rose and nightingale 32–3, 143–4,
 145, *145*
Rose Bowl Stadium, Pasadena,
 California 15
rose hips 77–8, 187, *187,* 189, 208–9
rose of Sharon 36
rose otto 191
rose petals *182,* 186, 206
rose rents 54–58
rose shows 73, 79, *112,* 113
rose thorns 32–3, 35–7, 51, 65, 130,
 135, 136, 142
rose windows 53, *162,* 162–3
Rosenkavalier, Die 16
Rosenkreus, Christian 49
Roseraie du Val de Marne, La 109,
 214
rosewater *33,* 34, 39, 124, 184, *184,* 185,
 186, 189–90, 192–4, 206
Rosicrucianism 46–9, *48,* 146
Rossetti, Christina 142–3, 148–9
Rossetti, Dante Gabriel 128
Royal Horticultural Society
 (previously Horticultural Society)
 68
 The Garden 96
rul al gulab 192
Ruysch, Rachel 168

Sa'd Ud Din Mahmud Shabistari
 35
Sa'di 35
 Gulistan 130, *131*
Sackville-West, Vita 13, 76, 118–19
Saladin 34
Sappho 23–24
Saudi Arabia 192
scent *see* fragrance *and* perfumes
Schubert, Franz, 'Heidenröslein'
 151, *153*
Schwartz, Joseph 73, 76
Scott, Sir Walter, *Anne of Geierstein* 51
secrecy 48

Sedulius 37
Seghers, Daniel 168
sexual symbolism 133, 134, 141, 155
Shakespeare, William 15, *51,* 53, 58,
 134, 135–8, 136, 179
Shelley, Percy Bysshe 143
Sikhism 43
Simpson, William 128–129
Sissinghurst 66, 76, 118–19, 121
Slater, Gilbert 65
Sleeping Beauty (story) 176
Sleeping Beauty, The (ballet) 156, 159
Smith, Ali 147
Society of Gardeners 168
Song of Solomon 36, 164
Spectre de la rose, Le 16, 155–6
Spenser, Edmund 137
Spry, Constance 13, 119, 180
Spurgeon, Caroline 135, 136, 137
St Gall, Switzerland 39
Steen, Alice 73
Stein, Gertrude 8
Strauss, Johann 151
Strauss, Richard, *Die Rosenkavalier* 16,
 154–5, *155*
striped roses 104–5, 200
stud Chinas 66–9, 75, 76, 195,
 201–2, 213
sub rosa 48
Sufism 34–5
Sullivan, Sir Arthur 152–3
surrealism 175
sweet briar *see Rosa rubiginosa*
symbolism 51–3
Syria 27, 63–4

Tantau Jr, Matthias 90, 215
tea roses 92, 201–2, 204
Tennyson, Alfred, Lord 140
 'Maud' *139*
Texas Rose Rustlers 13
Theophrastus 21–22, 24, 27
Thibault IV king of Navarre 40, 212
Thomas, Graham Stuart 13, 119, 121,
 168, 171–2, 215
 Shrub Roses of Today 120

Tudor rose 15, 58, 59, 138, 194
Turin, Luca 193
Turkey 27, 30, 179, 183, 189, 190,
 191
Twombly, Cy 175

Ultragoth, Queen 39

Verdier, Eugène 76
Vibert, Jean-Pierre 73, 76, 108
Victoria, queen of England 75
Viraraghavan, Girija and Vira 97
Virgil 29
vitamin C 189

Ward, Abu 63–4
Ward, Frank Kingdon 84, 96
wars of the roses 15, 51, 58
Washington, George 124, 171
Watt, Sir George 83
Wheatcroft, Harry 116, *118*

White House Rose Garden 99, *126*,
 126–7
white rose 37, 51, 53, 54, 58, 62
Wilde, Oscar 145–6
Wilkins, Eithne 43
Willmott, Ellen 174
Willock, Sir Henry 82, 213
Wilson, E. H. 83, 97, 214
wine 14, 28, *29*, 30, 36, 40, 185, 192
Woolf, Virginia 146
Wordsworth, William 141

Xerxes, king of Persia 48

Yeats, W. B. 146
York and Lancaster rose *see Rosa* ×
 damascena 'Versicolor'

Zevio, Stefano da, *Madonna in the
 Rosary 163,* 212
Zoroastrianism 32